# Thomas Gainsborough

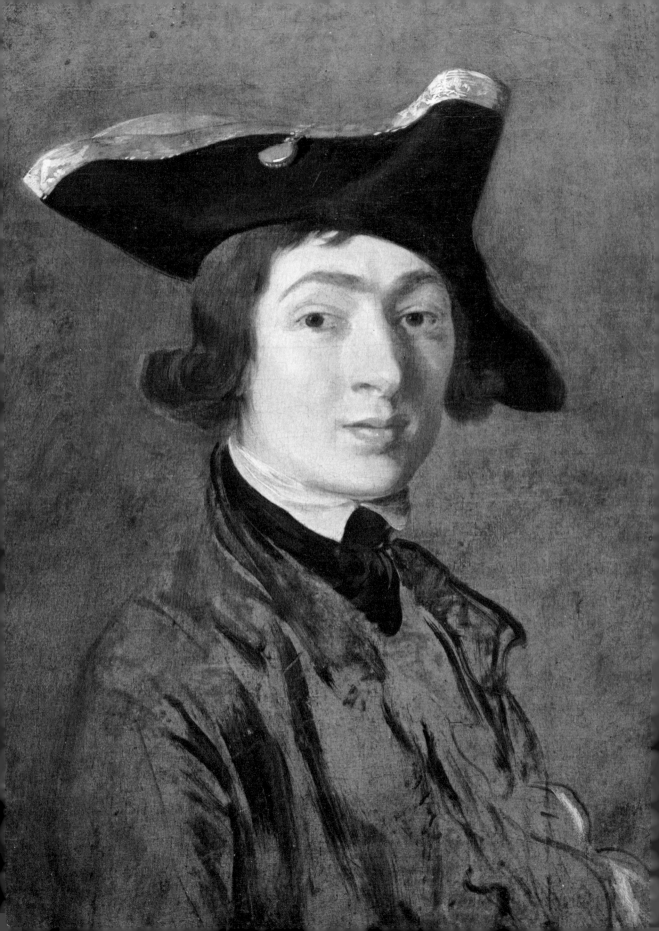

# Thomas Gainsborough

**John Hayes**

THE TATE GALLERY

ISBN 0 905005 72 4 paper  0 905005 77 5 cloth
Published by order of the Trustees 1980
for the exhibition of 8 October 1980–4 January 1981
Copyright © 1980 The Tate Gallery

Published by the Tate Gallery Publications Department,
Millbank, London SW1P 4RG
Designed by Sue Fowler
Printed in Great Britain by Balding + Mansell, Wisbech, Cambs.

# Contents

Cover/jacket
Front : Ann Ford, later Mrs Philip Thicknesse   (Cat.no.91)
Back : River Scene with Cattle Watering and Ferry Boat   (Cat.no.86)

# Foreword

This exhibition of Gainsborough's work is one in our continuing series devoted to major figures in British painting of the eighteenth and nineteenth centuries. After Hogarth, Turner, Constable and Blake we turn to the most assured and delightful of all British painters.

We are fortunate in having persuaded John Hayes, Director of the National Portrait Gallery, to make the selection and write the catalogue. Dr Hayes is an authority on Gainsborough, well known for his books and articles on the artist, including catalogues raisonné of his drawings and his landscape paintings, the latter of which is due to be published next year. Dr Hayes describes the contents of the exhibition in his own prefatory note.

Our request for loans from public and private collections, both in this country and abroad, has met with a marvellous response, and we are most grateful to all lenders for their generosity. Some of their names can be found at the end of the catalogue, but many have preferred to remain anonymous. To all, however, we extend our sincere thanks, with a particular acknowledgement of the gracious loans from Her Majesty The Queen.

When the exhibition closes at the Tate a major part, with additions from other sources, will be shown in Paris at the Grand Palais from 7 February until 26 April, under the auspices of the Réunion des Musées Nationaux and the British Council. We look forward with anticipation to the reaction of our French friends to this great master of eighteenth-century art.

ALAN BOWNESS, Director

# *Preface*

I am greatly indebted to Sir Norman Reid, lately Director of the Tate Gallery, for the invitation to select and catalogue this exhibition. To Alan Bowness and his colleagues, notably Ruth Rattenbury, upon whose organising energy and co-ordination so much has depended, I am equally grateful. Joe Pradera has designed a sympathetic setting for the exhibition, within the financial constraints imposed, with his customary flair and attention to detail. The text of this catalogue has been typed, impeccably, by Mollie Luther.

This is the first comprehensive exhibition of Gainsborough's work for nearly a hundred years. Since the retrospective at the Grosvenor Gallery in 1885 there have been several smaller scale exhibitions, notably those organised by Sir Philip Sassoon in 1936 and at the Tate Gallery in Coronation Year, 1953. But none of these has included loans from both sides of the Atlantic. Her Majesty The Queen has graciously lent three masterpieces from the Royal Collection and owners and curators in this country and abroad have responded with an exceptional enthusiasm and generosity deeply appreciated by me. Museums in the United States and Canada have been outstandingly generous in their loans.

I have assembled an especially large group of pictures to show the development of Gainsborough's early landscape style, hitherto imperfectly understood, and placed as much emphasis as possible on works which will be unfamiliar to the public. Hardly any paintings – except portraits of the artist, his family and friends – have been requested from London public collections. Visitors should also see the masterpieces at the National Gallery and at the Iveagh Bequest, Kenwood, and the Tate's own fine collection (a special display of prints and drawings has been arranged in Room 18), which should be regarded as an indispensable part of the exhibition. The showing to take place from 7 February until 26 April at the Grand Palais, Paris – the first retrospective of a non-contemporary British artist ever to be held there – has deliberately been planned on different lines.

The introduction to the catalogue has been cast in the form of a short biography, rather than a critical or art-historical appreciation, since I have attempted the latter elsewhere. I am most grateful to Lord Normanton for kindly allowing me to quote from the unpublished Gainsborough letters in his possession.

JOHN HAYES
National Portrait Gallery
July 1980

# Biographical Outline

**1727**
Baptized on 14 May at the Independent meeting house in Friars Street, Sudbury, Suffolk, the fifth son and youngest child of John Gainsborough, clothier, and Mary Burrough

**1739**
Ramsay (1713–84) settled in London

**c.1740**
Sent up to London and became a pupil of Hubert François Gravelot, the French draughtsman and engraver. Hogarth presented his full-length of 'Thomas Coram' to the Foundling Hospital

**c.1745**
Established his own studio in London

**1746**
Married Margaret Burr on 15 July at Dr Keith's Mayfair Chapel, London

**1748**
Returned to Sudbury to practise. Birth of his elder daughter, Mary

**1752**
Birth of his younger daughter, Margaret. Moved to Ipswich

**1753**
Reynolds (1723–92) settled in London as a portraitist after his return from three years study in Italy. Painted his 'Admiral Keppel', inspired by the Apollo Belvedere

**1757–8**
Wilson (1712/14–82) settled in London as a landscape painter after spending six or seven years in Italy

**1758**
Worked as a travelling portrait painter in and around Buckinghamshire

**1759**
Moved from Ipswich to Bath

**1761**
First exhibited at the Society of Artists

**1763**
Seriously ill, and subsequently took a house just outside Bath, in Lansdown Road

**1764**
Death of Hogarth at the age of sixty-seven

**1766**
Moved to a house in The Circus, Bath

**1768**
Invited to become a founder-member of the Royal Academy, of which Reynolds had been appointed President

**1769**
First exhibited at the Royal Academy. The full-length of 'Lady Molyneux' (Walker Art Gallery, Liverpool) was his *chef d'oeuvre*

**1772**
Took as an apprentice his nephew, Gainsborough Dupont (1754–97). Dupont was his only recorded pupil and assistant

**1773**
Quarrelled with the Royal Academy over the hanging of his pictures, which resulted in his not contributing to the annual exhibition again until
**1777**

1774
Settled in London, taking a tenancy of the west wing of Schomberg House, Pall Mall

1777
Exhibited 'The Watering Place' (National Gallery) and the full-length of 'The Hon. Mrs Graham' (National Gallery of Scotland) at the Royal Academy

1780
Exhibited a whole series of masterpieces at the Royal Academy, including full-lengths of 'Sir Henry Bate-Dudley' (Baroness Burton: Cat.no.125) and 'Johann Christian Fischer' (H.M. The Queen: Cat.no.126), and six landscapes which were said to 'beggar description', notably 'The Country Churchyard' (now known only from fragments) and 'The Cottage Door' (Henry E. Huntington Art Gallery, San Marino, California)

1781
Exhibited full-lengths of 'George III' and 'Queen Charlotte' at the Royal Academy, and thereafter received numerous commissions from members of the Royal Family, virtually becoming court painter

c.1781–2
Constructed his peep-show box in which he displayed his transparencies

c.1782
Made a tour in the West Country with Gainsborough Dupont. Death of Wilson

1783
Made a tour of the Lakes with Samuel Kilderbee

1784
Again quarrelled with the Royal Academy over the hanging of his pictures, which he withdrew. Never again exhibited at the Academy, and started a series of annual exhibitions in his own studio at Schomberg House. Death of Ramsay, and appointment of Reynolds as Principal Painter to the King.

1788
Died on 2 August, and was buried in Kew Churchyard

1789
Private sale of his pictures and drawings held at Schomberg House. Further sales were held at Christie's in 1792, 1797 (following the death of Gainsborough Dupont) and 1799 (after Mrs Gainsborough's death)

1792
Death of Reynolds. Lawrence (1769–1830) appointed Principal Painter to the King

Fig.1 Johann Zoffany (1734/5–1810),
*Gainsborough in his early to mid forties, c.*1771–2.
Tate Gallery (on permanent loan to the
National Portrait Gallery)

# Introduction

Gainsborough was one of the most remarkable men of an age rich in talent. A painter of acknowledged genius, he was a gifted amateur musician, intimate with all the leading composers and instrumentalists of the day, a letter-writer whose spontaneous and idiosyncratic style was compared to that of Sterne, an equally skittish and brilliant conversationalist – and, though essentially modest and unpretentious, clearly something of a character, an original in everything he said or did. 'His cranium is so crammed with genius of every kind that it is in danger of bursting upon you, like a steam-engine overcharged,' so his friend Garrick is said to have remarked. 'There certainly was only a very thin membrane which kept this wonderful man within the pale of reason', wrote Philip Thicknesse, another close friend. Both Gainsborough's daughters suffered from some form of mental illness, and one doctor described Margaret's feverish illness of 1771 as 'a family complaint.' Sensitive, highly strung, easily excitable, Gainsborough was nothing if not intensely alive. No experience left him unmoved. His eye was sharp, and Reynolds tells us how 'He had a habit of continually remarking to those who happened to be about him, whatever peculiarity of countenance, whatever accidental combination of figures, or happy effects of light and shadow, occurred in prospects, in the sky, in walking the streets, or in company . . . He neglected nothing which could keep his faculties in exercise'. So affected was he once by the sight of Dr Johnson's nervous tics that he declared 'he could not hold his head still, sleeping or waking, for the

space of a calendar month'. 'His conversation was sprightly, but licentious', wrote William Jackson (Cat.no.102), with whom he was especially intimate: 'his favourite subjects were music and painting; which he treated in a manner peculiarly his own. The common topics, or any of a superior cast, he thoroughly hated, and always interrupted by some stroke of wit or humour... so far from writing, [he] scarcely ever read a book – but, for a letter to an intimate friend, he had few equals, and no superior. It was like his conversation, gay, lively – fluttering round subjects which he just touched, and away to another'. So in music, of which he was 'passionately fond' and for which he possessed a natural ear and taste. 'His chief forte', according to Rimbault, 'consisted in modulating upon the harpsichord', and his friend Sir Henry Bate-Dudley (Cat.no.125) pronounced that 'His performance on the Viol de Gamba was, in some movements, equal to the touch of Abel. He always played to the feelings.' Of his pictures Bate-Dudley said the same, that he 'always paints to the heart'.

Gainsborough was an intuitive genius, a person of feeling and impulse, not, like his great contemporary, Reynolds, a man of reason, calculation and evenness of temper. 'He was irregular in his application, sometimes not working for 3 or 4 weeks together, and then for a month wd. apply with great diligence. He often wondered at Sir Joshua Reynolds *equal* application'. 'I wish you would recollect', he once wrote to a patron who was 'damnably out of humour about his Pictures not being finished', 'that Painting & Punctuality mix like Oil & Vinegar, & that Genius & regularity are utter Enemies, & must be to the end of Time'. He was apt to follow his impulses and enthusiasms unreflectively, wherever they might lead him, whether it was 'fool's pleasures' – ' a Moments Gratification' with his 'Friends . . . towards the City' which, recollecting 'a most terrible Fever' that had brought him perilously close to death, he would afterwards regret – a musical instrument he coveted, a picture (not always a good one) he was determined to buy and often could not afford, or a new technique with which he would experiment far into the night. 'I am the most inconsistent, changable being', he declared, 'so full of fitts [sic] & starts'. He was devoted to his wife, incompatible and infuriating though she was, to his 'dear Girls', affectionately known as Molly and the Captain, and to his many friends – 'Poor Abel!', he wrote to Bate-Dudley the day that eminent musician died, 'I shall never cease looking up to heaven – the little while I have to stay behind – in hopes of getting one more glance of the man I loved from the moment I heard him touch the string . . . My heart is too full to say more.' He was easily touched, and infinitely compassionate and generous. One evening on the way to the theatre, moved by a tale of misfortune he heard from Thicknesse, he promptly returned home: 'I could not go to the play till I had

relieved my mind by sending you the inclosed bank note, which I beg you to transmit to the poor woman by to morrow's post.' If he constantly took thought for others, he believed in making the most of life himself, and was saddened by those either too prim or too lacking in imagination to do the same. Though 'I would have every body enjoy, unmolested, their own opinions', 'Do but recollect', he once wrote, 'how many hard featured fellows there are in the world that frown in the midst of enjoyment, chew with unthankfulness, and seem to swallow with pain instead of pleasure'. Such was not his own practice; though, unlike his equally raffish contemporary, Rowlandson, his constitution and nervous system were by no means robust. 'I have done nothing but fiddle since I came from London', he wrote from Bath in 1774, 'so much was I unsettled by the continual run of Pleasure which my Friend Giardini and the rest of you engaged me in.' Gainsborough's daughter Margaret told the diarist Joseph Farington that her father had 'often exceeded the bounds of temperance & his Health suffered from it, being occasionally unable to work for a week afterwards', and, in his last illness, Gainsborough confided to his old friend Samuel Kilderbee (Cat.no.60) that he regretted the dissolute life he had led, adding, however: 'They must take me altogether, liberal, thoughtless, and dissipated'.

But, as his daughter was careful to impress on Farington, her father 'had two faces, his studious & Domestic' as well as 'His Convivial one'. 'As to his common acquaintance he was sprightly and agreeable, so to his intimate friends he was sincere and honest'. Gainsborough probably had a far greater knowledge of his craft than any other painter of his time, and the soundness of his technique is reflected in the good condition in which those of his pictures not damaged by the ignorance of restorers still remain. If he knew well enough when he was behaving 'like old square toes' he could be serious-minded when he needed to be, and was capable of giving considered and excellent advice; he hated humbug and deceit and was determined to have what he called 'truth and Day light' in all things. 'I trust if I do my best, all will be well through the merits of Him who hath promised to make good our failings if we trust sincerely.' Though he joked with his pious eldest sister Mary about her Methodist predilections – 'I have a d-mned plague with Her when she comes to Town, to find out new Methodist Chapels enough for Her' – he was himself, perhaps surprisingly, a chapel man: 'I have not neglected the chapel one day *since I took a liking to it*, nor don't mean ever to quit it', he wrote to the celebrated preacher, Dr Dodd, in 1773. Unlike Reynolds, he did not work on the Sabbath: 'I generally view my Works of a Sunday, tho: I never touch'. He thought and acted like a gentleman, was elegant in person, un-affected in manner and though 'of a modest, shy, reserved disposition,

which continued with him till his death', commanded a very genuine respect. He 'maintained an importance with his sitters, such as neither Beechy [sic] or Hoppner can preserve'. It is significant, because in some ways unexpected, that he was much beloved of George III and Queen Charlotte; in 1784, on the death of Ramsay, he was 'very near being King's Painter only Reynold's Friends stood in the way'. Though he had many close friends among the aristocracy, he was impervious to the claims of rank as such: 'now damn Gentlemen, there is not such a set of Enemies, to a real Artist, in the world as they are . . . *They* think . . . that they reward your merit by their Company & notice; but I, who blow away all the chaff & by G-- in their Eyes too if they dont stand clear, know that they have but one part worth looking at, and that is their Purse'.

II

Fig.2 The Court Room at the Foundling Hospital now the Thomas Coram Foundation

Gainsborough was born in the small market town of Sudbury in Suffolk, and was baptized in May 1727 in the Independent meeting house in Friars Street. He came of Dissenting stock, and many of the Gainsboroughs had been associated with, or supported, the Friars Street chapel. His forebears had long been connected with one of the staple industries of East Anglia, the manufacture of woollen goods, and Gainsborough's father, John, was a prosperous cloth merchant until his business fell on hard times in the early 1730s.

There were nine children, five sons and four daughters, of whom Gainsborough was the youngest. 'All', according to Thicknesse, 'were wonderfully ingenious'. The eldest son, John, was known as 'Scheming Jack'; he never left Sudbury, and passed his days inventing useless curiosities, such as a cradle that rocked by itself and a cuckoo that sang

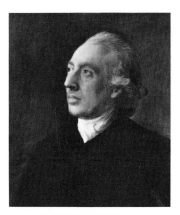

Fig.3 *Humphry Gainsborough,* early 1770s. Yale Center for British Art, New Haven

all the year round; to help maintain his large family Gainsborough later made him a small allowance, but this was usually frittered away on brass-work for his inventions. Humphry (Fig.3) became a Dissenting minister, and was a toll-keeper at Henley. He also had a bent for mechanics, but of a more practical application; his drill-plough and tide mill were awarded premiums by the Society of Arts, and one of his inventions, which we hear of from a letter Gainsborough wrote shortly after Humphry's death in 1776, was of service to James Watt: 'Mr. Cooper advises me to keep on the house till we can make the most of the steam-engine, (as the work, if taken to pieces, perhaps may never be put together again,) and also the maid in the house, lest any discovery should be made of it'. Of Mathias and Robert little is known; the former is supposed to have died young. The four daughters all married. Mary Gibbon, a woman of great piety, with whom some of Gainsborough's correspondence survives, married a Dissenting minister and became a milliner and lodging-house keeper, and both she and Susannah (Sally) Gardiner settled in Bath. Sarah Dupont, the mother of the boy who was to become Gainsborough's only studio assistant, and Elizabeth (Betsey) Bird married husbands in Sudbury.

Gainsborough went to school at Sudbury Grammar School, of which his uncle, the Revd Humphrey Burrough, Rector of Borley and Rede, was then the master. We are told that the youngster often prevailed upon his father to give him a note to his uncle letting him off school so that he could go sketching in the countryside, and Thicknesse said that Gainsborough had told him 'that during his *Boy-hood*, though he had no idea of becoming a Painter then, yet there was not a Picturesque clump of Trees, nor even a single Tree of beauty, no, nor hedge row, stone or post, at the corner of the Lanes, for some miles round about the place of his nativity, that he had not . . . perfectly in his *mind's eye*'. At the age of thirteen he persuaded his parents (his mother Mary was said to have been an amateur artist herself) to let him go up to London to study. This would have been in 1740 or 1741. He remained an art student for four or five years before setting up on his own in about 1745.

Gainsborough was exceptionally fortunate to have been young when he was. Ten or twenty years earlier he would have been dispirited by the survival of outworn traditions. But the early 1740s were a period of unprecedented ferment in the London art world. The auction houses were in the first flush of their success. Hogarth, who had already developed both the conversation piece and the 'modern moral subject' (cautionary series like 'The Rake's Progress'), painted his revolutionary 'Captain Coram', a grand full-length of a middle-class sitter, for the Foundling Hospital in 1740. He and Francis Hayman were encouraging the development of British history painting both there

[17]

(the pictures painted for the Court Room still survive *in situ* (Fig.2))
and in the extensive pictorial decorations, which also encompassed a
new style of genre painting, for Vauxhall – the most popular of
London's many pleasure gardens – works sponsored by its enterprising
owner, Jonathan Tyers. Ramsay had settled in London in 1739;
Rysbrack and Roubiliac were at the height of their powers. And in the
field of the decorative arts, Hubert Gravelot, a French draughtsman
living in London, had revolutionised standards of design and the art of
book illustration, and was chiefly responsible for introducing and
disseminating the rococo, a style which flowered in silversmithing,
furniture-making and ceramics the equal of anything in Europe. It was
Gravelot who took on Gainsborough as a pupil.

When Gainsborough first arrived in London 'the person, at whose
house he principally resided, was a silversmith of some taste, and from
him he [Gainsborough] was ever ready to confess he derived great
assistance'. His niece, Sophia Lane, stated that this silversmith was an
intimate family friend, which seems probable enough, but, though
plausible suggestions have been put forward, his identity has not so far
been established. He 'made his first essays in the art by modelling
figures of cows, horses and dogs, in which he attained very great
excellence'. Were these perhaps models for silverware? At any event,
Gainsborough retained his skill in modelling throughout his life;
Thicknesse tells us how, once, 'after returning from the Concert at
Bath . . . where we had been charmed by Miss Linley's voice, I went
home to supper with my friend, who sent his servant for a bit of clay
from the small beer barrel, with which he first modelled, and then
coloured her head, and that too in a quarter of an hour, in such a
manner that I protest it appeared to me even superior to his paintings!'
After joining Gravelot's studio he is reputed to have drawn most of the
ornamental surrounds for the engraved portrait heads accompanying
Birch's *Lives of Illustrious Persons*, but, although there is no evidence to
support this, he must have been employed in similar work which would
have given him a lasting feeling for the beauties of rococo line. Through
Gravelot he would also have met most of the finest avant-garde artists
and craftsmen of the day. Bate-Dudley says that Gravelot introduced
Gainsborough 'at the old academy of the arts, in St. Martin's Lane';
Gravelot himself taught there, so that this seems likely. Another
teacher at this academy was Francis Hayman, who is reputed to have
taught Gainsborough, and whose portraits-in-little and conversation
pieces with landscape settings were an early influence on his style.

Gainsborough's very early work must to a large extent have been
associated with the decorative arts, but, in the absence of documentary
evidence, none of this is likely ever to be identified. However, when he
established his own studio, possibly in Hatton Garden, in about 1745,

at the age of eighteen, he seems to have left the world of Gravelot firmly behind him, for 'his first efforts were small landscapes, which he frequently sold to the dealers at trifling prices'. 1745 was the year, too, of his earliest dated painting, a portrait of a dog in a landscape setting (Cat.no.54). He studied hard in the best school of the day, the London salerooms (there was no such thing as a National Gallery), where landscapes by the Dutch seventeenth-century naturalists, Ruisdael, Hobbema, Wijnants and others, were just beginning to appear on the market; and one of his drawings after Ruisdael, perhaps one of many, a large and meticulous copy in chalks of the picture known as 'La Forêt', survives in the Whitworth Art Gallery. From these masters he learnt the elements of pictorial composition. One source, who claims to have known Gainsborough in his early London days, wrote later that he was then 'only a landscape painter, and merely as such must have starved – he did not sell six pictures a year'. It is true that, with one notable exception, we know nothing of any patrons Gainsborough may have attracted at this time – the exception was Hogarth, for it was probably he who, in 1748, invited the young artist to paint the little roundel of 'The Charterhouse' for the decoration of the Court Room in the Foundling Hospital, a picture which, of the eight in the series, the chronicler of British art of the time, George Vertue, tells us was 'tho't the best & masterly manner'. He supplied drawings for the young engraver and print-publisher, John Boydell (four were engraved and published in 1747); and he seems to have been obliged to do hack work for the art trade to supplement his income, since there is record of his repairing a Dutch landscape, and putting figures into a landscape by Wijnants. But he was in no danger of starving. On 15 July 1746, at Dr Keith's notorious Mayfair Chapel, he had married Margaret Burr, a beautiful Scots girl a year or so younger than himself, who was, as their daughter later told Farington, 'a natural daughter of Henry, Duke of Beaufort, who settled £200 a yr. upon Her', a not insubstantial annual income for the period. According to Fulcher, a Sudbury printer who was the first serious biographer of Gainsborough, she was the sister of a commercial traveller employed by the artist's father. Why Gainsborough was obliged to celebrate a clandestine wedding is not clear, unless his parents, perhaps strict Methodists, objected to Margaret because she was an illegitimate child.

Doubtless, like any young countryman might who was not tied down to the daily grind of a job in London, Gainsborough made visits to his native Suffolk in the summer months. It remained true, as innumerable landscape sketches bear witness, that 'Nature was his teacher and the woods of Suffolk his academy'. In October 1748 his father died, and it was at about this time that he decided to return to Sudbury. His elder daughter Mary was born there that year. In spite of the *réclame*

attached to his view of 'The Charterhouse', 'he had not formed any high Ideas of his own powers, but rather considered himself as one, among a crowd of young Artists, who might be able in a country town (by turning his hand to every kind of painting) pick up a decent livelihood'. One of the first pictures he painted in Suffolk is among his masterpieces (Fig.4) – the double portrait of Robert Andrews of Auberies, and Frances Carter, commissioned, presumably, to cele-brate their wedding at All Saints, Sudbury, in November 1748. Here was an opportunity for Gainsborough to display his powers as a landscape painter, and it is no accident that, for the first time in this type of picture, the sitters have been withdrawn to one side of the canvas and the landscape, the broad acres of a modern and well-tended estate, given equal prominence. But insufficient work seems to have been forthcoming. Though we know that, probably through the agency of his friend Joshua Kirby, he was entrusted with one significant topographical commission, the view of Hadleigh Church (Cat.no.82), in November 1751 he was seeking a loan of four hundred pounds, and, soon after the birth of his younger daughter Margaret he moved to Ipswich, a larger town with a population of some ten thousand inhabitants which was not only a good deal more thriving commercially but a social and cultural centre of some consequence in East Anglia. The house he rented was close to the harbour, in Foundation Street, opposite the Shire Hall, and an advertisement describes the property as consisting of 'a Hall, and two Parlours, a Kitchen, a Wash-house, with a Garden and Stable, good Cellars, and well supply'd with Cock-Water, five Chambers and Garrets, with other Conveniences'. Here he lived and worked, and brought up his young children, for seven years.

Gainsborough first made the acquaintance of Philip Thicknesse, a perverse character of a malicious and quarrelsome disposition, but who was to become one of his closest friends, and was his first biographer, soon after his arrival in Ipswich. Thicknesse came to visit the studio not long after he had taken up his appointment as Lieutenant-Governor of Landguard Fort, on the estuary of the Orwell, facing Harwich, in February 1753. The portraits he saw on this first visit he thought 'perfectly like, but stiffly painted, and worse coloured . . . but when I turned my eyes to his little landscapes, and drawings, I was charmed, those were the works of fancy and gave him infinite delight'. He at once asked Gainsborough to dinner, and 'to take down in his pocket book, the particulars of the Fort, the adjacent hills, and the distant view of Harwich, in order to form a landscape of the [Royal] Yachts passing the garrison under the salute of the guns, of the size of a pannel over my chimney piece'. For this work (Fig.5) (sadly long since perished from damp) Gainsborough 'modestly said, he hoped I would not think

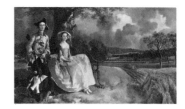

Fig.4 *Mr and Mrs Robert Andrews*, *c.*1748–9. National Gallery, London

Fig.5 *Landguard Point and Fort*, 1753. Detail from the engraving by Thomas Major

fifteen guineas too much'. Overmantels and overdoors were positions in which it was customary to hang landscapes, and Gainsborough's most important commission of this description came from the Duke of Bedford, a cultivated patron of the arts whom he may originally have met in London, for whom he painted two overmantels – pictures over which he took particular pains – in 1755. There were other such commissions, for example, from Thomas Spencer, of Hart Hall, for whom he executed another exceptionally fine work (see Cat.no.86), but on the whole he found little outlet for his landscapes. Some he sent up to London for sale, and Panton Betew, the dealer in Old Compton Street, is known to have handled his work: 'I have had many and many a drawing of his in my shop-window before he went to Bath', he told Nollekens, 'ay, and he has often been glad to receive seven or eight shillings from me for what I have sold: Paul Sandby knows it well'. How often he himself was in London is hard to say. Nathaniel Dance tells us that, before he [Dance] went to Italy in 1755, he had been 'abt. 2 years with Hayman, as a pupil, where He became acquainted with Gainsborough'; and he was certainly there in connection with the etchings he made in the early 1750s of two or three of his landscapes. For the most part, however, Gainsborough depended on local portraiture for his living. His clientèle was largely among the clergy and professional classes, whose requirements were a simple and inexpensive likeness: head and shoulders and a plain background, no more. But some of the local gentry also sat to him, including the Hon. Richard Nassau, of Easton Park (Cat.no.64), who had married the widow of the Duke of Hamilton, and his first full-length was of William Wollaston, later M.P. for Ipswich (Cat.no.71).

Sociable, convivial and warm hearted, Gainsborough was clearly much liked as a person. The son of his friend and patron, the Revd Robert Hingeston, who lived near Southwold, said that he had 'seen the aged features of the peasantry lit up with a grateful recollection of his many acts of kindness and benevolence . . . Many houses in Suffolk, as well as in the neighbouring county, were always open to him, and their owners thought it an honour to entertain him.' He was a member of the Ipswich Musical Club, where he probably met Wollaston, who was an amateur flautist; and he has left us an account of a benefit concert conducted by Giardini at which he acted as steward. But, in spite of his popularity and local prominence, work was not always easy to come by – demand was limited in most provincial centres – and he was often in financial difficulties. Early on in his residence in Ipswich we find him writing to his landlady: 'I call'd yesterday upon a Friend in hopes of borrowing money to pay you, but was disapointed [sic] & as I shall finish the Admiral's picture in a Week [the portrait of Admiral Vernon in the National Portrait Gallery, now on loan at Beningbrough

Hall, York] you shall have it when I go to Nacton will call & pay you at your new abode. I'm sorry it happen's so but you know I can't make money any more than yourself & when I receive it you shall surely have it before anybody'. In 1756 he declared that there were 'but 3 Debts standing against me one of them is 6 pounds odd'; but at the end of the 1750s he was in arrears again with his rent. He was never able to raise his charges from eight guineas for a head and fifteen for a half-length though, by 1755, Hudson and Reynolds, the leading portraitists in the metropolis, were charging twelve and twenty-four guineas respectively and, in 1757, increased their fees to fifteen and thirty. 'I thank you, Sir', he wrote to William Mayhew, a client in Colchester, in 1757, 'for your kind invitation of procuring me a few Heads to paint when I come over'; and, a year later, 'I thought I should have been at Colchester by this time . . . but business comes in, and being chiefly in the Face way, I'm afraid to put people off when they are in the mind to sit.' In December 1758 he was far away from home, at Middleton Park, near Bicester, to paint the Earl of Jersey and his son, Lord Villiers, and, perhaps on their recommendation, at nearby Hartwell to paint the Lees, patrons of some cultivation. His work was admired. 'We have a painter here', wrote William Whitehead, Lord Villiers's tutor, to the future Lord Harcourt, 'who takes the most exact likenesses I ever saw. His painting is coarse and slight, but has ease and spirit.' Perhaps by now he needed little inducement to leave Suffolk and felt more confident of success further afield. Thicknesse, who had a house in Bath, where he lived during the winter, may have had some hand, as he certainly claimed, in Gainsborough's decision to try his fortune in the smart West Country spa rather than to risk London. But we should remember also that Gainsborough had two sisters there.

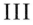

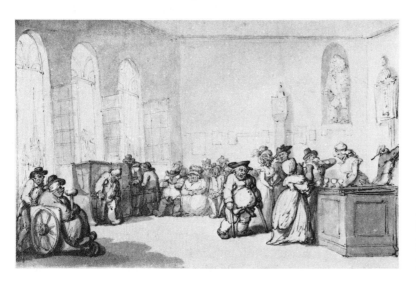

Fig.6 'The Pump Room at Bath'
by Thomas Rowlandson
from *The Comforts of Bath*, 1798.
Yale Center for British Art,
New Haven

The upheaval of the move took place in the autumn of 1759. The contents of the house in Ipswich were sold in October, some of his landscapes having 'the lowest prices set upon them . . . as he is desirous of leaving them among his friends.' Thicknesse tells us that, on Gainsborough's arrival in Bath, he 'accompanied him in search of lodgings, where a good painting room as to light, a proper access, &c. could be had, and upon our return to my house, where his wife was impatiently awaiting the event, he told her he had seen lodgings of fifty pounds a year, in the Church yard, which he thought would answer his purpose'. Whether or not he took these lodgings in the fashionable Abbey Churchyard – and he speaks later of a house, not lodgings – there is no doubt that he achieved a quick, and perhaps startling, success. Admittedly his only rival was a distinctly mediocre talent, William Hoare, who had held the stage hitherto and was patronised by Pitt, then Prime Minister. But 'business came in so fast' that he was soon able to raise his prices from eight to twenty guineas for a head, and from fifteen to forty guineas for a half-length; his charge for a full-length was sixty guineas, and this remained his price until the time of the first Royal Academy exhibition, in 1769. His painting changed as radically as his means. For nothing in the Ipswich style prefigures the grandeur, originality of pose and sheer beauty of brushwork of the full-length he painted in 1760 of Ann Ford (Cat.no.91), soon to be the bride of Philip Thicknesse. It was as though Gainsborough's imagination had suddenly found the impetus it needed amongst the press and gaiety of Bath society. Before long he was writing to his friend, Jackson of Exeter, the composer: 'I might add perhaps in my red hot way that damn me Exeter is no more a place for a Jackson, than Sudbury in Suffolk is for a G--'.

In 1763 Gainsborough, never in the best of health, succumbed to the strain of his now over-fashionable practice; indeed, so seriously ill was he known to be that in October *The Bath Journal* erroneously announced his death. 'I have kept my Bed 5 weeks to morrow excepting two hours sitting up for the last 3 Days of a most terrible Fever', he wrote a week after this report had appeared. 'My Life was dispair'd [sic] of by Doctor Charleton after he had tried all his skill, and by his own desire Dᵣ Moisey was call'd in when in three days my faintings left me and I got strength. I am now what they call out of Danger'. Though the direct cause seems to have been venereal – 'O my dear Friend nobody can think what I have suffer'd for a Moments Gratification' – 'The truth is, I have apply'd a little too close for these last 5 years, that both my Doctors and Friends really think.' Towards the end of the year he took a house with a good-size garden away from the centre of Bath, 'about three quarters of a mile in the Lansdown Road; 'tis sweetly situated and I have every convenience I could wish for; I pay 30

pounds per year, and so let off all my House in the smoake [sic] except my Painting Room and best parlour to show Pictures in. Am I right to ease myself of as much Painting work as the Lodgings will bring in. I think the scheeme [sic] a good one.'

He now 'refused frequent Invitations to undertake large Pictures in Town', and was only prepared to go up to London for an old and valued patron, like the Duke of Bedford, from whom, we hear in 1765, he had received 'a Letter to inform me that more work was cutting out for me, and to know if I would goe [sic] to Town to do it.' There were few great men that Gainsborough cared 'a farthing for, or would wear out a pair of Shoes in seeking after; long-headed cunning people, and rich fools are so plentiful in our country that I don't fear getting now & then a Face to paint for Bread.' He seems also to have become increasingly dilatory about delivery. In 1771 we find him apologising to Edward Stratford: 'I swear by Saint Luke's Pencil, I have not dress'd nor sent a finished half length out of my doors since yours have been in hand', adding, 'if I disapoint [sic] you . . . I'll give you leave to boil me down for Painters Drying oil, and shiver my Bones into Pencil Sticks'; but in spite of this reassurance no progress had been made nine months later: 'Stratford is damnably out of humour about his Pictures not being finished because the Frames hang up in his best Visiting Room in readiness. He writes every post . . .' There was no doubt that finishing off routine pictures irked him, as it did Lawrence and many another society portraitist. Even beginning them was not much better, 'the continual hurry of one fool upon the back of another'. 'If the People with their damn'd Faces could but let me alone a little I believe I should soon appear in a more tolerable light but I have been plagued very much', he wrote one May: 'Thank God I shall now shut myself up for the summer and not appear til September comes in.'

In the summer months, after he had finished his pictures for the annual exhibition of the Society of Artists in London, Gainsborough was accustomed to spend much of his time out of doors, sketching, and working on his landscapes. Ozias Humphry, then a young student who had lodgings with Gainsborough's lively and talented musical friends, the Linleys, tells us that 'when the Summer advanced, and the luxuriance of Nature invited and admitted of it, he accompanied M.ʳ Gainsborough in his Afternoon Rides on Horseback to the circum-jacent Scenery, which was in many Parts, picturesque, and beautiful in a high Degree. – To those and succeeding Excursions the Public are indebted, for the greater Part of the Sketches, and more finished Drawings from time to time made public by that whimsical, ingenious, but very deserving Artist.' One watercolour that chances to survive is inscribed as being of beech trees at Foxley, and dates from 1760. The Prices, of Foxley, in Herefordshire, Gainsborough knew well; he

painted old Uvedale Tomkyns (Cat.no.92), who by this time had retired to Bath to benefit from the waters, and his son Robert, both of whom were amateur draughtsmen; and the grandson, Uvedale (later the writer on 'the Picturesque'), who was in his 'teens in the 1760s, said that he then 'made frequent excursions with him into the country', from which the painter 'used to bring home roots, stones, and mosses, from which he formed, and then studied foregrounds in miniature'.

Gainsborough's practice of composing landscapes in miniature is the subject of comment by several of his contemporaries, including Reynolds. One writer said that he had 'more than once sat by him of an evening, and seen him make models, or rather thoughts, for landscape scenery, on a little, old-fashioned, folding oak table, which stood under his kitchen dresser . . . He would place cork or coal for his foregrounds, make middle grounds of sand and clay, bushes of mosses and lichens, and set up distant woods of brocoli [sic].' Jackson added that 'he modelled his horses and cows, and knobs of coal sat for rocks.' Perhaps such models were an intermediate resource once an idea had settled in his mind, for the process of invention required simpler and more obvious means. 'He loved to sit by the side of his wife during the evenings, and make sketches of whatever occurred to his fancy, all of which he threw below the table, save such as were more than commonly happy, and those were preserved, and either finished as sketches or expanded into paintings.'

He now had an opportunity, denied to him in Suffolk, of seeing outstanding collections of old masters. We know that he spent a week at Wilton in the spring or summer of 1764, 'partly for my amusement, and partly to make a Drawing from a fine Horse of L.$^{d}$ Pembroke's, on which I am going to set General Honeywood' (his first equestrian portrait: Fig.7). He was familiar with Bowood, Corsham, Longford Castle, Shobdon and Stourhead, all of whose owners sat to him or bought his work. Lord Shelburne, of Bowood, he met on one occasion on his way home from Exeter: he 'insisted on my making them a short visit, and I don't regret going . . .'tho I generally do to all Lord's Houses'. Lord Bateman, of Shobdon, was a valued patron, and Gainsborough is known to have given him a present of a number of drawings in 1770. Henry Hoare, of Stourhead, was his banker from 1762 until 1785. He spoke to Lord Hardwicke of the merits of Claude and Gaspard Poussin, a taste one would not have associated before with Gainsborough, and became 'passionately fond', as his daughter tells us, of Berchem and Cuyp. Rubens and Van Dyck, however, were the principal influences on his Bath style as it matured in the mid 1760s. Lord Camden, who Bate-Dudley tells us in his obituary was remembered by Gainsborough 'with a degree of veneration . . . for the patronage and favor' he extended to him at Bath, owned two land-

Fig.7 *General Philip Honywood*
Exhibited Society of Artists 1765.
John and Mable Ringling
Museum of Art, Sarasota, Florida

scapes by Rubens, and in 1768 Gainsborough wrote enthusiastically to Garrick: 'I could wish to you to call *upon any pretence* any day after next Wednesday at the Duke of Montagu's because you'd see the Duke & Dutchess [sic] in my *last* manner; but not as if you thought anything of mine worth that trouble, only to see his Grace's Landskip of Rubens, and the 4 Vandyke's whole length in his Graces dressing Room'. The Duke of Montagu's Rubens, the celebrated picture of 'The Watering Place', now in the National Gallery (Fig. 31), was a specific influence on Gainsborough's work.

Gainsborough's enthusiasms frequently impelled him to copy what he admired. There is no record of his ever having copied a landscape by Rubens, but he did sketch and partially finish, from the engraving, a brilliant, large-scale copy of his 'Descent from the Cross' (Cat. no. 107), which was almost certainly inspired by a sight of the original *modello*, then at Corsham. At Corsham, too, hung Van Dyck's portrait of the Duke of Richmond, presumably the picture Gainsborough is recorded as having copied at full length; this canvas is no longer extant, but his splendid full-length copy of Van Dyck's double portrait of Lord John and Lord Bernard Stewart, then in Lord Darnley's collection, does survive, in the Art Museum in St Louis, and shows his fascination by the dash and bravura, as well as by the elegance, of the great court painter of Charles I. We may well believe Jackson, who reported Gainsborough's last words as he lay on his death-bed: 'We are all going to Heaven and Vandyke is of the party.' The most important other work he copied at this date was the magnificent large Teniers, 'The Return from Shooting', at Longford Castle, of which he made two versions, one a close copy, the other a variant executed in his own more fluent style. Most of these copies were done for his own benefit, and remained in his studio until his death; but one, perhaps of lesser significance, he seems to have given to his physician Dr Charlton, as he refers to it in a letter, and with typical modesty: 'My dear Doctor I forgot entirely that you had a Copy of the little dutch Spire of my Hand, tis not worth a Farthing, so do what you please with it, hang it in your Study at Woodhouse, where it may not be compared with the Original, and I shall be easy.'

It is possible that Gainsborough was already making the beginnings of a collection, which was later to be an inspiration to his own painting, but the only reference to an acquisition in these years is contained in a letter he wrote to Jackson in 1768: 'Pray do you remember carrying me to a Picture dealers somewhere by Hanover Square, and my being struck with the leaving and touch of a little bit of Tree; the whole Picture not above 8 or 10 Inches high & about a foot long – I wish if you have time that you'd enquire what it might be purchased for.'

Gainsborough's landscape paintings gained a new amplitude in

these years – a new breadth of chiaroscuro and a new richness of handling – and his position among his contemporaries was fully recognised, as it had not been earlier. To some extent this recognition must have been due to the masterpiece he sent up to London for exhibition in 1763, probably the picture at Worcester (Cat.no.110). No longer, one may suppose, did he need (or intend) to have his canvases displayed in Panton Betew's shop window; for Thomas Jones recalls in his memoirs that, at the beginning of his own career, in 1765, 'there was Lambert, & Wilson, & Zuccarelli, & Gainsborough, & Barret, & Richards, & Marlow in full possession of Landscape business . . .' Moreover, unlike all these artists, with the exception of Zuccarelli, Gainsborough refused to accept topographical commissions, which were the kind of landscape most in request, indeed the almost indispensable staple of an eighteenth-century landscape painter. As we have seen from the example of 'Hadleigh Church', he had been prepared to do so in his early twenties, when he was ready to turn his hand to anything, but now he would insist quite firmly to a potential aristocratic patron that 'if His Lordship wishes to have anything tollerable [sic] of the name of G. the Subject altogether, as well as figures &c must be of his own Brain; otherwise Lord Hardwicke will only pay for Encouraging a Man out of his Way – and had much better buy a Picture of some of the good Old Masters.' Unlike Wilson or Marlow, Gainsborough did not, of course, depend upon landscape sales for his livelihood. Portraiture was *his* staple, and it remained a necessary one. In spite of Jones's assertion, and in spite of a few distinguished patrons – the Toledo landscape (Cat.no.113) was almost certainly commissioned by Lord Shelburne, one of the three pictures for Bowood 'intended to lay the *foundation of a school of British landscapes*', and the first of his 'Cottage Door' subjects was bought by the young Charles Manners, later fourth Duke of Rutland (Fig.8) – most of the landscapes Gainsborough sold, as opposed to those he gave away, were acquired by patrons, like Sir William St Quintin (see Cat.no.112), who had become good friends, while a high proportion of his output, including the famous 'The Harvest Waggon' in the Barber Institute, Birmingham, remained on his hands. 'I should be glad to lend you any of my Landskips to copy', he replied to a request from Ozias Humphry, 'did it not affect the sale of new Pictures, to have any copies taken of them, for which reason I have often been obliged to refuse.' In 1774, the last year of Gainsborough's residence at Bath, Mary Hamilton paid a visit to his studio and noted in her diary: 'All portraits with the exception of two or three Landscapes. If I might presume to give my opinion I should prefer him as Landscape to Portrait Painter, yet they say he pays but little attention to the former.' In fact he was careful to keep them out of sight. According to Prince

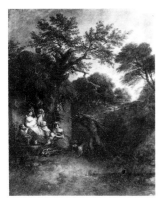

Fig.8 *The Woodcutter's Return*, c.1773. Duke of Rutland, Belvoir Castle

Hoare, he was 'so disgusted at the blind preference paid to his powers of portraiture, that, for many years of his residence at Bath, he regularly shut up all his landscapes in the back apartments of his house, to which no common visitors were admitted.'

It is to Ozias Humphry that we owe the only account we possess of Gainsborough's painting methods at this time. It dates from observations made in the early 1760s – Humphry lived at Bath from 1760 to 1764 – but, for the most part, it is equally applicable to Gainsborough's practice thenceforward. 'Exact resemblance in his Portraits . . . was M.<sup>r</sup> Gainsborough's constant Aim, to which he invariably adhered. – These Pictures (as well as his Landskips) were often wrought by Candle Light, and generally with great force, and likeness. But his Painting Room even by Day (a kind of darkened Twilight) had scarcely any Light; and our young Friend has seen him, whilst his Subjects have been sitting to him, when neither they or their pictures were scarcely discernible . . . Having previously determined and marked with chalk upon what part of the Canvasses the faces were to be painted they were so placed upon the Eisel [for this purpose the canvas was not yet attached to its stretcher, but remained loose, secured by small cords] as to be close to the Subject he was painting, which gave him an Opportunity (as he commonly painted standing) of comparing the Dimensions and Effect of the Copy, with the original both near and at a distance; and by this method (with incessant study and exertion) he acquired the power of giving the Masses, and general Forms of his models with the utmost exactness. Having thus settled the Ground Work of his Portraits, he let in (of necessity) more light, for the finishing of them; but his correct preparation was of the last Importance, and enabled him to secure the proportions of his Features as well as the general Contours of Objects with uncommon Truth.'

Gainsborough's practice of painting by subdued light in order to establish the basic tonal relationships is amply attested. Thicknesse confirms that 'he stood, not *sat* at his Palate, and consequently, of late years at least, five or six hours work every morning, tired him exceedingly', a point substantiated by Margaret Gainsborough, who told Farington that 'her father always dined at 3 oClock, began to paint abt. eleven oClock and was generally exhausted by dinner time'. John Thomas Smith, who knew Gainsborough at a later time, elaborates on his concern with verisimilitude, but describes a different method of observing sitter and canvas at an equal distance from the one Humphry had noted: 'Mr. Gainsborough . . . allowed me frequently to stand behind him to see him paint, even when he had sitters before him. I was much surprised to see him paint portraits with pencils on sticks full six feet in length, and his method of using them was this: he placed himself and his canvases at a right angle with the sitter, so that he stood

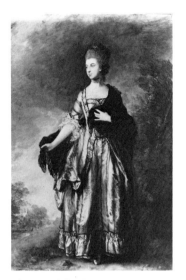

Fig.9 *Isabella, Viscountess
Molyneux (later Countess of
Sefton)*. Exhibited R.A. 1769.
Walker Art Gallery, Liverpool

still, and touched the features of his picture exactly at the same distance
at which he viewed his sitter.' He never touched 'unless from the Life',
and, as Thicknesse wrote in 1770: 'He finishes with his own hand every
part of the drapery; this, however trifling a matter it may be to some, is
of great importance to the picture. The other eminent painters either
cannot or will not be at that trouble.' Even so, only too conscious of the
limitations of his art, Gainsborough lamented: 'Had a picture Voice,
Action, &c to make itself known . . . but only a face, confined to one
View, and not a muscle to move to say here I am, falls very hard upon
the poor Painter who perhaps is not within a mile of the truth in
painting the Face only.'

In 1768 Gainsborough was appointed one of the Directors of the
Society of Artists. 'I thank you for the honour', he replied, 'but for a
particular reason I beg leave to resign.' The offer had come too late; he
had already received a letter from Reynolds asking him to become a
member of a new body which was soon to eclipse the Society of Artists,
the Royal Academy. For the first Academy exhibition, in the summer
of 1769, Gainsborough painted one of his masterpieces, the full-length
of the young and newly married Lady Molyneux (Fig.9). With its
aristocratic Van Dyck pose, its exquisite softness of modelling and the
quite exceptional bravura handling of the satin dress, it must have
created a sensation. But Gainsborough was never happy with what he
called the 'impudent style' necessitated by the competitiveness of
public exhibitions. True, in 1772 he was the subject of criticism
himself for throwing a dash of purple into every colour, and for colours
that were too glaring. No doubt this was an adverse comment on the
highlights in his pastel-like flesh tones, the result of his painting in a
subdued light. In fact, though we are told that Gainsborough 'often
painted higher for the room, and afterwards brought his pictures
down', he was unwilling to force his colours, and painted with
particular settings in mind. To Garrick he wrote in the same year,
1772: 'A Word to the Wise; if you let your Portrait hang up so high,
only to consult your Room, and to insinnuate [sic] something over the
other Door, it never can look without a hardness of Countenance and
the Painting flat: it was calculated for breast high & will never have its
Effect or likeness otherwise.' This natural concern that his pictures
should be seen as they were meant to be seen was the cause of an
unfortunate row with the Academy in 1773: 'I don't send to the Exhi-
bition this year; they hang my likenesses too high to be seen, & have
refused to lower one sail to oblige me.' He kept away for four years.

By the beginning of the 1770s Gainsborough felt sufficiently
established to raise his scale of fees to thirty guineas for a head, sixty for
a half-length and a hundred for a full-length. He did not increase them
again until 1787. Though Reynolds had been charging a hundred

guineas for a full-length more than a decade earlier and had already raised his fee to a hundred and fifty, Gainsborough was well ahead of any other rival, and was now fairly well off. Late in 1766 he had moved from Lansdown to the Circus, then also, and this was part of its attraction, on the outskirts of the city, but undeniably smart: one of the principal houses was occupied by the Duke of Bedford, and among other residents were William Pitt and Lord Stanhope, for whom he painted a portrait of Lord Chesterfield.

Of Gainsborough's life at Bath we catch only the most tantalising glimpses. He lived 'in great intimacy' with the Linleys, all talented musicians (see Cat.no.26) – Elizabeth was the leading soprano at the Three Choirs Festival in the early 1770s – and must surely have been an habitué of the concert room and theatre. Among literary figures he certainly knew Richard Graves, Rector of Claverton, who apostrophised him in a poem in 1762. Ralph Allen, of Prior Park, who owned a small landscape of this period, and was a neighbour of Graves, may have been another friend. The woods at Claverton and Warley were supposed to be among the painter's favourite haunts. The fashionable social life and tittle-tattle of the city – the 'fine Ladies & their Tea drinkings, Dancings, *Husband huntings* &c' – bored him profoundly; he said of Derrick, successor to Beau Nash as Master of Ceremonies at the Pump Rooms, 'a stupider Face I never beheld'. Riding he enjoyed, notably when he was recuperating after his illness in 1763; Sir William St Quintin, an ever solicitous patron, gave him a horse at that time, 'not handsom [sic] but perfectly sure footed & steady upon the Road', and 'I Ride every minute in the Day unless it rains pouring'. Though his 'Dear Good Wife' sat up every night during the critical weeks of his 'most terrible Fever', and he gratefully acknowledged that 'I shall never be a quarter good enough for her if I mend a hundred degrees', it is equally clear that she was 'never much formed to humour my Happiness', and her meanness was a constant source of friction and vexation: for a time he was even 'induced to try how far Jealousy might be cured by giving into her Hands every Farthing of the Money as I earn'd it, but very soon found that . . . it was a further incouragment [sic] to Govern me . . . so that now I have taken the Staff into my own hands again'. A postscript to one of his letters to a patron sums up the difference between husband and wife in a sentence: 'Packing Case cost me 7 shillings which my Wife desires me always to remember and I often forget voluntarily because I'm afraid to mention it.' '*He* had so utter a disregard to money'. As to entertaining at home: 'We never had above a Bed & a half to spare in our lives,' and Thicknesse tells us that 'those who best loved Mr. Gainsborough, and whom he most loved, were unfortunately least welcome to his house.'

His trips to London, probably more frequent than is generally

supposed, must have been a relief to him, though they were all too short in their duration, and 'such is the Nature of that D——— place, or such that of this T.G that I declare I never made a journey to London that I ever did what I intended. 'Tis a shocking place for *that*.' Once, running into Abel in Harley Street, he agreed to dine with him and 'found Fisher [sic], Bach & Duport, all ready to make a finish of me for the Day I had to stay in Town, so that not a Friend, a Picture, or any thing I liked could I enjoy – except only a little Venus *rising from the Sea* in my way to my Lodgings . . .' In the mid 1760s his 'dear Girls' were at school there, at Blacklands School in Chelsea: 'you must know I'm upon a scheeme [sic] of learning them both to paint Landscape; and that somewhat above the common Fan mount stile . . . I don't mean to make them only Miss Fords in the Art, to be partly admired & partly laugh'd at at every Tea Table; but in case of an Accident that they may do something for Bread' (Fig.10). Gainsborough was also away on country house visits, sometimes protracted ones, both for pleasure and on business. 'I went by appointment', he wrote in 1770, 'only to spend two or three Days at M.r George Pitt's country House, by way of taking leave of him, as a staunch Friend of mine before his going to Spain, and behold he had got two whole length Canvasses, & his son & Daughter L.d & Lady Ligonier in readiness to take me prisoner for a months work.' There were holidays, too. We know that he was a frequent guest at Barton Grange, near Taunton, where he went sketching (see Cat. no.101), and there are references to a hoped-for visit to his friend, James Unwin, in Derbyshire, in 1768: 'I suppose your Country is very woody – pray have you Rocks and Water-falls! for I am as fond of Landskip as ever', and in 1770: 'I'll pack up all my Drawing things, and see Derbyshire next summer, if I'm alive.'

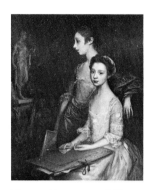

Fig.10 *Margaret and Mary Gainsborough*, *c*.1763–4. Worcester Art Museum, Worcester, Mass

In 1774 Gainsborough left Bath, seemingly unexpectedly. In March he had had a harpsichord, selected for him by his friend, Giardini, sent to his house in the Circus from Broadwood's, in London, a delivery he is unlikely to have arranged if a move was afoot. Thicknesse claimed, unconvincingly, that the move was due to a row over his own portrait, which Gainsborough had set on one side and would never complete. Joseph Wright of Derby said later that he had heard 'that the want of business was the reason of Gainsborough leaving Bath', but the number of canvases dating from the years up to 1774 does not suggest any slackening of activity; indeed, in 1772 he had taken on his young nephew, Gainsborough Dupont, as an apprentice. Moreover, as Wright went on, 'the want of encouragement of the Arts, I fear, is not only felt here but in Town also, and artists are become so numerous that the share which falls to each is small'. Whatever the explanation, Gainsborough's tenancy of the west wing of Schomberg House, Pall Mall, began towards the end of 1774.

IV

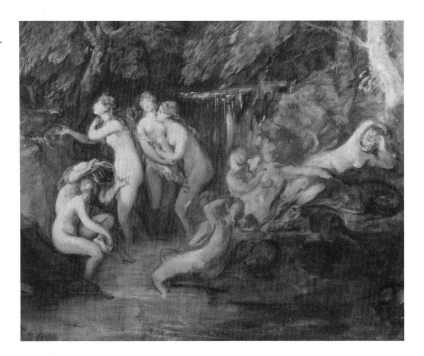

Fig.11 Detail from *Diana and Actaeon*, c.1784–5. Her Majesty The Queen, Buckingham Palace

Bate-Dudley tells us that, after his remove from Bath, Gainsborough passed 'a short time in town not very profitably'. This gives some credence to the ever interfering Thicknesse's story of his fears for him: 'I was much alarmed, lest with all his merit and genius, he might be in London a long time, before he was properly known to that class of people, who alone could *essentially* serve him, for of all the men I ever knew, he possessed least of that wordly knowledge, to enable him to make his own way into the notice of the GREAT WORLD. I therefore wrote to Lord Bateman who knew him . . .' But Gainsborough was already perfectly well known to 'the great world', and by Christmas 1775 he was writing with satisfaction to his sister Mary Gibbon that 'my present situation with regard to encouragement is all that heart can wish . . . I live at a full thousand pounds a year expense'.

One of the first jobs he did in London, a labour of love, was to paint on glass an over-life-size Comic Muse, one of a number of such paintings lit from behind by candles, for the decoration of Bach and Abel's new concert room in Hanover Square, opened in February 1775. In 1777 he received the first of many commissions from the Royal Family – full-lengths of the Duke and Duchess of Cumberland – and returned triumphantly to the Academy: his portrait of the Hon. Mrs Graham, in Van Dyck dress (National Gallery of Scotland) (Fig.12), like Lady Molyneux, a magnificent paean to youthful feminine beauty and grace, is not only one of the grandest but one of the most glamorous of his creations, impressionistic yet exquisite in handling and colour,

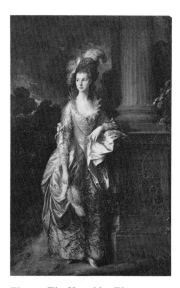

Fig.12 *The Hon. Mrs Thomas Graham*. Exhibited R.A. 1777. National Gallery of Scotland, Edinburgh

while Horace Walpole acclaimed 'The Watering Place' as 'by far the finest Landscape ever painted in England, & equal to the great Masters'. From this time onwards both his financial circumstances and his position as one of the leading British painters of the day were assured. Everything he did was fully, and for the most part favourably, reported in the press, notably by Bate-Dudley, editor of *The Morning Post* and subsequently, in 1780, founder and editor of *The Morning Herald*, a redoubtable character who was a staunch ally and friend.

In July 1777, and again in August 1778, Gainsborough had money enough to spare to invest in Government stock, an oddly circumspect action perhaps prompted by his wife; it was probably he, therefore, rather than his landlord John Astley, a former (and now wealthy) pupil of Reynolds, who had already made major alterations to the house, who had the studio added to the back of the wing of Schomberg House in his tenancy: two large rooms, an upper and a lower, each fifteen feet high, with single big windows overlooking the gardens of Marlborough House (a north light being of little consequence to him since, as we have seen, he was accustomed to use either artificial or carefully controlled lighting for his painting). He was able – perhaps some years later, the date is uncertain – to afford a retreat in the environs, on Richmond Hill, close to the house owned by Reynolds, where, so we are told, he was often visited by his patron, George III; this house was mentioned in his will, the pictures and household effects being bequeathed to his wife. His cottage in Essex, which we know of from the inscription on a drawing by Rowlandson, an artist who must surely have known Gainsborough well, is likely to have been on Bate-Dudley's estate at Bradwell. He was also able to buy works of art. 'He was a universal admirer of fine pictures, and was not exclusively devoted to any one in particular. – With Rubens, Vandyke, Morillio & Velasquez.' With characteristic enthusiasm he rashly offered the collector Agar a thousand pounds for a painting of Don Balthasar on horseback attributed to Velasquez, now in the Dulwich College Art Gallery – but was afterwards confused and obliged to confess that 'however he might admire it, he could not afford to give so large a sum for it.' Later, however, he did pay the dealer Desenfans as much as five hundred guineas for a Murillo of 'St John in the Wilderness', recently imported from Spain, a picture now in the National Gallery but no longer accepted as an autograph Murillo (Fig. 13). He owned three portraits by Van Dyck, and a Rubens of 'Two Monks' Heads', which he copied. His old masters were not an artist-connoisseur's cabinet, like the collections of Lely, Hudson, Reynolds and Lawrence, but an adjunct to his painting. Of the fifty-odd pictures he acquired, over half were landscapes, and some were undoubtedly related directly to new departures in his own style: for example, he bought a seapiece by the

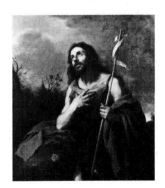

Fig. 13 Follower of Bartolomè Esteban Murillo (1617–82). *St. John the Baptist.* National Gallery, London

Dutch painter, Backhuysen, in December 1781, at exactly the time he was experimenting with this genre himself – and he also owned three seascapes by the greatest of all Dutch marine painters, William van de Velde. One of his Ruisdaels, which hung in his house at Richmond, is known to have been a favourite with the King.

By 1777 Gainsborough possessed his own coach – his family went off to Suffolk in it, accompanied on horseback by their servant, David, to visit the Kilderbees in the autumn of that year, 'but some how or other they seem desirous of returning rather sooner than the propos'd time . . . I don't know what's the matter, either people don't pay them honour enough for Ladies that *keep a Coach*, or else Madam is afraid to trust me alone at home in this great Town.' Such luxuries had no mitigating effect on Mrs Gainsborough's parsimony. If her husband were to come home from an appointment in a hackney coach, he was always 'obliged to be set down in St. James's Square, or out of the sight of his own windows.' Even after the successes of the summer of 1777, and the affluence proved by his subsequent investments, he was compelled to write to Mary Gibbon, that very September, for the loan of twenty pounds, so that, 'from Charity and humane feelings', he could help 'a poor wench' he knew who was in distressed circumstances. 'His susceptible mind and his benevolent heart, led him into such repeated acts of generosity'. To avoid embarrassments of this kind caused by his wife's surveillance of the purse-strings, he kept the prices of his landscapes, which he increased substantially towards the end of the 1770s, a close secret from Mrs Gainsborough. 'I am under everlasting engagements to deliver up to my Wife, all but Landskip deductions where she cannot come at the knowledge of my Price.'

There were other more worrying problems in these years. Both his daughters were infatuated with Fischer, a man reputed to have 'no more intellect than his hautboy [oboe]'. When Mary (Fig.14) eventually became engaged to him, Gainsborough was furious. 'I have never suffered that worthy Gentleman ever to be in their Company since I came to London; and behold while I had my eye on Peggy, the other Slyboots, I suppose, has all along been the Object.' He reluctantly gave his consent to the match, 'which was a mere compliment to affect to ask.' 'I would not have the cause of unhappiness lay upon my conscience', he wrote in February 1780, 'accordingly they were married last Monday [at St Anne's, Soho], and are settled for the present in a ready furnished little house in Curzon Street . . . as to his oddities and temper, she must learn to like as she likes his person . . . I pray God she may be happy with him.' But before very long Gainsborough was writing with concern to his sister Mary: 'Fischer has deceived me in his Circumstances and his Wife has been playing the devil to raise Money.' The marriage proved a disaster, and the

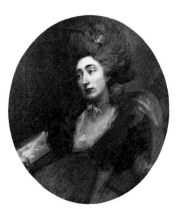

Fig.14 *Mary Gainsborough (later Mrs J.C. Fischer)* late 1770s. Formerly Adolph Hirsch

couple soon separated. Margaret never married. After the death of their parents the two sisters lived together, first at Brook Green, then at Acton. Mary was by this time deranged, living under the delusion that the Prince of Wales was in love with her, and Margaret, perhaps not surprisingly in these circumstances, had become something of an eccentric. They died, old ladies, in 1826 and 1820 respectively, and were buried at Hanwell.

In 1778 Gainsborough sent eleven portraits to the Academy. *The Morning Chronicle* declared that he was 'a favourite among the demi-reps. He has, it is plain, been visited by Miss Dalrymple, Clara Haywood, and another well-known character of the same stamp.' In fact Gainsborough portrayed almost as wide a range of English society as Reynolds; it is the literary figures that are missing, Johnson, Gibbon, Goldsmith, Burke. His marriage portrait of the young Halletts (Cat.no.130) was painted in what was recognised at the time as 'une nouvelle stile', the figures inseparable from the landscape in which they move, ribbons and bows and sketchiness of handling echoing the feathery Watteauesque foliage. This romantic conception would seem to have carried the youthful portrait group in a landscape setting represented by 'Mr and Mrs Andrews' to the ultimate degree of sophistication and the ultimate point of its development. Yet there was one stage further, the concept of 'The Richmond Water-walk', a picture intended for the royal collection, which was in the course of preparation in the same autumn of 1785 but never painted; five or six figures, of which magnificent drawings happily survive (Cat.nos.41 and 42), were to be represented in a dramatised conversation piece, moving to and fro in a romanticised woodland.

It is odd that the urbane and courtly Reynolds was not a favourite with George III, though, as a result of pressure, he was appointed to the office of Principal Painter to the King on the death of Allan Ramsay in 1784; it is Gainsborough, who told Sir Francis Bourgeois that 'he talked bawdy to the King, & morality to the Prince of Wales', who has left us an incomparable gallery of images of members of the Royal Family. Full-lengths of the King and Queen were exhibited in 1781. Apparently he was late with the portrait of the Queen, for we are informed by Northcote that 'the drapery was done in one night by Gainsborough and his nephew, Gainsborough Dupont; they sat up all night, and painted it by lamp-light.' In September 1782 he was down at Windsor painting a set of small ovals of George III and Queen Charlotte and their thirteen children which were shown, though not without ruffled exchanges, at the Academy of 1783. 'I w$^d$ beg to have them hung with the Frames touching each other, in this order.' 'Mr Gainsborough presents his Compliments to the Gentlemen appointed to hang the Pictures at the Royal Academy; and begs leave to *hint* to

Them, that if the Royal Family . . . are hung above the line along with full lengths, he never more, whilst he breaths, will send another Picture to the Exhibition – This he swears by God.' The final rupture came the following year, when Gainsborough submitted eighteen works for the summer exhibition, including 'The Mall', now in the Frick Collection, reported as painted for George III (Fig.15). The Hanging Committee respectfully, and quite rightly, informed Gainsborough that they could not break the rules solely in his favour and comply with his request to hang the portrait of 'The Three Eldest Princesses' below the line established for full lengths (the height of the doorways, about nine feet). But the artist was adamant. 'Mr Gainsboroughs Comp$^{ts}$ to the Gent$^n$ of the Committee, & begs pardon for giving them so much trouble; but as he has painted this Picture of the Princesses in so tender a light, that notwithstanding he approves very much of the established Line for Strong Effects, he cannot possibly consent to have it placed higher than five feet & a half, because the likenesses & Work of the Picture will not be seen any higher; therefore at a Word, he will not trouble the Gentlemen against their Inclination, but will beg the rest of his Pictures back again.' He fitted out rooms at Schomberg House for the display of his paintings, and held an exhibition in July. This he repeated in subsequent years. He never showed at the Academy again.

From 1777, the year of 'The Watering Place', contemporary writers on Gainsborough were at one with Horace Walpole that 'as a landscape painter, he is one of the first living', and it was the fashion 'to admire the Richness and Embroidery' of his landscapes. Amongst patrons 'the Duke of Dorset is to buy two Landskips as soon as his House is ready.' But Gainsborough had become increasingly aware that he lacked the range and profundity characteristic of Reynolds: 'Damn him, how various he is.' In the last decade of his life he sought to deepen his expressive powers and to extend his subject matter and appeal. To some extent he followed current fashion. In 1783 he made a tour of Cumberland and Westmorland, already the mecca of tourists in search of picturesque scenery. 'I purpose', he declared, 'to mount all the Lakes at the next Exhibition, in the great stile; and you know if the People don't like them, 'tis only jumping into one of the deepest of them from off a wooded Island, and my reputation will be fixed for ever.' He made drawings in the manner of Gaspard Poussin. His first two seascapes, acclaimed for their naturalism at the Academy of 1781, were a storm and a calm, following the tradition of contrasted companion scenes established by Joseph Vernet; while his 'Country Churchyard', exhibited in 1780 (Fig.16), in which two peasants are depicted examining a tombstone and reflecting on mortality and the passage of time, a rustic interpretation of the familiar theme of 'Et in Arcadia Ego', was a compromise with

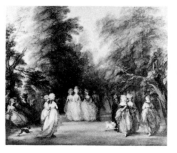

Fig.15 *The Mall*, 1783. Frick Collection, New York

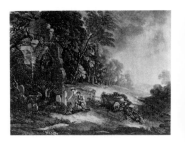

Fig.16 *The Country Churchyard.* Exhibited R.A. 1780. From the aquatint by M.C. Prestal

[ 36 ]

the 'higher' art of history painting.

But Gainsborough's compromises were intuitive solutions. As in the case of his extension of portrait painting into the realm of romantic mood and evanescence, Gainsborough's new directions were generally instinctive, and highly personal. He wrote to Sir William Chambers about his 'Two Shepherd Boys with Dogs Fighting', now at Kenwood: 'I believe next Exhibition I shall make the Boys fighting and the Dogs looking on – you know my cunning way of avoiding great subjects in Painting and of concealing my Ignorance with a flash in the pan'. Of course he had his tongue in his cheek but, for all that, his remark is exceptionally self-revealing. Sent a copy of Reynolds's Fourth Discourse, Gainsborough had commented that 'Sir Joshua either forgets, or does not chuse see that his Instruction is all adapted to form the History Painter, which he must know there is no call for in this country.' But Sir Joshua was perhaps more accurate in his assessment of Gainsborough when he said that 'he had a painter's eye, but not a painter's mind.' According to Jackson, Gainsborough 'either wanted conception or taste, to relish historical painting, which he always considered as out of his way, and thought he should make himself ridiculous by attempting it.' The truth is that 'poetic' invention as such, invention which did not spring from his own deep feeling (Fig. 11), he found difficult. There is the case of his portrait of Garrick with the bust of Shakespeare. 'I have been several days rubbing in & rubbing out my design for Shakespeare', he told Garrick, 'I was willing like an Ass as I am, to expose myself a little, out of the simple Portrait way, and had a notion of showing where that inimitable Poet had his Ideas from, by an immediate Ray darting down upon his Eye turn'd up for the purpose; but G-- damn it I can make nothing of my Ideas ... Lord, what can one do such Weather as this, continual Rains. My Genius is so dampt by it that I can do nothing to please me.' He defended himself in a letter to Jackson in 1767: 'do you consider', he wrote, 'what a deal of work history Pictures require to what little dirty subjects of coal horses & Jack asses and such figures as I fill up with' – and nearer to what he really felt: 'do you really think that a regular Composition in the Landskip way should ever be fill'd with History, or any figures but such as fill a place (I won't say stop a Gap) or to create a little business for the Eye to be drawn from the Trees in order to return to them with more glee.' The expression of mood, not didacticism through subject matter, was always the purpose of his painting. Not that he was totally unlearned. He knew a great deal about musical instruments, 'took great pains to buy the best, & would give large prices for them'. His art library included important architectural books and Stubbs's *Anatomy of the Horse*. We know that he read descriptive guides to the Lakes before setting out on his tour, as he intended, in

[37]

the pictures painted on his return, 'to show . . . that your Grays and
Dr. Brownes were tawdry fan-Painters.' He was probably *au courant*
with the literature and thought of the day, but more from the con-
versation of his friends than through reading, which we are told he
disliked. Though when he was asked by Boydell to contribute to his
Gallery of Shakespearean paintings, he proposed a composition con-
taining ten or twelve figures – for which, incidentally, he asked a
thousand pounds – the only other Shakespearean subjects he contem-
plated, the grave-diggers in *Hamlet* and Timon in solitude, would
presumably have developed the strain of melancholy apparent in 'The
Country Churchyard'.

Gainsborough's melancholy sprang partly from his confinement to
society portraiture – 'we must Jogg on . . . only d-mn it I hate . . . being
confined *in Harness* to follow the track, whilst others ride in the
Waggon, under cover, stretching their legs in the straw at Ease, and
gazing at Green Trees & Blue skies without half my *Taste* that's
d-mn'd hard' – and partly from a nostalgia, shared by Goldsmith and
other contemporaries, for the old ways of country life that were
disappearing under the pressures of agricultural improvement and the
exodus to the newly built factories of industrial Britain. His feelings
found expression in an arcadian style of landscape which developed, in
his later years, into an organ of sentiment. Uvedale Price, speaking of
their rides together, said that 'when we came to cottage or village
scenes, to groups of children, or to any objects of that kind which struck
his fancy, I have often remarked in his countenance an expression of
particular gentleness and complacency.' It was cottage scenes, with
groups of children, that became his most characteristic landscape
subject (Cat.no.142), but, from 1781 onwards, Gainsborough de-
veloped a type of painting in which the rustic figures from his
landscapes took on the scale of life (Cat.no.139). These 'fancy' pictures
of figures in sentimental attitude or engaged in some sentimental
activity, exhibiting 'that pathetic simplicity which is the most powerful
appeal to the feelings', and which were soon to 'engage the attention
of every company of taste,' provided an ampler vehicle for Gains-
borough's nostalgia. They were wholly in tune with the times, and
fetched high prices, while, in spite of patrons as distinguished as the
Prince of Wales, many of his finest landscapes remained unsold:
Beechey tells us that they 'stood ranged in long lines from his hall to his
painting-room, and they who came to sit for him for their portraits . . .
rarely deigned to honor them with a look as they passed them.'

Characteristically, the fancy pictures were painted from living
models. One was a Richmond child named Jack Hill, another a small
girl whom Gainsborough met, with her dog in her arms (just as he
painted her) on Richmond Hill (Cat.no. 139). Reynolds said that his

studies were primarily directed to the living world; the pigs, which were the subject of the celebrated 'Girl with Pigs' (Castle Howard) that he bought himself and subsequently sold in 1789 to the great French collector Calonne, were to be seen gambolling about Gainsborough's studio. 'If, in his walks, he found a character that he liked, and whose attendance was to be obtained, he ordered him to his house: and from the fields he brought into his painting-room, stumps of trees, weeds, and animals of various kinds; and designed them, not from memory, but immediately from the objects.' The figures in 'The Mall' he painted from dressed-up dolls, and his friend de Loutherbourg's 'Eidophusikon', sequences of moving scenery on a model stage accompanied by dramatic sound effects and music by Dr Arne, an entertainment that delighted London, directly inspired his own peep-show box (Cat.no.145). Gainsborough, we are told, was 'so wrapt in delight' by the 'Eidophusikon' that 'for a time he thought of nothing else – he talked of nothing else – and passed his evenings at that exhibition in long succession . . . [indeed he] could not rest until he had invented and completed a series of scenery, which were lighted by lamps . . . these, however, were wrought as transparencies.' This apparatus was designed partly for the amusement and delight of his friends; there is an account of an evening party at Schomberg House when Gainsborough, 'possessed with a new thought, late as it was, (for he was no slave to time,) set his palette, and began to touch up a moonlight, with gipsies over a blazing fire, dashing it in with magical effect.' But it was also a stimulus to the further heightening and dramatizing of his effects. In the early 1770s he had experimented with drawings in imitation of oil painting, works in a mixture of oil, gouache and chalks, to produce a bolder chiaroscuro than he had so far achieved: 'I intend two spanking ones for the Exhibition, if I succeed in getting large Paper made on purpose.' Now it was effects of light and movement that concerned him. He employed 'a lamp with the sides painted with vermillion [sic] which illuminated the shadows of his figures, and made them like the splendid impositions of Rubens.' And his fluency was so astonishing as to provoke adverse criticism. His daughter tells us that 'he scarcely ever in the advanced stage of his life drew with black lead pencil as He cd. not with sufficient expedition make out his effects', while his paints were plentifully diluted with turpentine: 'his colours were very liquid, and if he did not hold the palette right would run over.'

Surprisingly, in view of his reputation as a wit, contemporary memoir writers hardly mention Gainsborough's life in London. Bate-Dudley informs us that 'about six years before his death [he] made a tour through the West of England', accompanied by his nephew and studio assistant, Gainsborough Dupont. From surviving sketches we

know that, perhaps on this occasion, he visited Glastonbury, which William Gilpin, the writer on 'the Picturesque', thought the finest ruins in England, and Tintern; and it is probable that he also visited Snowdonia. We hear of him as a witness in a trial between the dealers Desenfans and Vandergucht in 1787, when the authenticity of a Poussin was in doubt. He was a welcome guest of Sir George Beaumont, later the friend of Constable. A neighbour of James Christie (Cat.no.121), his presence and repartee at a sale were said to add greatly to the competition and prices realised. 'He knew everybody and everybody knew him.' Music remained his principal form of relaxation. Margaret Gainsborough said that 'her Father had drawn much by Candle Light towards the latter part of his life when He thought he did not sleep so well after having applied to drawing in the evening not being able to divest himself of the ideas which occupied his mind, He therefore amused himself with Music.'

In April 1788 Gainsborough made his first mention of a disease of which he had been conscious for some time past, and that was soon to prove fatal. 'What this painful swelling in my neck will turn out I am at a loss at present to guess. Mr. John Hunter found it nothing but a swell'd gland, and has been most comfortable in pesuading [sic] me that it will disperse with the continued application of a sea water poultice. My neighbour Dr. Heberden has no other notion of it. It has been 3 years coming on gradually, and having no pain till lately, I paid very little regard to it; now it is painful enough indeed, as I can find no position on my pillow to admit of getting rest in bed.' A month later he wrote: 'My swelled Neck is got very painful indeed . . . God only knows what is for me, but hope is the Pallat of Colors we all paint with in sickness – 'tis odd how all the Childish passions hang about one in sickness, I feel such a fondness for my first imatations [sic] of little Dutch Landskips that I can't keep from working an hour or two of a Day, though with a great mixture of bodily Pain – I am so childish that I could make a Kite, catch Gold Finches, or build little Ships.' Bate-Dudley reported in June, after Gainsborough had been taken to his house at Richmond for rest and quiet, that he 'is perfectly recovered'; but he was soon obliged to be brought back to London and, in spite of the constant attentions of Dr Heberden and Mr Hunter, who were among the most eminent physicians of the day, his condition grew steadily worse. Dupont later accused both doctors of 'a strange mistake or neglect' in their ministrations.

Only a few days before the end Gainsborough wrote a pathetic note to Reynolds, from whom he had been estranged for some time. 'The extreme affection which I am informed of by a Friend which Sir Joshua has expresd [sic] induces me to beg a last favor, which is to come once under my Roof and look at my things, my woodman you never saw . . . I

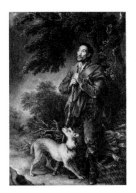

Fig.17 *The Woodman*, 1787.
From the engraving by Simon.

can from a sincere Heart say that I always admired and sincerely loved Sir Joshua Reynolds.' 'The Woodman' (Fig.17), which George III had requested him to bring to Buckingham House for him to examine early in 1788, was purchased by Lord Gainsborough for five hundred guineas shortly after the painter's death, but later destroyed by fire. It was the picture Gainsborough regarded as his greatest work, and was among those canvases brought to his bedside for Reynolds to see. 'If any little jealousies had subsisted between us, they were forgotten, in those moments of sincerity; and he turned towards me as one, who was engrossed by the same pursuits . . . Without entering into a detail of what passed at this last interview, the impression of it upon my mind was, that his regret at losing life, was principally the regret of leaving his art; and more especially, as he now began, he said, to see what his deficiencies were; which, he said, he flattered himself in his last works were in some measure supplied.' At two o'clock in the morning on 2 August he died at Schomberg House, at the age of sixty-one. On his own request the funeral was private, and he was buried in Kew Churchyard next to the grave of his old Suffolk friend, Joshua Kirby.

V

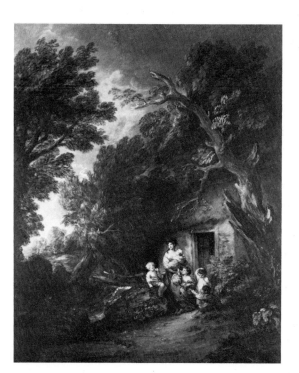

Fig.18 *The Cottage Door*
Exhibited R.A. 1780. Henry E.
Huntington Art Gallery,
San Marino

Later that year Reynolds devoted his annual Discourse to the students of the Academy, when it was his custom to develop his theories about the philosophy and practice of the fine arts, to an analysis of

Gainsborough's painting. This was a remarkable tribute in itself, for it was the first time he had ever illustrated his ideas by reference to a particular artist. 'I confess', he pronounced, that 'I take more interest in, and am more captivated with, the powerful impression of nature, which Gainsborough exhibited in his portraits and in his landskips, and the interesting simplicity and elegance of his little ordinary beggar-children, than with any of the works of that [the Roman] School, since the time of Andrea Sacchi, or perhaps, we may say Carlo Maratti . . . If ever this nation should produce genius sufficient to acquire to us the honourable distinction of an English School, the name of Gains-borough will be transmitted to posterity, in the history of the Art, among the very first of that rising name.'

Gainsborough's portraits did not remain in favour for long; they were very soon eclipsed by the bravura and personality of Lawrence, who set his stamp on British portraiture for over fifty years. When the first retrospective exhibition of Gainsborough's work was held, at the British Institution in 1814, only fourteen of his portraits were included in the show as against forty-five landscapes and almost all the fancy pictures. Nor did his pictures maintain their prices. There seems to have been a certain vogue for his work, notably his drawings, for a short period, but by 1794 the dealer Vandergucht was telling Farington that 'the pictures of Gainsborough are decreasing in value. The raging fashion of collecting them subsiding fast.' Mrs Gainsborough found it no easier to sell her husband's landscapes after his death than Gainsborough did in his lifetime – the 'Peasant Smoking at a Cottage Door' (Cat.no.152), for example, was offered, unsuccessfully, at five hundred guineas at the studio sale in 1789, and only bought ten years later, at half the price, by Sir George Beaumont. Turner said of 'The Cottage Door', then in Sir John Leicester's collection, and now in the Huntington Art Gallery (Fig.18), that it was a work of 'pure and artless innocence'. But Hazlitt, after viewing the exhibition at the British Institution, echoed Hoppner's opinion when he spoke of 'flimsy caricatures of Rubens', and wrote that the defects of Gainsborough's late landscapes (few of the early ones were shown) were that they 'neither presented the spectator with a faithful delineation of nature, nor possessed any just pretensions to be classed with the epic works of art.' Though he believed that it was the fancy pictures 'on which Gainsborough's fame chiefly rests', he was unsympathetic to Gains-borough's sentiment, and said that it was his 'general fault . . . that he presents us with an ideal common life, of which we have had a surfeit in poetry and romance', finding in a characteristic example 'a conscious-ness in the turn of the head, and a sentimental pensiveness in the expression, which is not taken from nature'.

Fidelity to nature, and a love of observed detail meticulously

rendered, were among the touchstones of early Victorian appreciation, in landscape as in other genres, and Constable's feeling for Gainsborough, put into words in his lectures at the Royal Institution in 1836, has more relevance to our own attitudes than to nineteenth-century taste. When Gainsborough's popularity revived in the later nineteenth century, it was through the medium of his most glamorous portraits, an expensive fashion carefully fostered by Duveen for the seduction of American millionaire collectors. Now, it is for Gainsborough's effortless mastery and miraculous beauty of paint, the brilliance and sketchiness of his drawings, the evocation of so many different strata of eighteenth-century society in his portraits, and the tenderness and nostalgic mood of his landscapes, that we value him. 'The landscape of Gainsborough', Constable had declared, in one of the most moving tributes ever paid by one great painter to another, 'is soothing, tender and affecting ... With particulars he had nothing to do; his object was to deliver a fine sentiment, and he has fully accomplished it ... The stillness of noon, the depths of twilight, and the dews and pearls of the morning, are all to be found on the canvases of this most benevolent and kind-hearted man. On looking at them, we find tears in our eyes, and know not what brings them.'

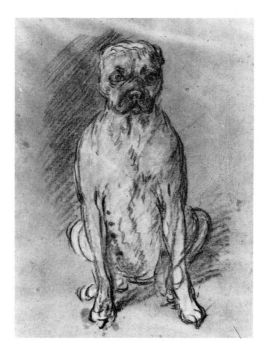

*Study of a Bull-terrier*, Later 1750s (verso of Cat.no.13) Staatlische Museen, Berlin

# Short Note on Further Reading

The principal source for our knowledge and understanding of Gainsborough is his correspondence, which has a place beside Sterne in eighteenth-century English literature. Gainsborough seems to have been a prolific – as well as a lively and entertaining – letter writer, but sadly hardly more than a hundred of his letters survive today. These have been gathered together by Mary Woodall in *The Letters of Thomas Gainsborough*, 1963. Sir Joshua Reynolds's account of, and tribute to, Gainsborough in his *Fourteenth Discourse*, still the most revealing critical essay, is available in numerous editions of the *Discourses*; that by Robert R. Wark, San Marino, 1959, is the best to consult. The standard biography, based on years of patient research and incorporating a vast amount of new material derived from eighteenth-century newspapers, remains William T. Whitley's *Thomas Gainsborough*, 1915. Ellis Waterhouse's *Gainsborough*, 1958, which contains a useful bibliography and the most comprehensive selection of illustrations of Gainsborough's paintings (300 plates), is the most important general study of the artist. Catalogues raisonné are in progress: those on the drawings and prints are published (1970 and 1971), and that on the landscape paintings will appear in 1981.

My *Gainsborough: Paintings and Drawings*, 1975, contains a selective reading list intended to be of use to students: to this should now be added Marcia Pointon's *Gainsborough and the Landscape of Retirement* in *Art History*, December 1979 and John Barrell's equally thought-provoking essay in *The Dark Side of the Landscape*, Cambridge, 1980. Catalogues were not included in my bibliographical note. Museum catalogues such as those of the Fitzwilliam Museum and the Frick Collection follow the example of painstaking scholarship set by Martin Davies in his National Gallery catalogue, *The British School*, 2nd edn, 1959. Oliver Millar's equally exemplary *The Later Georgian Pictures in the Collection of Her Majesty The Queen*, 1969, incorporates much invaluable information from material in the royal archives. Among recent exhibition catalogues Lindsay Stainton's *Gainsborough and his Musical Friends*, The Iveagh Bequest, Kenwood, 1977, is a substantial contribution to our understanding of this aspect of Gainsborough's life.

CATALOGUE NOTE

Dimensions are given in centimetres followed by inches in brackets; height precedes width. The catalogue entries have been designed primarily for the assistance and pleasure of the visitor to the exhibition. Where I compiled notes of a similar nature for my Phaidon book on Gainsborough (1975), these have been utilised. References have been confined to accessible modern works which contain additional information not found in the entries. For the interested student, the catalogues raisonné published so far include complete bibliographies. The following abbreviations have been employed:

Hayes *Drawings*
    John Hayes, *The Drawings of Thomas Gainsborough*, 2 vols., London, 1970

Hayes *Landscape Paintings*
    John Hayes, *Gainsborough's Landscape Paintings* (for publication London, 1981)

Waterhouse
    Ellis Waterhouse, *Gainsborough*, London, 1958

Whitley
    William T. Whitley, *Thomas Gainsborough*, London, 1915

# Drawings

For Gainsborough drawing was a compulsive activity, a means of expression in itself which was also a recreation. It was not primarily a preparatory process, as it was for Reynolds. He sketched from nature throughout his life. But most of his surviving drawings are imaginary landscape compositions done for pleasure in the evenings; some of these he used for paintings, usually without alteration except for the

Fig.19 First study for *The Duke and Duchess of Cumberland*, *c.*1783–5. Her Majesty The Queen, Windsor Castle

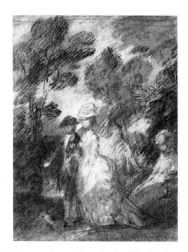

Fig.20 Second study for The Duke and Duchess of Cumberland, *c.*1783–5. British Museum, London

addition of *staffage*. In his early years he probably made many more studies than he did later, when he preferred to develop his ideas directly upon the canvas. Early studies of detail exist, drawings of plants or animals which were incorporated in the foregrounds of his landscapes, sketches of some element of costume, perhaps a coat or cuff. When he was first painting full-lengths he made a good many sketches of ladies' dresses, often from jointed dolls he possessed, with the object of studying the fall of the elaborate folds and flounces of the fashions of the day. Later there are fewer of these, and composition drawings only for his more complex pictures, such as 'The Duke and Duchess of Cumberland' (Cat.no.128; Figs.19 and 20), the 'Diana and Actaeon' (Cat.nos.40 and 137) or the 'Richmond Water-walk' (Cat.nos. 41 and 42). Though many of Gainsborough's early sketches from nature are still extant – the sketchbooks themselves are now broken up – examples of his later nature work are rare, though we know of some of the sketching trips he made, for example, to the West Country in about 1782, to the Lakes in 1783. Finished drawings, as opposed to sketches, are less common. In earlier life he did some elaborate

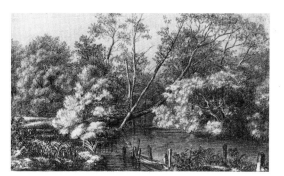

Fig.22 Antonie Waterloo,
*Wooded River Scene*

finished landscape drawings for sale; one or two portrait drawings also survive. Later he did a number of pastels. After his Suffolk days he never sold his drawings, and those he gave away to friends, even the 'presentation' drawings which he provided with special gold-tooled borders, are indistinguishable from his other sketches.

Fig.21 Antonie Waterloo,
*Study of Trees*

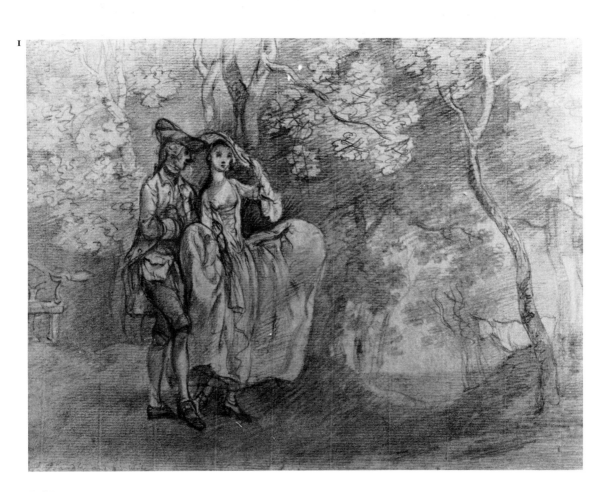

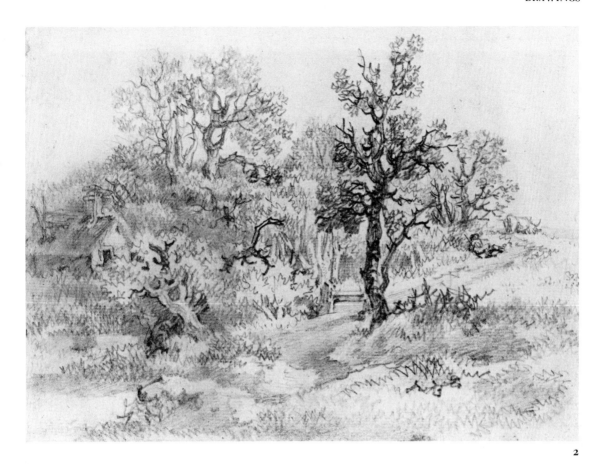

**2**

1 **An Unidentified Lady and Gentleman, probably the Artist and his Future Wife, Margaret Burr**
Pencil, 20.2 × 26.8 ($7\frac{15}{16}$ × $10\frac{9}{16}$)
Mid 1740s
Lit: Hayes *Drawings*, No.3
*Private collection*

Although the sheet is inscribed bottom left: *Mr P Sandby and his Wife*, the inscription is far from contemporary, and this captivating drawing of a courting couple does not represent Paul Sandby and his wife, who were, in any case, not married until 1757. Identification with the couple in the more sophisticated double portrait in the Louvre (Cat. no.55), is, however, entirely plausible. The wooded setting, somewhat tentatively drawn, is like a photographer's backdrop, with a cow on a bank to suggest the country rather than parkland.

2 **Landscape with resting Herdsman and Cottage**
Pencil, 13.7 × 19.4 ($5\frac{3}{8}$ × $7\frac{5}{8}$)
Mid to later 1740s
Lit: Hayes *Drawings*, No.81
*Pierpont Morgan Library, New York*

This drawing is conceived in terms of delicate contrasts of light and shade. The technique is influenced by the methods of Dutch draughtsmen of the seventeenth century. The zig-zag touch employed throughout derives from Anthonie Waterloo, whose etchings were much admired in eighteenth-century England, and the brittle, angular treatment of the tree trunks from Jacob Ruisdael.

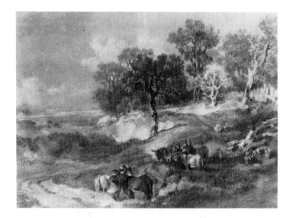

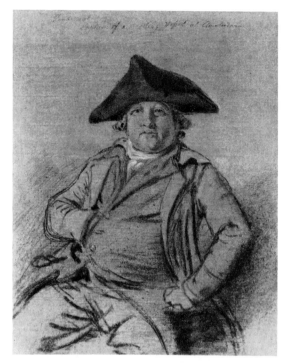

**3  Landscape with Donkeys**
Black chalk and stump, grey stump and white
chalk on buff paper, 37 × 51.6 (14 $\frac{9}{16}$ × 20 $\frac{5}{16}$)
Mid to later 1740s
Lit: Hayes *Drawings*, No.82
*Private collection*

This more elaborate and highly finished work, one of
the largest of Gainsborough's early drawings, is
similarly influenced in its technique by Waterloo and
Jacob Ruisdael. The composition revolves round a
track winding into the wood, and the marked con-
trasts of light and shade throughout are used not only
for the sake of vitality but to convey a sense of depth
and distance.

**4  Portrait of a Dutch Sea Captain**
Black, white and coloured chalks on grey
prepared paper, 31.7 × 25.7 (12 $\frac{1}{2}$ × 10 $\frac{1}{8}$)
Early to mid 1750s
Lit: Hayes *Drawings*, No.11
*National Gallery of Scotland, Edinburgh*
[colour repr. p.73]

The drawing has been inscribed, at a later date, with
the name of the sitter, which is difficult to decipher
(and has been shown by Keith Andrews's application
to Dutch archives not to be 'Van Gieront', as
formerly transcribed, since no sea captain of that
name is registered), together with the legend: *Captain
of a sailing Vessel at Amsterdam.* Apparently also,
according to the Maritime Museum in Amsterdam,
the cocked hat was not normal wear for a Dutch
skipper. The degree of finish in the head and the use
of coloured chalks indicate that this is not a prepara-
tory drawing for an oil but a portrait in its own right.

Presumably the captain wanted something small that
could be executed quickly. The direct gaze and the
bluff, 'no nonsense' pose are matched by the vigour
of the chalkwork, and the drawing effectively con-
veys both the vitality and the cheerful disposition
of the Dutchman. Who recommended him to Gains-
borough? Was this, one wonders, an isolated example,
or did Gainsborough do other sketches, now lost to
us, of Dutch merchants or seamen who traded with
East Anglia?

5

5    **Study of Cottages**
Pencil, 14 × 18.9 (5½ × 7$\frac{11}{16}$)
Early to mid 1750s
Lit: Hayes *Drawings*, No.144
*Trustees of the British Museum*

A page from one of Gainsborough's sketch-books, sold at Christie's after his widow's death, in 1799, and bought by Richard Payne Knight, the well-known connoisseur and writer on aesthetics, who bequeathed it to the British Museum. The book seems to have been broken up after it was acquired by the Museum. There is a drawing of a hut on the other side of the page.

7

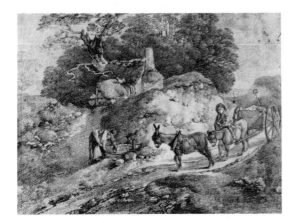

6    **Landscape with Country Cart and Cottage beside a Bank**
Pencil, 21 × 27.6 (8¼ × 10$\frac{7}{8}$)
Early to mid 1750s
Lit: Hayes *Drawings*, No.132
*Private collection*

A carefully finished drawing, mellifluous in its rhythmical design, in which the principal focus of attention is the strongly lit sandy bank.

7    **Study of an old Hurdle**
Pencil, 14.9 × 18.4 (5$\frac{7}{8}$ × 7¼)
Mid to later 1750s
Lit: Hayes *Drawings*, No.164
*Courtauld Institute Galleries, Witt Collection*

A study from nature, probably a page originally part of a sketch-book.

8    **Study of Trees**
Pencil, 14 × 19 (5½ × 7½)
Mid to later 1750s
Lit: Hayes *Drawings*, No.168
*Private collection*

A rapid sketch from nature, again probably a page originally part of a sketch-book.

8

9    **Study of Mallows**
Pencil, 19 × 15.6 (7½ × 6$\frac{1}{8}$)
Later 1750s
Lit: Hayes *Drawings*, No.177
*H. Cornish Torbock*

One of the very few surviving examples of Gainsborough's detailed studies of plants, sensitively

Another page from the sketch-book purchased by Richard Payne Knight. Although, in this very summary sketch, the forms are scarcely more than outlined, Gainsborough has brought the scene to life through the play of sunlight. There is a sketch of some logs on the other side of the page.

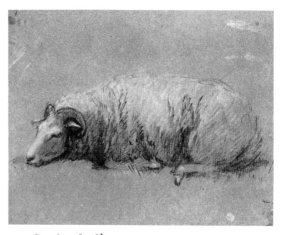

11  **Study of a Sheep**
Black and white chalks on grey paper,
14.1 × 18.4 ($5\frac{9}{16}$ × $7\frac{1}{4}$)
About 1757–9
Lit: Hayes *Drawings*, No.864
*Staatliche Museen, Preussischer Kulturbesitz, Kupferstichkabinett, Berlin*

and accurately drawn. The sheet probably originally formed part of a sketch-book and, like many similar studies by seventeenth-century draughtsmen, was no doubt sketched for use in the foreground of one of his landscape paintings.

This study from life of a sheep as it lay asleep was drawn on a page from one or other of the three sketch-books bought by George Hibbert, a West India merchant who was an avid book and print collector, at the dispersal of Gainsborough's effects at Christie's in 1799. These books were broken up at some point before their sale by the family in 1913. The drawing provides a useful illustration of the way in which Gainsborough used his sketch-books. He incorporated both this and another drawing from life of two sheep, without change of pose, in a larger, and more loosely drawn, composition study in which the three sheep are watched over by a shepherd boy. This idea was then used, but with four sheep of a different breed differently grouped, as the principal subject-matter in the oval landscape now in the Toledo Museum of Art.

10  **Sketch of a Horseman and Cottage**
Pencil, 14.8 × 19 ($5\frac{13}{16}$ × $7\frac{1}{2}$)
Later 1750s
Lit: Hayes *Drawings*, No.213
*Trustees of the British Museum*

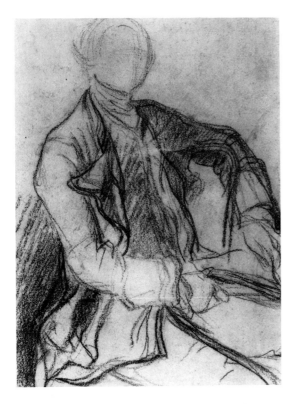

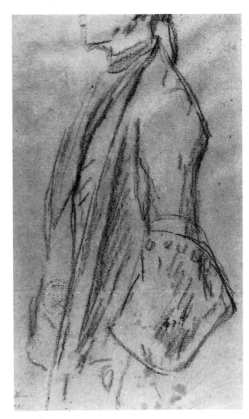

**12 Study for the Portrait of the Hon. Richard Savage Nassau** (1723–80)
Black chalk, 28.2 × 20.8 ($11\frac{1}{8}$ × $8\frac{3}{16}$)
Later 1750s
Lit: Hayes *Drawings*, No.13
*Staatliche Museen, Preussischer Kulturbesitz, Kupferstichkabinett, Berlin*

Comparatively few studies for Gainsborough's portraits are known. The 'Richard Savage Nassau' was one of the first of his more ambitious full-scale Suffolk portraits and, in order to try out an idea which would be both relaxed and natural, he drew from life this study of the pose and fall of the coat; the head, which, as in his smaller head-and-shoulders portraits, he would have painted directly upon the canvas, is only blocked out.

**13 Study of a Man for an Unidentified Portrait Group**
Black chalk on buff paper, 31.6 × 24.4 ($12\frac{7}{16}$ × $9\frac{5}{8}$)
Later 1750s

Lit: Hayes *Drawings*, No.14
*Staatliche Museen, Preussischer Kulturbesitz, Kupferstichkabinett, Berlin*

A costume study from life, more rapidly, and even more vigorously, executed than the study for the 'Richard Savage Nassau'. The bold, staccato character of the line can be paralleled in certain French drawings of the period, notably those of Parrocel. There is a lively drawing of a bull terrier on the other side of the sheet (see illustration p.43).

**14 Wooded Landscape with Herdsman and Cow on a Bank**
Pencil, 27.9 × 38.3 (11 × $15\frac{1}{8}$)
About 1758–9
Lit: Hayes *Drawings*, No.233
*Sir John and Lady Witt*
The foliage in this drawing is very rhythmically handled, in quick, looped strokes, and the composition seems to rotate around the broad, conical shape of the bank, partly sunlit, partly in shadow. In

[ 53 ]

gouache drawings of the fashionable early-eighteenth-century Italian artists, Marco Ricci and Giovanni Battista Busiri. Busiri drawings in particular he would have seen in the collection of his friend, Sir Robert Price, of Foxley, in Herefordshire. This drawing was originally owned by one of Gainsborough's physicians at Bath, Dr Rice Charlton, and was probably a gift from the artist.

these respects the drawing is one of the most splendidly rococo of Gainsborough's early landscape inventions.

**16   Herdsman and Cows with Distant Village Seen Between Trees**
Pencil, watercolour and bodycolour on pinkish paper, 21.4 × 28.3 ($8\frac{7}{16}$ × $11\frac{1}{8}$)
Mid 1760s
Lit: Hayes *Drawings*, No.273
*Ingram Family Collection*
[colour repr. p.73]

The loose handling of the foliage and the fresh, pale tone in this peaceful, sun-drenched landscape are strongly influenced by Van Dyck's landscape sketches.

**15   Hilly Landscape with Peasants Approaching a Bridge**
Watercolour and bodycolour, 27.5 × 37.8 ($10\frac{13}{16}$ × $14\frac{7}{8}$)
Early 1760s
Lit: Hayes *Drawings*, No.264
*Yale University Art Gallery, New Haven (James W. and Mary C. Fosburgh Collection)*

This composition owes its exceptional vigour and drama to the strong, but fitful, sunlight playing over the scene, and the intensely rhythmical treatment of the tree trunks and swathes of foliage. The idea of using lead white to enhance the sense of movement, to create a rococo surface glitter and to highlight forms Gainsborough probably derived from the

**17   Country Waggon Passing Through a Woodland Glade**
Black chalk and watercolour heightened with white, 23.7 × 31.7 ($9\frac{5}{16}$ × $12\frac{1}{2}$)
Stamped *TG* in monogram in gold
Mid 1760s
Lit: Hayes *Drawings*, No.282
*Trustees of the British Museum*

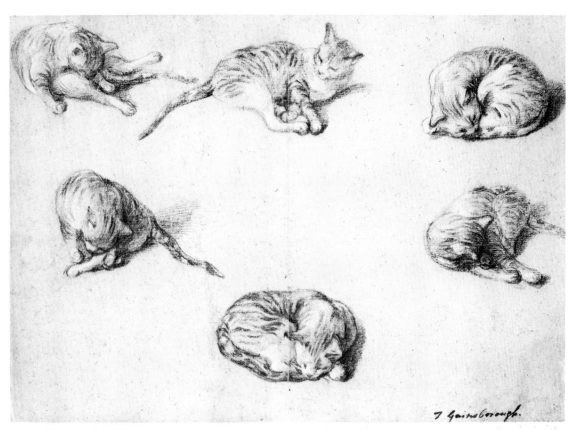

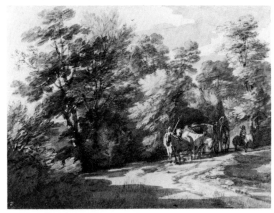

**18 Studies of a Cat**
Black chalk and stump and white chalk on buff
paper, 33.2 × 45.9 ($13\frac{1}{16}$ × $18\frac{1}{16}$)
Signed in full
Mid to later 1760s
Lit: Hayes *Drawings*, No.874
*Rijksprentenkabinett, Rijksmuseum, Amsterdam*

This sheet of studies of a cat as it lay curled up on the
hearth-rug, sketched in six different attitudes, is one
of Gainsborough's most appealing drawings. The
sketches are traditionally supposed to have been
done in a country house and presented to his hostess.

The subtlety of tint and the immediacy of this
watercolour suggest that it was done from nature, but
it may have been worked up, as was Gainsborough's
practice, from slighter sketches made on the spot.
The pool of sunlight and the resting horses induce a
mood of pastoral contentment. There is an un-
finished watercolour on the other side of the sheet.

**19 Study of a Woman seen from behind**
Black chalk and stump and white chalk on
grey-green paper, 48.9 × 30.3 ($19\frac{1}{4}$ × $11\frac{15}{16}$)
Mid to later 1760s
Lit: Hayes *Drawings*, No.30
*Visitors of the Ashmolean Museum, Oxford*

[ 55 ]

19                                    20

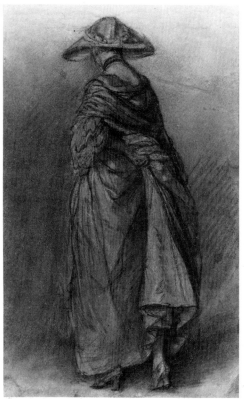
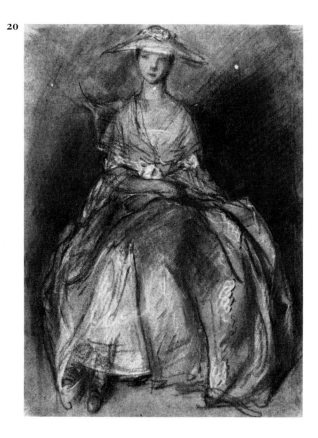

An elaborate study of costume not associated, as far as we know, with any painting Gainsborough was projecting. The unusual nature of the pose, in which the sitter is shown hitching up her skirts as though to avoid a puddle, suggests a study from life rather than a drawing from one of the articulated dolls he possessed. This was one of a group of Gainsborough's finest figure drawings which descended in the family, and was engraved by the artist's great nephew, Richard Lane, for a portfolio of lithographs published in 1825.

Gainsborough's concern in this drawing was with the fall of the skirt around the figure, and the feet, most unconvincingly related to the body (there are other folds over the knee in the centre), seem to have been added as an afterthought. This was another of the group of Gainsborough's figure drawings which descended in the family, and was engraved by Richard Lane for the portfolio of lithographs published in 1825. There is an outline sketch of a small girl seated on a bank on the other side of this sheet.

20   **Study of a Woman Seated**
     Black chalk and stump and white chalk on blue paper, $31.4 \times 23.7$ ($12\frac{3}{8} \times 9\frac{5}{16}$)
     Mid to later 1760s
     Lit: Hayes *Drawings*, No. 32
     *Mrs Gertrude B. Springell*

A study probably from life, but perhaps from a dressed doll, for the pose in an unidentified portrait.

21   **Peasant Boy reclining in a Cart**
     Pen and brown ink, with grey and brown washes, $17.6 \times 22.1$ ($6\frac{15}{16} \times 8\frac{11}{16}$)
     Later 1760s
     Lit: Hayes *Drawings*, No. 307
     *Trustees of the British Museum*

A sketch of a peasant boy lazing in the back of a cart, untroubled by the cares of rural husbandry, which

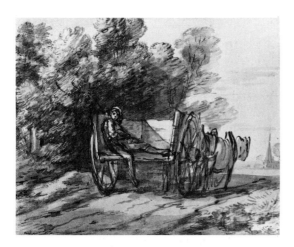

gives the impression of having been done from the life, *con amore*. The brilliant penwork in the horse and cart-wheel has the assurance of a Rembrandt, and may have been done in conscious emulation.

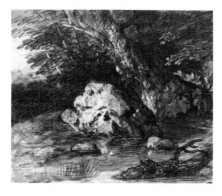

**22 Study of a Boulder and Plants at the Foot of a Tree**
Black chalk and watercolour, heightened with white, varnished, 22.9 × 28.4 ($9 \times 11\frac{3}{16}$)
Later 1760s
Lit: Hayes *Drawings*, No.311
*Yale Center for British Art, New Haven (Paul Mellon Collection)*

A study of the fall of light on a boulder, done direct from nature.

**23 Ruined Castle Beside a River**
Black chalk and stump and white chalk on grey-blue paper, 24.6 × 30.8 ($9\frac{11}{16} \times 12\frac{1}{8}$)
Early 1770s
Lit: Hayes *Drawings*, No.329
*Birmingham City Museum and Art Gallery by courtesy of Mrs P. L. M. Wright*

A deliberate sense of melancholy is evoked by this image of a ruined building, a mood intensified by the figure sitting in its shadow and by the rays of the setting sun.

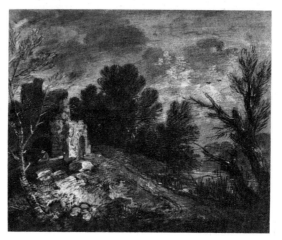

**24 Church on a Hillside and Herdsman Driving Cows**
Black chalk, grey wash and oil on brown-toned paper, varnished, 21.9 × 31.6 ($8\frac{5}{8} \times 12\frac{7}{16}$)
Early 1770s
Lit: Hayes *Drawings*, No.346
*Birmingham City Museum and Art Gallery by courtesy of Mrs P. L. M. Wright*

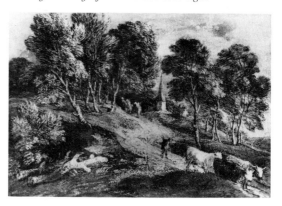

A pastoral in which Gainsborough has introduced a peasant driving cattle home after the day's labours and made the church the focal point of the design. Goldsmith's *The Deserted Village* appeared in 1770, and Gainsborough's village scenes of the early 1770s are to some extent a visual counterpart to the imagery of the poem: his church is analogous to Goldsmith's 'decent church that topp'd the neighbouring hill'.

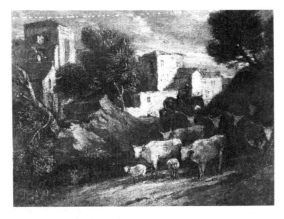

**25  Mounted Herdsman Driving a Herd of Cattle Home**
Oil on brown-toned paper, varnished,
21.4 × 30.6 ($8\frac{7}{16}$ × $12\frac{1}{16}$)
Early 1770s
Lit: Hayes *Drawings*, No.363
*Private collection*

A pastoral in which the shady part of the lane through which the cattle are passing is emphasised by the strong sunlight playing on the buildings. This effect, and the strange character of the buildings themselves, out of place in a country scene, suggests the influence of Gaspard Poussin. In many of his drawings of this period and later Gainsborough used an admixture of oil to give added richness to his effects. Here, in order to accentuate the drama of his chiaroscuro, oil is the only medium employed.

**26  Study of a Music Party**
Red chalk and stump, 24.1 × 32.4 ($9\frac{1}{2}$ × $12\frac{3}{4}$)
Trimmed at all four corners
Early 1770s

Lit: Hayes *Drawings*, No.47; Lindsay Stainton, *Gainsborough and his Musical Friends*, catalogue of an exhibition at Kenwood, 1977, No.18; *Gainsborough and Reynolds in the British Museum*, catalogue of an exhibition, 1978, No.37
*Trustees of the British Museum*

One of the most brilliant and evocative of Gainsborough's drawings from life; in no other sketch is the artist's miraculous ability to convey weight, posture and expression with a few swiftly drawn lines more conspicuously apparent. The use of red chalk, though common among French draughtsmen, is unusual in Gainsborough. The scene had tentatively been identified as the Linleys' house in Bath, where Gainsborough was a constant and welcome visitor, and the sitters round the harpsichord as members of the Linley family, with the violinist, Giardini. Inscriptions on the back, however, by Gainsborough's great nephew, Richard Lane – which were only revealed a few years ago when the backing was removed – show that the drawing, like many others, was originally in his possession (he gave it to his friend, William Mulready) and also that he believed the sitters to be 'Portraits of Himself [i.e. Gainsborough], his two Daughters, and Abel'. Since it is unlikely that Gainsborough would have included himself in such a sketch from life, and the two women do not resemble portraits of Gainsborough's daughters, while Abel's usual instrument was not the violin but the viola da gamba, Lane may well have been mistaken. The earlier identification seems, on balance, to be the more plausible.

**27  Portrait of Gainsborough Dupont** (1754–97)
Black chalk and stump, coloured chalks and watercolour, varnished, 16.5 × 14.1 ($6\frac{1}{2}$ × $5\frac{9}{16}$)
Early 1770s
Lit: Hayes *Drawings*, No.49
*Victoria and Albert Museum*

Dupont was the eldest surviving son of Gainsborough's sister, Sarah, and of Philip Dupont, of Sudbury. As he showed some aptitude for painting, Gainsborough took him on as an apprentice in January 1772, when he was seventeen; he was

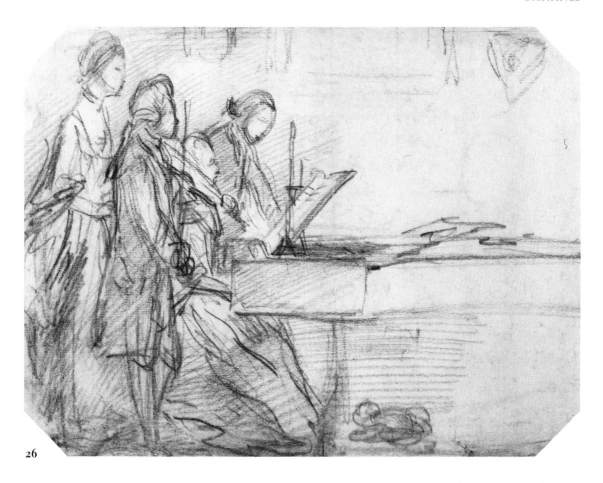

26

admitted to the Royal Academy Schools in 1775. After he had completed his articles he stayed on as Gainsborough's assistant, taking over the studio after the latter's death in 1788. During the remaining eight years of his life he exhibited regularly at the Academy and enjoyed the patronage of the Royal Family and of William Pitt, who secured for him the commission to paint the large group portrait of the Merchant Elder Brethren at Trinity House. His style was closely imitative of Gainsborough, and he never achieved a significant reputation, failing to be elected an A.R.A. at the third attempt in 1795. This portrait, swiftly executed in coloured chalks with some red wash splashed across beneath to suggest the coat, is inscribed on the back by Dupont as having been done at 'Bath about the Year 1775'; Gainsborough left Bath in 1774, so that the sketch probably dates a little earlier.

**28 Panoramic Landscape with Herdsman and Cows**
Black chalk and stump and white chalk on grey paper, 22.7 × 31.7 ($8\frac{15}{16}$ × $12\frac{1}{2}$)
Mid 1770s
Lit: Hayes *Drawings*, No.388
*Lord Clark*

A pastoral idyll based on the compositions of Claude in which the eye is led past trees into an extensive plain swept by sunlight, with hills in the distance beyond.

29

**29 Wooded Landscape with rustic Lovers**
Pen and grey-black ink with grey and grey-black washes on pale buff paper, heightened with white, 35.2 × 24.4 ($13\frac{7}{8}$ × $9\frac{5}{8}$)
Early 1780s
Lit: Hayes *Drawings*, No.499
*Cabinet des Dessins du Musée du Louvre*

Tall, broadly washed trees arch over the pair of lovers, an unusually overt example of this theme, familiar from Gainsborough's Suffolk style. The cow on the bank is rather awkwardly placed, and seems to be an afterthought.

**30 Peasants returning from Market**
Grey, grey-black and brown washes, 19.4 × 24.4 ($7\frac{5}{8}$ × $9\frac{5}{8}$)
Early 1780s
Lit: Hayes *Drawings*, No.502
*Private collection, U.S.A.*

The pastoral idyll of a group of peasants ambling contentedly home after a day at market is enhanced by depicting them in open country, silhouetted against the radiance of the setting sun. Figures and light combine to form an image of profound, and totally uncloyed, sentiment.

**31   Country Mansion with Figures on a
    Terrace**
Grey and grey-black washes and black and
white chalks, 26 × 37.1 (10¼ × 14⅝)
Early 1780s
Lit: Hayes *Drawings*, No.519
*Whitworth Art Gallery,*
*University of Manchester*

One of a number of similar compositions of this
period in which a country house, without garden or
surrounding wall, has been set down, somewhat
incongruously, in a pastoral landscape. The building
itself is made up of a strange array of features. The
shepherd boy reclining at the foot of the flight of
steps may be intended to point the contrast with the
gentility of the family on the terrace.

**32   Study of Glastonbury Abbey**
Black and white chalks on grey paper,
16.5 × 21.1 (6½ × 8⁵⁄₁₆)
Early 1780s
Lit: Hayes *Drawings*, No.573
*Sir John and Lady Witt*

A study, done on the spot, of the eastern piers of the crossing and the adjacent bays of the transepts with, beyond, St Michael's Chapel on Glastonbury Tor. Characteristically, the drawing is picturesque rather than archaeological, a summary sketch of the ruins which does not pretend to accuracy in detail: obvious faults are the proportions of the arches, which should be heightened, and the failure to bring the piers into line. The state of the ruins seen here is not altered today, except for the removal of the bushes in the course of tidying up. Gainsborough made a tour of the West Country in the company of his nephew and studio assistant, Gainsborough Dupont, in about 1782, and it is possible that the drawing was made on this trip. Similar sketches survive of St Joseph's Chapel at Glastonbury and of another ruined abbey inscribed, but difficult to identify as, Tintern.

which pulsate across the composition and create an almost violent sense of lateral movement. The heightening in white chalk, still used in part to create a surface glitter and to suggest reflected light, adds powerfully to this impetus, not only in the sky, where it is applied in long sweeping strokes and follows the entire silhouette of the mountains, but also in the rising ground on the right, where it is touched into a loose form of hatching.

33　**Study of Langdale Pikes**
　　Pencil and grey wash, 26.4 × 41.3 (10⅜ × 16¼)
　　Probably 1783
　　Lit: Hayes *Drawings*, No.577
　　*Dr Charles Warren*

In the late summer of 1783 Gainsborough made the by then fashionable tour of the Lake District in the company of his old friend, Samuel Kilderbee (Cat. no.60). Only two drawings done on this trip survive, of which this is one. Although the silhouette of the peaks has been softened, the view is otherwise an accurate representation of Langdale Pikes as seen from Elterwater. The moisture-laden atmosphere of the Lake District is sensitively conveyed.

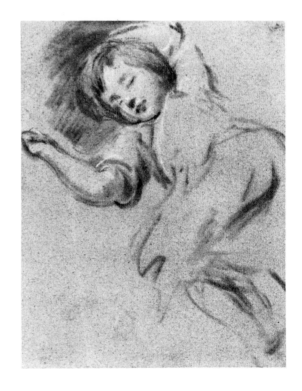

34　**Mountain Landscape with Shepherd and Sheep**
　　Black chalk and stump and white chalk on
　　buff paper, 23.3 × 36.3 (9³⁄₁₆ × 14⁵⁄₁₆)
　　About 1783
　　Lit: Hayes *Drawings*, No.590
　　*Museo de Arte de Ponce, Puerto Rico*
　　*(Luis A. Ferré Foundation)*

A composition study based on his memories of Langdale Pikes, but conceived by Gainsborough in terms of Rubens's superhuman rhythms of design. All the shapes are softened into undulating forms

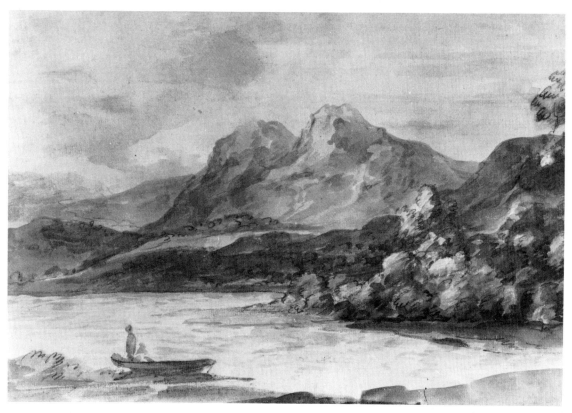

**35   Study of a Child Asleep**
Black chalk and stump and white chalk on
blue paper, 19.2 × 14.6 ($7\frac{9}{16}$ × $5\frac{3}{4}$)
Early 1780s
Lit: Hayes *Drawings*, No.53
*Private collection*

A brilliant and evocative sketch from life. The
drawing had always been framed horizontally until
Mrs Judy Egerton, pointing out the difficulty of
interpreting the pose, especially that of the right arm,
if the child was shown this way, recently suggested
the present vertical format as the correct one.

**36   Study of an Unknown Woman in a
Mob Cap**
Black and white chalks on buff paper,
19.4 × 13.5 ($7\frac{5}{8}$ × $5\frac{5}{16}$)
Early to mid 1780s
Lit: Hayes *Drawings*, No. 54
*Yale Center for British Art, New Haven
(Paul Mellon Collection)*

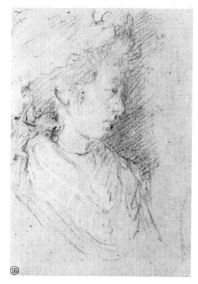

A portrait sketch, in which Gainsborough has
successfully held the quiet, pensive mood of the sitter
amidst the welter of rough chalk-work suggesting the
cap and dress.

[ 63 ]

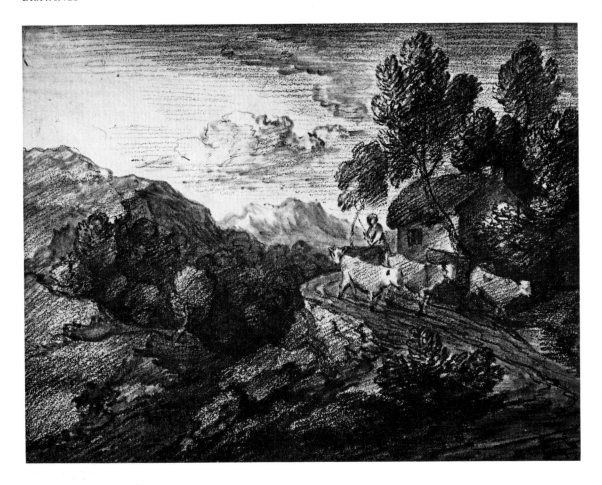

37  **Mountainous Landscape with Herdsman
    and Cows passing a Cottage**
    Black chalk and stump, 27.8 × 37.5
    ($10\frac{15}{16} \times 14\frac{3}{4}$)
    Mid 1780s
    Lit: Hayes *Drawings*, No.636
    *Trustees of the Holker Estate Trust*

One of Gainsborough's most densely and highly
wrought compositions in black chalk. The inhospit-
able mountains, which make a harsh contrast with
the pastoral features on the right, are influenced by
the example of Gaspard Poussin, whose work he was
emulating at this period. This drawing was engraved
by Gainsborough's friend Rowlandson.

38  **Woodcutter with Girls Tying up Bundles
    of Faggots**

Brown chalk, grey wash and oil on brown prepared paper, varnished, 22.1 × 31.3 ($8\frac{11}{16}$ × $12\frac{5}{16}$)
Mid 1780s
Lit: Hayes *Drawings*, No.663
*Private collection*

The peasants in Gainsborough's landscapes are nearly always seen in repose, either resting or returning home at the end of the day's work. The ploughman with his plough-team, a frequent motif in the pictures of the Suffolk period, disappeared from Gainsborough's compositions thereafter, and this drawing, in which a woodcutter is shown chopping wood, is an unusual example of vigorous activity.

### 39 Upland Landscape with Cows
Brown wash over an offset outline, 20.2 × 26.7 ($7\frac{15}{16}$ × $10\frac{1}{2}$)
Mid 1780s
Lit: Hayes *Drawings*, No.708
*Museum Boymans-Van Beuningen, Rotterdam*

Gainsborough seems to have experimented with offset, not in order to make replicas, which was the practice of such artists as Rowlandson, but with the idea of producing some unexpected combination of lines that would spur on his invention: these drawings he finished in brown (or sometimes) grey washes often applied in a highly impressionistic manner. The fact that Gainsborough usually stamped this type of sketch with his signature and surrounded the sheet with a decorative gold tooled border, pre-

sumably with the intention of preparing them as gifts, suggests that this was the kind of work he particularly favoured as presentation drawings in his later years: in other words, suggestiveness increasingly became a positive quality for him. The original owner of the drawing was George Nassau, scion of a Suffolk county family and a noted bibliophile, whose father had been painted by Gainsborough many years before (see Cat.no.64); at the sale of his collection in 1824, it was bought by the banker, William Esdaile, of Clapham Common, who owned the finest print collection of his day and, amongst his drawings, numbered over a hundred Gainsboroughs.

### 40 Study for the 'Diana and Actaeon'
Black and white chalks and grey and grey-black washes on buff paper, 25.6 × 33.3 ($10\frac{1}{16}$ × $13\frac{1}{8}$)
About 1784–5
Lit: Hayes *Drawings*, No.810
*Private collection*

The first of three designs for the picture in the royal collection (Cat.no.137). In this initial sketch the scene is one of confusion, some of the figures turning away in embarrassment, one hurriedly putting on some clothes, and another climbing up the bank to the right. Diana is seen in the centre about to throw a handful of water at Actaeon, water that will transform the intruding huntsman into a stag. The sense of confusion is heightened by the vigorously sketched tree trunks, spiralling in different directions above the figures.

[ 65 ]

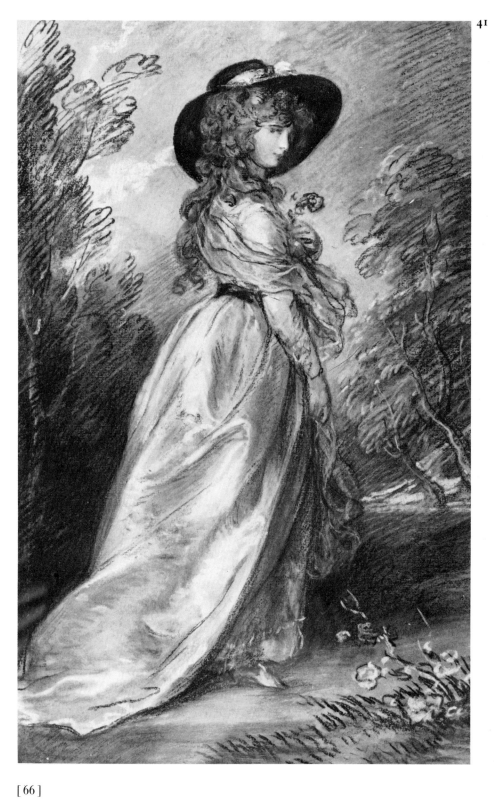

41 **Study of a Lady for 'The Richmond
Water-walk'**
Black chalk and stump on buff paper,
heightened with white, 49.1 × 31.1
($19\frac{5}{16} × 12\frac{1}{4}$)
About 1785
Lit: Hayes *Drawings*, No.59
*Trustees of the British Museum*

One of a magnificent group of figure studies,
executed with exceptional vigour, for a painting,
never completed and perhaps never begun, noted in
*The Morning Herald* for 20 October 1785 as intended
for George III, and as a companion to 'The Mall',
painted in 1783, now in the Frick Collection, New
York. The setting was to be 'Richmond water-walk,
or Windsor – the figures all portraits'. Gains-
borough's friend, William Pearce, to whom the
drawing was given, recorded, in an inscription
formerly on the back of the frame: 'While sketching
one morning in the Park for this picture, he (Gains-
borough) was much struck with what he called "the
fascinating leer" of the Lady who is the subject of the
drawing. He never knew her name, but she was that
evening in company with Lady N . . . field, &
observing that he was sketching she walked to & fro'
two or three times, evidently to allow him to make a
likeness. Sir Thomas Lawrence when he lodged in
Jermyn Street came to my house in Pall Mall, for
several successive days, when Lord Derby employed
him to paint Miss Farren to study this drawing.'

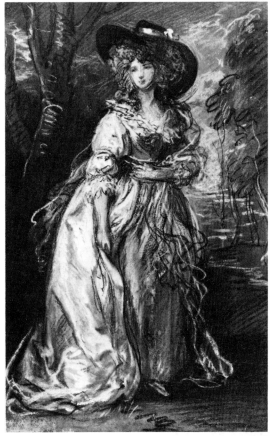

42

42 **Study of a Lady, Probably for 'The
Richmond Water-walk'**
Black chalk and stump and white chalk on buff
prepared paper, 49.2 × 31.1 ($19\frac{3}{8} × 12\frac{1}{4}$)
About 1785
Lit: Hayes *Drawings*, No.61
*Pierpont Morgan Library, New York*

This drawing is the same size as that in the British
Museum (Cat.no.41), and is almost certainly another
of Gainsborough's studies for his projected painting
of the Richmond Water-walk. The pose is identical
with that used for one of his romanticised pictures of
women in woodland settings, the portrait of Lady
Sheffield, now at Waddesdon, begun in the spring of
1785, but the likeness is of a different sitter.

43 **Study of a Woman Seated, with
Three Children**
Black chalk and stump on pale buff paper,
heightened with white, 35.6 × 24.1 ($14 × 9\frac{1}{2}$)
Mid to later 1780s
Lit: Hayes *Drawings*, No.845
*Pierpont Morgan Library, New York*

A study from life related in theme to Gainsborough's
'cottage door' subjects. The figures are very broadly
blocked out in stump (the side of the chalk moistened),
and rough outlines, more suggestive than descrip-
tive, have been sketched over the stumpwork in
chalk. The girl on the left is typical of a number of
Gainsborough's sketches of this period. The heads
and bonnets, notably of the girl on the right, suggest
a certain gentility.

[ 67 ]

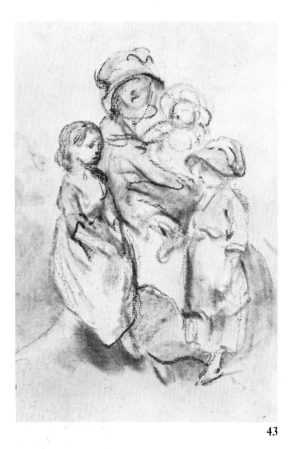

43

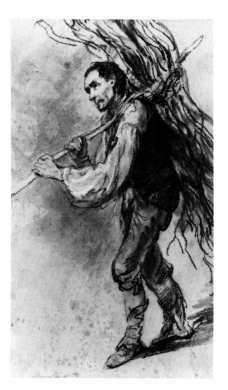

could be interpreted as 'slight martial attire'. At any event, the two drawings relate to the same composition. The likeness, in so far as it is rendered, is not inconsistent with the appearance of the Prince at the age of twenty-five. The picture itself is untraced, and may not have reached a very advanced stage.

**44 Study for an Unidentified Portrait, Probably George, Prince of Wales, Later George IV** (1762–1830)
Black chalk and stump and white chalk,
35.4 × 26.5 (13$\frac{15}{16}$ × 10$\frac{7}{16}$)
Later 1780s
Lit: Hayes *Drawings*, No.65
*Private collection*

A brilliant composition sketch, equally suggestive of the dignity of the sitter and the liveliness of his mount. The identification rests on the fact that the Prince of Wales was sitting for an equestrian portrait in 1785 or 6 and that, when it was announced in June 1787 that he was to sit again for its completion, the costume was to be 'either in armour; or else slight martial attire'. A second drawing exists showing a similarly posed horse and a similar background, and the sitter in armour; the costume in the present study

**45 Study of a Woodman Carrying Faggots**
Black chalk and stump on buff paper,
heightened with white, 51.4 × 30.6
(20$\frac{1}{4}$ × 12$\frac{1}{16}$)
About 1787
Lit: Hayes *Drawings*, No.850
*Private collection*

A study from life, one of several drawings of woodmen sketched from the same model that Gainsborough used for his celebrated painting, 'The Woodman', painted in the summer of 1787 (Fig.17). This picture, which he regarded as his greatest work, and was especially anxious to show Reynolds during his last illness, was destroyed by fire in 1810. The sitter was 'a poor smith worn out by labour . . . Mr. Gainsborough was struck by his careworn aspect and

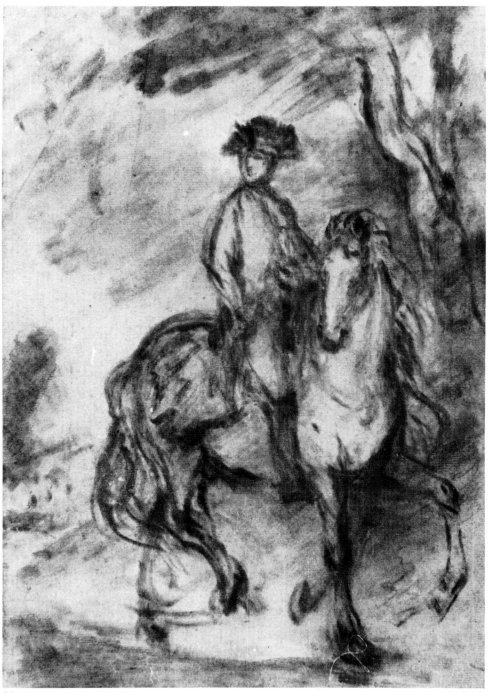

44

took him home; he enabled the needy wanderer by his generosity to live – and made him immortal by his art!' John Thomas Smith tells us that Mrs Gainsborough gave him, after her husband's death, a small model of the woodman's head made from the life by Gainsborough.

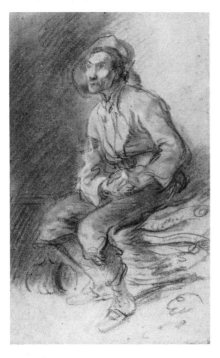

**46  Study of a Woodman Seated on a Bundle of Faggots**
Black chalk and stump on buff paper, heightened with white,
47.5 × 29.2 ($18\frac{11}{16} \times 11\frac{1}{2}$)
About 1787
Lit: Hayes *Drawings*, No.852
*Private collection*

Another study from the same model, a careworn smith, whom Gainsborough employed for his picture of 'The Woodman' (see Cat.no.45). This study was used for the pose of the figure on the right in his first design (Cat.no.49) for the 'Peasant Smoking at a Cottage Door' (Cat.no.152). The chalkwork is rapid but brilliant, giving the figure an extraordinary vitality.

**47  Herdsman and Cows near a Watering Place**
Watercolour and oil on reddish-brown prepared paper, varnished,
21.3 × 30.6 ($8\frac{3}{8} \times 12\frac{1}{16}$)
Mid to later 1780s
Lit: Hayes *Drawings*, No.731
*Private collection*

The white cow is the focal point in this pastoral landscape, the point towards which the eye is first directed and finally comes to rest; but the landscape itself is in a state of rhythmic movement. The tree stump on the right arches over and leads the eye across towards the wiry, windswept trees on the left, whence it is returned immediately by the trees behind in the direction of the rapidly moving clouds. The forms are all suggested more than modelled, and enlivened with brilliantly placed highlights; indeed, Gainsborough's extraordinary dexterity and sureness of touch are nowhere more apparent than in the background of this sketch, where distance is created almost effortlessly in carefully graded tones ranging from pale yellow-green to blue, beautifully set off by the dark browns of the leaves of the tree overhanging, while the mountain itself is suggested in similar hues, subtly modulated to create at the same time both form and depth.

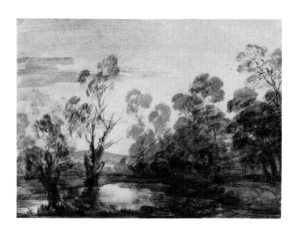

**48  Riders near a Pool**
Black chalk and watercolour,
22.5 × 31.6 ($8\frac{7}{8} \times 12\frac{7}{16}$)
Mid to later 1780s
Lit: Hayes *Drawings*, No.796
*Private collection*

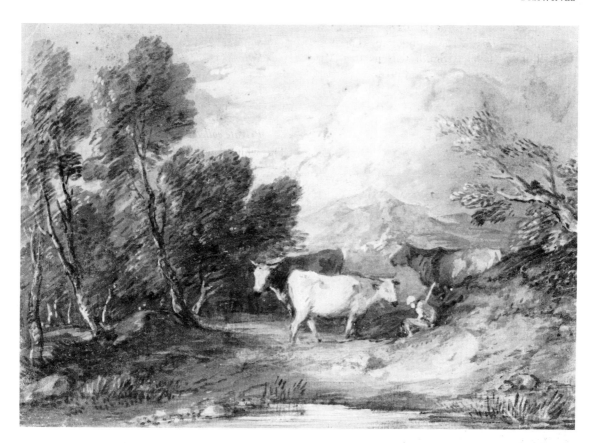

A brilliant, broad and sketchy drawing typical of Gainsborough's handling of wash in his later years, in which the group of horsemen are seen in shadow and the real subject is the romanticism of the sun setting over the horizon and the reflections in the pool.

**49 Wooded Landscape with Peasant Family**
   Black chalk and stump with some red chalk, and grey and brown washes, on buff paper, touched with bodycolour,
   $39.4 \times 31.7$ $(15\frac{1}{2} \times 12\frac{1}{2})$
   About 1788
   Lit: Hayes *Drawings*, No.803
   *Yale Center for British Art, New Haven*
   *(Paul Mellon Collection)*

A study for the 'Peasant Smoking at a Cottage Door' (Cat.no.152) and one of Gainsborough's most atmospheric late drawings. Most of the elements included

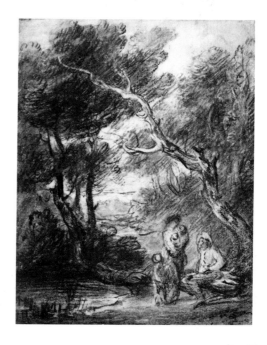

in the finished work are already present except for the cottage and the man smoking: at this stage Gainsborough had conceived the principal figure as a woodman seated on a bundle of faggots, using for the pose one of his studies (Cat.no.46) taken from the model he had employed for 'The Woodman'.

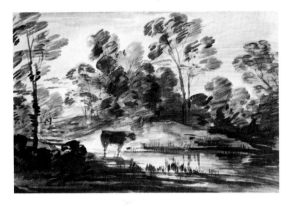

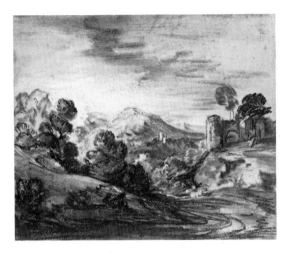

**50    Mountainous Landscape with part of a Ruined Castle**
Black chalk and stump and white chalk on grey paper, $26.2 \times 32.7$ $(10\frac{5}{16} \times 12\frac{7}{8})$
Later 1780s
Lit: Hayes *Drawings*, No.806
*Yale Center for British Art, New Haven*
*(Paul Mellon Collection)*

A brilliant and rapidly executed sketch, in which the eye is led by means of the winding road to the unusually resplendent sunset, and thence back to the castle gateway on the bank. Much of Gainsborough's late imagery corresponds closely with what the late eighteenth century understood as 'Picturesque', and ruined castles are among features that play a significant role in William Gilpin's *Tours*, the first of which was published in 1783.

**51    Wooded Landscape with Cow at a Watering Place**
Black and brown chalks, with grey and grey-black washes, heightened with white, $24.1 \times 37.3$ $(9\frac{1}{2} \times 14\frac{11}{16})$
Later 1780s
Lit: Hayes *Drawings*, No.809
*Staatliche Museen, Preussischer Kulturbesitz, Kupferstichkabinett, Berlin*

One of Gainsborough's most brilliant late drawings, in which the forms are scarcely more than blocked out, and the trees seem to be in perpetual motion. The cow, by contrast, stands immobile at the pool, silhouetted against the light. This drawing was once part of the distinguished collection of Old Master drawings formed by the 4th Earl of Warwick.

**Portrait of a Dutch Sea Captain**
Cat.no.4 (p.50)

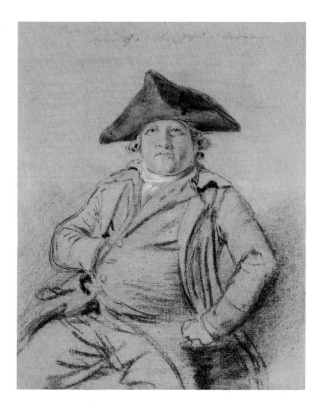

**Herdsman and Cows with**
**Distant Village seen between Trees**
Cat.no.16 (p.54)

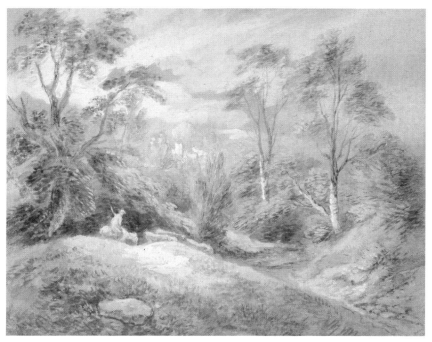

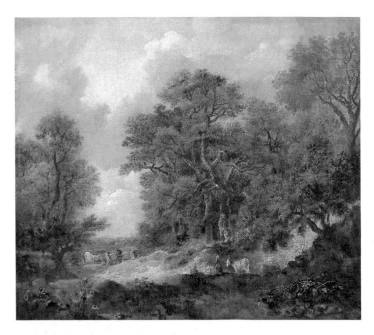

**Wooded Landscape
with Figures and Donkeys**
Cat.no.75 (p.88)

**Heneage Lloyd and his Sister**
Cat.no.58 (p.80)

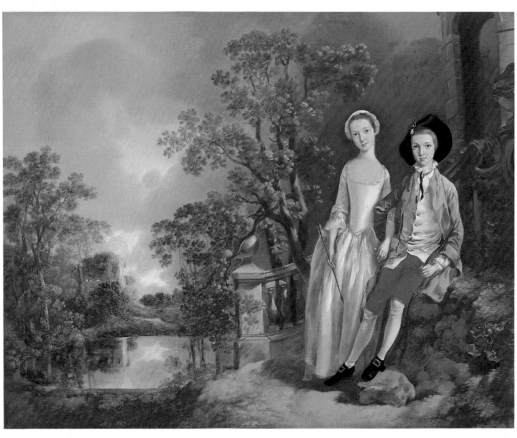

# Prints

Always intrigued by techniques, Gainsborough was a highly accomplished and original print-maker. His early etchings were only marred by his impetuosity: in one case we are told that 'he spoilt the plate by impatiently attempting to apply the aqua fortis before his friend, Mr. Grignion, could assist him, as was agreed'. In the 1770s he became fascinated, first by the possibilities of aquatint, then by those of soft-ground etching – processes new at the time – as a means of reproducing his drawings. In many of his prints, of which we know of seventeen, he combined the two processes. Oddly, there is no evidence that Gainsborough ever published editions of any of these works, though final proofs dated 1780 exist of three subjects.

52  **Landscape with Herdsman driving Cattle**
Aquatint, with some grey wash,
28.1 × 34.9 ($11\frac{1}{16} × 13\frac{3}{4}$)
Mid to later 1780s
Lit: John Hayes, *Gainsborough as Printmaker*, London, 1971, No.19
*Staatliche Museen, Preussischer Kulturbesitz, Kupferstichkabinett, Berlin*

This fine impression is the first state of this subject, before the addition of soft-ground, in which corrections have been made in grey wash in parts of the tree on the right, in each of the cows and on the ground beneath them.

53  **Herdsman and Cows in a Woodland Glade**
Aquatint, 28.1 × 34.9 ($11\frac{1}{16} × 13\frac{3}{4}$)
Mid to later 1780s
Lit: John Hayes, *Gainsborough as Printmaker*, London, 1971, No.20
*Trustees of the British Museum*

A highly rhythmical composition comparable with some of Gainsborough's very late drawings. This impression was one of those printed after Gains-borough's death by the publisher with whom he had co-operated in his youth, John Boydell, who issued editions of twelve of Gainsborough's prints in 1797.

[75]

# The early years in London and Suffolk: 1745–59

Gainsborough's earliest works, when he first established his own studio in London in about 1745, were portraits-in-little with landscape settings – a popular genre originated by Hogarth and developed by Authur Devis, in which he was influenced by his teacher, Francis Hayman (Fig.23) – and small landscapes in which, according to the obituarist of *The Morning Chronicle*, 'the first master he studied was Wynants, whose thistles and dock leaves he frequently introduced into his early pictures.

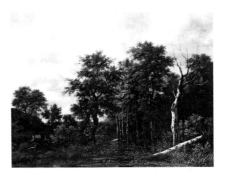

Fig.24  Jacob Ruisdael, *A Pool Surrounded by Trees*. National Gallery

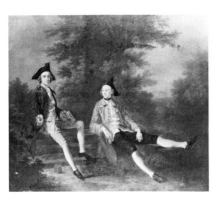

Fig.23  Francis Hayman (1708–76), *David Garrick and William Windham*. Captain G. Lowther. (Photo. Sotheby's)

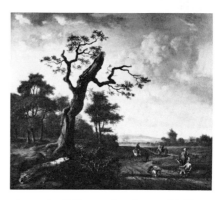

Fig.25  Jan Wijnants, *Landscape with Figures*. Greater London Council, Trustees of the Iveagh Bequest, Kenwood

The next was Ruysdale, but his colouring is less sombre . . .' (Figs.25 and 24). This assessment is remarkably accurate. Gainsborough combined a Watteauesque freshness of handling with Dutch pictorial construction and *staffage*, a wholly individual feeling for the light and atmosphere of the English countryside, and sensitive attention to detail. 'Gainsborough's Forest' (National Gallery) is the best-known of several important large-scale landscapes he painted in this idiom between 1746 and 1748. In his portraits on the scale of life his concern was always for likeness rather than idealisation; he was deeply influenced by the directness, infor-

mality and naturalism of Hogarth, whose sitters, members of the independent middle class, had little sympathy with the outworn baroque conventions handed down from the age of Kneller.

Gainsborough returned to Suffolk when he was twenty-one, settling in his native Sudbury in 1748, and moving to Ipswich in 1752, where he remained until 1759. His celebrated portrait-in-little of Mr and Mrs Andrews (National Gallery: Fig.4), in which the sitters' estate is given equal prominence in the composition, and the detail is superbly rendered, was painted soon after his return. In later groups the

background is either more generalised, or else artificial, deliberately rococo in character. His landscapes followed the same pattern, becoming increasingly mannered and schematic. In the mid 1750s he developed a personal rococo style far removed from his early Dutch naturalism, an equivalent to the pastoral idylls of Boucher or his equally fashionable Italian contemporary, Zuccarelli. Flowing or serpentine rhythms, lusciousness of handling, warm colour, glowing atmospheric distances and subject matter often

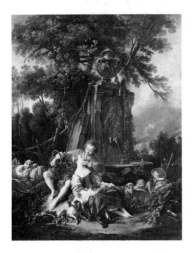

Fig.26 François Boucher, *Landscape with Shepherd and Shepherdess.* Wallace Collection

dominated by the theme of rustic love-making – a Suffolk counterpart to the shepherds and shepherdesses of Boucher (Fig.26) – combined to produce a new harmony of mood and feeling. His portraits, satisfying the demands of a provincial clientèle, were chiefly head-and-shoulders or half-lengths, in which the smooth, bland modelling characteristic of Van Loo and Ramsay and a certain stiffness of posture gradually gave way, in the later 1750s, to a greater spontaneity and a more broken touch influenced by the hatching technique of the French pastellists, La Tour and Perroneau. 'You please me much', he wrote to a client in 1758, 'by saying that no other fault is found in your picture than the roughness of the surface . . . being of use in giving force to the effect at a proper distance, and what a judge of painting knows an original from a copy by; in short being the touch of the pencil, which is harder to preserve than smoothness.' Gainsborough's last portraits of the Ipswich period evince a broader modelling in light and shade comparable to that of Reynolds. In these years also he was given commissions for a number of portraits on a larger scale, in which spiralling movement and sinuous rococo line play as important a rôle in the design as they do in his landscapes.

---

**54 'Bumper': a Bull Terrier**
Canvas, 34.9 × 29.8 (13¾ × 11¾)
Dated 1745
Lit: Waterhouse, No.817
*Private collection*

This is Gainsborough's earliest dated picture, inscribed on the back of the relining canvas: *Thos Gainsborough/Pinxit Anno/1745.* He was then eighteen. Gainsborough loved animals, and there are instances of portraits including dogs in which the dog is far more convincingly and sympathetically portrayed than the sitter. 'Bumper' is described on the inscription on the back of the canvas as: *A most Remarkable Sagacious/Cur*, and the terrier's alert

intelligence is clearly conveyed through the posture in this vivid characterisation. The realistic woodland setting is a novelty in contemporary animal portraiture but, though the handling of paint is admirably fresh, signs of Gainsborough's inexperience are evident: transitions between the foreground hillock and the background have been avoided as too difficult, and the somewhat stiffly painted tree on the right is an awkward device for stabilising the composition comparable to that in 'Crossing the Ford' (Cat.no.72). Gainsborough's portrait of Bumper's owner, the Revd Henry Hill, rector of Buxhall, is lost, but that of Mrs Hill now hangs at Montacute House, Somerset.

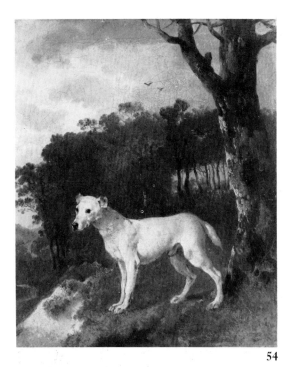

54

## 55 Probably a Self Portrait, with his Wife Margaret (1728–98)
Canvas, 76.2 × 67.3 (30 × 26½)
About 1746–7
Lit: Waterhouse, No.752
*Musée du Louvre, Paris*

This elegant double portrait has been known as Gainsborough and his wife at least since 1832, when it was catalogued as such at a Christie's sale. Comparison with other portraits suggests that this identification is correct. If the drawing (Cat.no.1) obviously represents courtship, this picture seems to represent marriage. Gainsborough married in July 1746. The man, who has laid aside a book in a pale grey cover, perhaps a sentimental novel, is motioning to the woman with a gesture of the hand, and she, dressed in an exquisitely painted pink dress, is looking proudly out at the spectator; part of a temple building, possibly intended to symbolize the Temple of Hymen, is seen in the background. Crisp in handling and pale in tonality, the foliage feathery and romanticised, the painting has an unusually French quality.

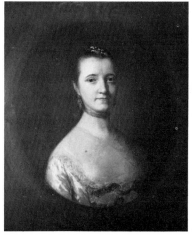

## 56 Thomas Vere
Canvas, 76.2 × 63.5 (30 × 25)
Late 1740s
Lit: Waterhouse, No.690
*Private collection (on loan to Gainsborough's House, Sudbury)*

This, and the companion portrait of Mrs Vere (Cat.no.57), originally hung at Broke Hall, Nacton, near Ipswich. The identification was made by Sir Ellis Waterhouse. The stiff posture is typical of Gainsborough's very earliest portraits, and the concept, with the sitter depicted in a decorative oval surround, is traditional in English portraiture from the time of Cornelius Johnson, in the early seventeenth century.

57

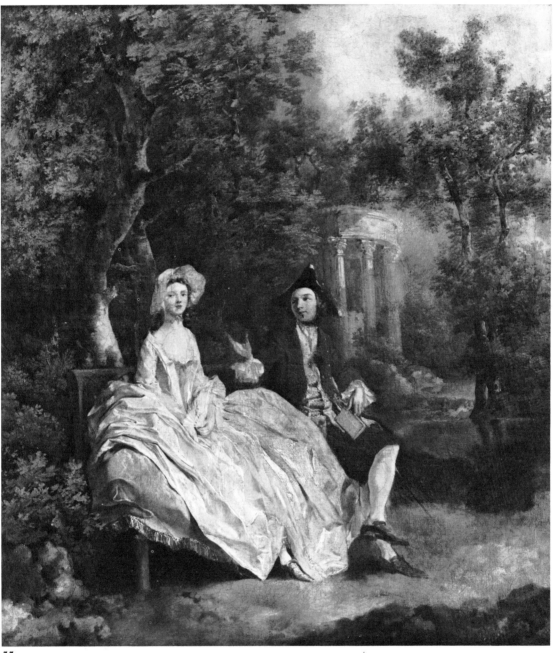

55

57  **Mrs Thomas Vere**
Canvas, 76.2 × 63.5 (30 × 25)
Late 1740s
Lit: Waterhouse, No.691
*Private collection (on loan to Gainsborough's
House, Sudbury)*

Companion to the portrait of her husband (Cat. no.56).

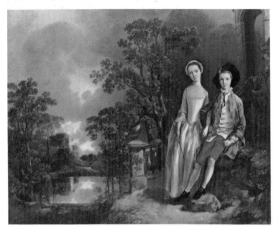

58  **Heneage Lloyd (1742/3–76) and his
Sister(?)**
Canvas, 64.1 × 81 (25¼ × 31⅞)
Signed with initials
Early to mid 1750s
Lit: Waterhouse, No.452; J. W. Goodison,
*Catalogue of Paintings*, Vol.III, *British School*,
Fitzwilliam Museum, Cambridge, 1977, pp.80–1.
*Fitzwilliam Museum, Cambridge*
[colour repr. p.80]

The backgrounds in Gainsborough's early conversation pieces are usually countrified, but in this case the setting is as artificial and sophisticated as a Boucher. The two children, appealing and ravishingly painted, are posed in front of a flight of steps, with a stone balustrade, leading to a garden pavilion which provides an excuse for some attractive rococo scrollwork. The church tower is simply an accent in the composition. The fluency of handling and the naturalism and sheer beauty of the lighting prevent the landscape from deteriorating into the category of a photographer's backdrop. Heneage Lloyd was the second son of Sir Richard Lloyd, of Hintlesham Hall, and later became a captain in the Coldstream Guards; but the identification of the sitters is open to doubt.

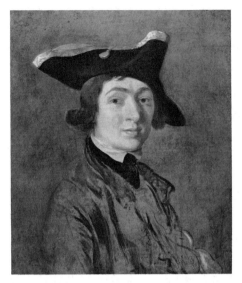

59  **Self Portrait**
Canvas, 58.4 × 49.5 (23 × 19½)
Dated on the back 1754
Lit: Waterhouse, No.290
*The Marquess of Cholmondeley*

A sketch, deliberately left unfinished, which shows Gainsborough, at the age of twenty-six or -seven, exactly as Zoffany painted him nearly twenty years later, sensitive and alert (Fig.1). The head is painted in the soft, creamy highlights and reddish shadows characteristic of the early 1750s; the tricorne hat has been fully modelled but, with the exception of the cravat, the costume has only been outlined in the sketchiest of brushwork over the brown priming.

60  **Samuel Kilderbee (1725–1813)**
Canvas, 128.3 × 102.9 (50½ × 40½)
About 1755
Lit: Waterhouse No.407
*Fine Arts Museums of San Francisco
(M. H. de Young Endowment Fund)*

Samuel Kilderbee, an Ipswich attorney who was for some years Town Clerk, was one of Gainsborough's lifelong friends. They travelled to the Lakes together in 1783, he was the recipient of letters, no longer extant, regarded in the early nineteenth century as 'too licentious to be published', and was asked by Gainsborough to oversee the execution of his will. In

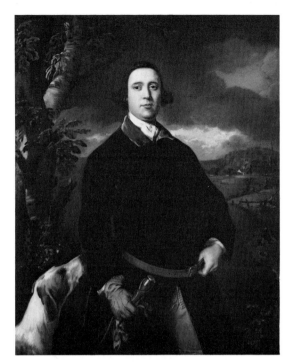

in the uniform of the 1st Dragoon Guards (a similar portrait by Gainsborough of one of his brother officers is dated 1756). The head is firmly and solidly modelled in the technique characteristic of Gainsborough's portraits of the mid 1750s.

this vigorous portrait the head, silhouetted against the stormy clouds, is crisply delineated and smoothly modelled, rather in the manner of Van Loo, a French painter fashionable in London around 1740. But in this earliest of Gainsborough's more ambitious portraits on the scale of life there are not unnatural weaknesses of design. The figure itself, positioned in the front plane of the canvas, is unrelated to the background (far sketchier than in the portraits-in-little of this period) except in the sense that the detail seems to 'climb up' the canvas beside the sitter towards the stormy clouds which frame the head, and the intertwined trees on the left are as awkward and artificial a supporting device as the similar feature in 'Bumper' (Cat.no.54), painted ten years earlier.

**61 Colonel The Hon. Charles Hamilton**
(1727–1806)
Canvas, 76.2 × 63.5 (30 × 25)
Mid 1750s
Lit: Waterhouse, No.340
*The Earl of Haddington*

The sitter, who was the brother of Charles, 7th Earl of Haddington, is depicted in a feigned oval surround

**62 Gainsborough's Daughters, Margaret**
(1752–1820) **and Mary** (1748–1826),
**Chasing a Butterfly**
Canvas, 113.7 × 104.8 (44¾ × 41¼)
About 1756
Lit: Martin Davies, *The British School*,
National Gallery Catalogue, 2nd edn., 1959,
pp.38–9; Waterhouse, No.285
*Trustees of the National Gallery*

Gainsborough always held that likeness was 'the principal beauty and intention of a Portrait', but here he has gone beyond likeness to capture, with an effectiveness anticipating the snapshot, the eager and intent expressions on the faces of his two young daughters, Margaret, then aged about four, and Mary, who was about eight, as, hand in hand, they chase after a butterfly. This charming little incident has dictated the informality, indeed novelty, of the composition, but even in so natural a portrait Gainsborough could not wholly forget style and he deliberately folded back Margaret's apron in order to indulge in some bravura painting. The plants on the left, unfinished, like most of the picture, would no doubt have been painted from a detailed pencil study similar to the drawing in the Torbock collection

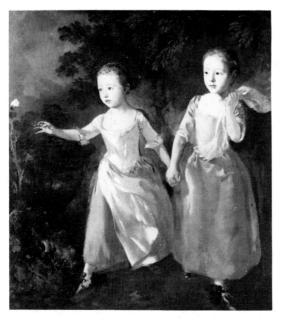

(Cat.no.9). It may be noted, in passing, that Margaret took after her mother. Gainsborough gave (or sold) this enchanting canvas to his friends and patrons, the Hingestons, of near Southwold.

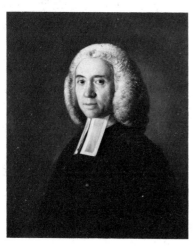

### 63  The Revd Richard Canning

Canvas, 76.2 × 63.5 (30 × 25)
About 1757
Lit: Waterhouse, No.118a
*Ipswich Borough Museums*

This portrait of the rector of Harkstead, formerly curate of St Lawrence's, Ipswich (who was also the editor of Gainsborough's friend John Kirby's *The Suffolk Traveller*), was presented by the sitter to his friend, the Revd Henry Hubbard, who reciprocated the gift (Richard Canning's son bequeathed the portrait of Hubbard to Emmanuel College, Cambridge). It marks a new phase in Gainsborough's portraiture, the abandoning of that bland, smooth style of face painting characteristic of such fashionable portraitists as Thomas Hudson. The elaborate system of hatching, derived from the practice of the French pastellists, La Tour and Perroneau, gives a new fullness to the flesh as well as that vitality of surface, 'being of use in giving force to the effect at a proper distance . . . the touch of the pencil, which is harder to preserve than smoothness', that Gainsborough was striving for at this period. The wig is executed with a neat, crisp touch.

### 64  The Hon. Richard Savage Nassau

(1723–80)
Canvas, 124.5 × 98.4 (49 × 38¾)
About 1757
*National Trust for Scotland, Brodick Castle (on loan from H.M. Treasury)*

Gainsborough's portrait closely follows the design of his drawing (see Cat.no.12), though slight variations in contour are to be detected in places. Richard Nassau, of Easton Park, was an aristocratic sitter, who had married the widow of the Duke of Hamilton, but the pose is nonetheless informal to a degree never quite found even in Hogarth's portraiture on the scale of life. The dramatic and sketchy handling in the landscape hanging on the wall behind the sitter anticipates Gainsborough's landscape style of the early 1760s (see Cat.no.108).

### 65  Joshua Kirby (1716–74)

Canvas, 41.9 × 29.2 (16½ × 11½)
About 1757–8
Lit: Waterhouse, No.418
*Victoria and Albert Museum*

Joshua Kirby, son of the author of *The Suffolk Traveller*, a house and coach painter who edited Brook Taylor's treatise on perspective, was, though quite the opposite in character – pious and earnest –

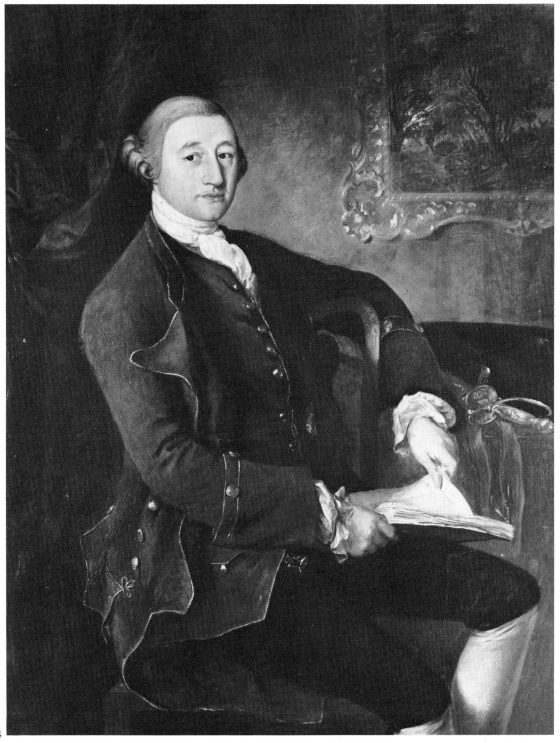

64

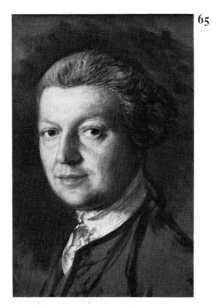

65

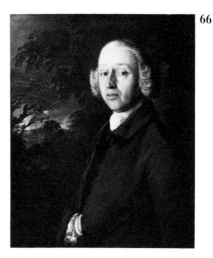

66

Park, between Thetford and Bury St Edmunds. Lambe Barry, of Syleham, was High Sheriff of Suffolk in 1748.

one of Gainsborough's closest friends, and is sup-. posed to have been responsible for bringing him before the notice of George III, with whom he was intimate. Gainsborough particularly requested that he should be buried near his friend's grave in Kew churchyard. The head of Gainsborough's purposeful friend is given added strength through the force of lighting, and the coat is left unfinished as in his own self-portrait (Cat.no.59). The picture was probably a gift, and remained in the family until the mid-nineteenth century.

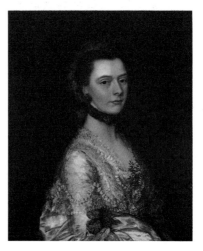

**66   Lambe Barry** (1704–68)
      Canvas, 76.2 × 63.5 (30 × 25)
      About 1757–8
      Lit: Waterhouse, No.41.
      *Private collection (on loan to
      Gainsborough's House, Sudbury)*

A lively characterisation, in which the touch in the modelling of the head is rougher and more painterly than in the regular, pastel-like strokes of the brush in the 'Richard Canning' (Cat.no.63) and the 'Richard Savage Nassau' (Cat.no.64). The tonality has an overall silvery quality. The hand tucked inside the coat was fashionable etiquette, much like the more recent custom of leaving the bottom button of one's waistcoat unfastened. The portrait has descended in the family through the Lee-Actons of Livermere

**67   Rebecca St Quintin** (1726–58)
      Canvas, 76.2 × 63.5 (30 × 25)
      About 1758
      Lit: Waterhouse No.597
      *Private collection*

Rebecca was the eldest daughter of Sir William Quintin, a patron and admirer of Gainsborough who subsequently bought one of his most important early Bath period landscapes (Cat.no.112). She died of smallpox at the early age of thirty-one. On her epitaph was inscribed: 'In her common Conversation she had a Flow of good Sense and Cheerfullness not to be exhausted but being sweetened by Piety and

Humility rais'd by Contemplation and emboldened by Virtue She always delighted, never offended'. Gainsborough seems to have painted her shortly before her premature death. She is depicted in a white dress with blue bows, her head roughly modelled in the technique characteristic of Gainsborough's late Ipswich portraits.

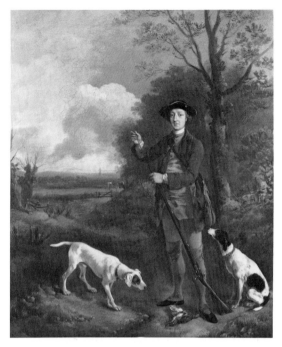

**69 Sportsman with Two Dogs**
Canvas, 76.2 × 64.8 (30 × 25½)
Late 1750s
Lit: Waterhouse, No.759
*The Earl of Inchcape*

A delightfully informal portrait of a sportsman out with his dogs, depicted in the process of cleaning the barrel of his gun, a pheasant at his feet. His mount is seen in the charge of a friend in the field beyond. The distance is fresh and atmospheric in handling. The tree on the right provides a compositional support for the figure.

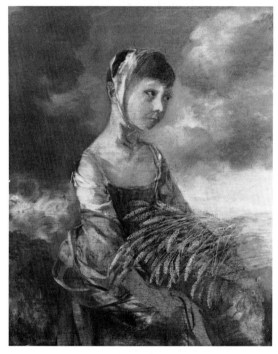

**68 Margaret Gainsborough (1752-1820) as a Gleaner**
Canvas, 73.7 × 63.5 (29 × 25)
Late 1750s
Lit: Waterhouse, No.283
*Visitors of the Ashmolean Museum, Oxford*

The painting of which this is the surviving fragment (examination makes it clear that it has been cut on the right) was seen in 1824 and described as representing 'portraits of his [Gainsborough's] two daughters, in the garb of peasant girls, on the confines of a corn-field, dividing their gleanings. They appear to be of the age of about eight or nine, and are the size of life.' The wistful expression anticipates the mood of Gainsborough's sentimental paintings of peasant children of the 1780s.

**70 Mrs John Kirby, née Alice Brown (married 1714)**
Canvas, 76.2 × 63.5 (30 × 25)
About 1759
Lit: Waterhouse, No.417; J. W. Goodison, *Catalogue of Paintings*, Vol.III, *British School*, Fitzwilliam Museum, Cambridge, 1977, pp.78-9.
*Fitzwilliam Museum, Cambridge*

In this extraordinarily direct portrait of the mother of his life-long friend, Joshua Kirby, the old lady is sitting bolt upright in a feigned oval surround, with her white cap silhouetted against a plain, brown

background. Her toothless mouth is suggested by the dexterous placing of the shadows, and her kindly, amused expression is caught to perfection. The highlights are rough and vigorous in handling, and this maturity in the modelling of the features argues against the much earlier dating usually, and with other good reasons (see Goodison, cited above), proposed. It should be noted that the portrait is in no sense a companion to that of her husband, probably painted about 1752–3.

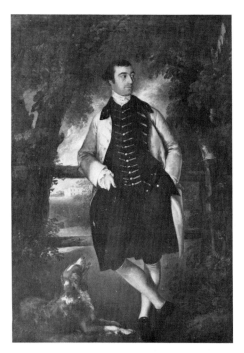

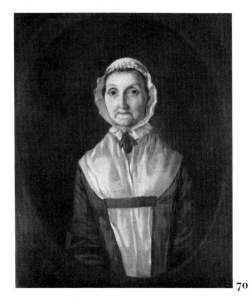

70

not uncommon in Gainsborough's work, produces an effect of slight imbalance. Wollaston, an amateur flautist who may have been a friend of Gainsborough's and obviously admired his work, as he had already been painted by him shortly before, was later M.P. for Ipswich in the Parliaments of 1768, 1774 and 1780; his country home, Finborough Hall, near Stowmarket, which he greatly improved, can be seen through the bars of the gate.

71   William Wollaston (1730–97)
     Canvas, 215.9 × 147.3 (85 × 58)
     About 1759
     Lit: Waterhouse, No.734
     *Trustees of the late H. C. Wollaston*

This is Gainsborough's earliest surviving full-length, and it is typical of his approach that the setting should be an outdoor one. The cross-legged pose was one favoured by popular artists of the day such as Arthur Devis, but the sharp turn of the head and the dramatic, richly painted sky against which the figure is set are entirely Gainsboroughesque. The sitter is neatly framed by the trees, which correctly leave part of his right arm in shadow, and the dog, more naturally posed than in the 'Samuel Kilderbee' (Cat. no.60), forms an integral part of the design; but one is uncomfortably aware that the arm is not really resting upon the gate, and this weakness, of a kind

72   **Crossing the Ford**
     Canvas, 32.4 × 35.9 (12¼ × 14⅛)
     About 1744–5
     Lit: Waterhouse, No.877; *Upton House: The Bearsted Collection: Pictures*, The National Trust, 1964, No.24; Hayes *Landscape Paintings*, No.2
     *National Trust (Bearsted Collection, Upton House)*

This tiny canvas is Gainsborough's earliest surviving landscape painting. The composition is unbalanced, the framing tree, with its branches spreading across the picture plane, an obvious pictorial device, and the bank on the left awkwardly modelled; but the fields on the right are broadly brushed and the moisture of

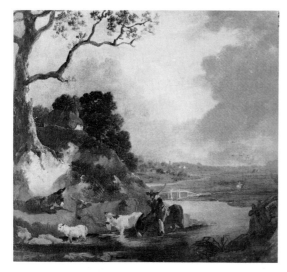

the atmosphere sensitively rendered. The relationship of sky to landscape is Dutch in character, but the cottage shown in the process of being thatched is typical of the 'naturalistic' vignettes included in much contemporary English landscape painting. 'Crossing the Ford' is one of a number of Gainsborough's small, early landscapes which came into the possession of his Ipswich friend, Joshua Kirby (Cat.no.65), and which may have been a gift from the artist.

**73 The Path Through the Woods**
Canvas, 34.3 × 26 ($13\frac{1}{2}$ × $10\frac{1}{4}$)
Unfinished
About 1745–6
Lit: Waterhouse, No.876; Hayes *Landscape Paintings*, No.4
*Sir Alfred Beit, Bt.*

One of Gainsborough's very early landscapes, small in size, like 'Crossing the Ford', and without figures or incident. Both the tree trunks and the sandy bank are more convincingly modelled than in 'Bumper', and the composition is a little less flat, with some suggestion of the depth and recesses of the wood. The winding path is swept in with one broad and vigorous stroke of the brush, and the handling is fresh and fluent, so close indeed to such masterpieces by Watteau as 'Le Mezzetin' (Metropolitan Museum of Art, New York), that one is left in no doubt that Gainsborough had been studying, with profit and enthusiasm, such contemporary French pictures as were finding their way onto the London market. The foliage on the left is only laid in in dead colour. This is another of Gainsborough's small, early landscapes which came into the possession of Joshua Kirby.

73

**74 Wooded Landscape with Shepherd Resting**
Canvas, 26.7 × 21 ($10\frac{1}{2}$ × $8\frac{1}{4}$)
About 1745–6

Lit: Waterhouse, No.882; Hayes *Landscape Paintings*, No.6
*Private collection*

The most strongly and dramatically lit of Gainsborough's very early landscapes; the light, which falls from the left, is, however, wholly naturalistic. The composition is the most balanced of this youthful group. This little landscape was also owned by Joshua Kirby.

**76 Landscape with Country Waggon**
Canvas, 48.3 × 60.3 (19 × 23¼)
About 1746–7
Lit: Waterhouse, No.867; Hayes *Landscape Paintings*, No.12
*Private collection*

One of Gainsborough's most rhythmic early landscapes. Waggon, track and banks are all absorbed into the flowing movement. Both the dark grey, threatening clouds dominating the scene, and establishing the mood, and the concept of the undulating track taking the eye into the distance, skilfully solving the pictorial problem of relating the different planes in the composition, are influenced by the example of Dutch seventeenth-century landscape. This, and a companion picture, were once in the possession of the Revd Thomas Rackett, the Dorset antiquary. A mezzotint was executed by William Giller.

**75 Wooded Landscape with Figures and Donkeys**
Canvas, 31.4 × 36.8 (12⅜ × 14½)
About 1746–7
Lit: Waterhouse, No.879; Hayes *Landscape Paintings*, No.9
*Cincinnati Art Museum (Gift of Emilie L. Heine in memory of Mr and Mrs John Hauck)*

The design of this more developed work, in which, for example, the treatment of the foliage is more varied than in previous pictures, is based on alternating dark and light planes, a scheme adopted from such Dutch seventeenth-century landscapists as Jacob van Ruisdael. The crisp, broken highlights in the centre of the picture seem to derive from the technique characteristic of early Van Goyen. These, and the sharp, nervous highlights used to outline many of the forms, give a lively rococo sparkle to the canvas. The pale tonality is characteristic of Gainsborough's early landscapes. This work was also in the possession of Joshua Kirby.

**77 Landscape with Sand Pit**
Canvas, 47 × 61 (18½ × 24)
About 1746–7
Lit: Waterhouse, No.870; Hayes *Landscape Paintings*, No.13
*National Gallery of Ireland*

One of Gainsborough's most exquisite and harmonious early landscapes, neatly, almost painstakingly, constructed on Dutch principles of design, yet entirely rococo in feeling. The prominence given to the sky, the way in which the clouds follow the silhouette of the landscape, and the organisation of the whole scene in clearly distinct planes, with a

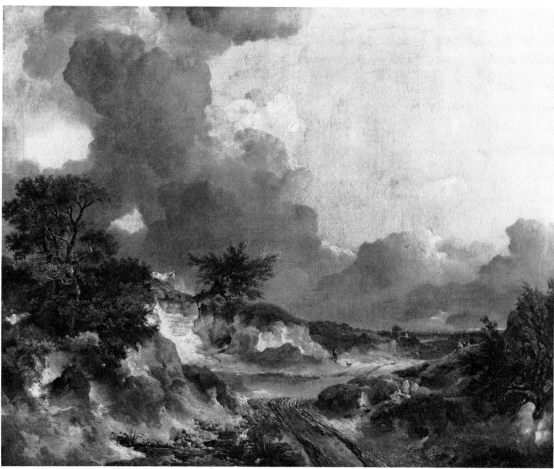

77

rutted path uniting these planes visually and little figures to plot the distance – all these are ideas which Gainsborough absorbed from the Dutch; while the crispness of touch and the complicated pattern of light and shade may be compared with his drawings of this period. On the other hand, the winding of the country track as it disappears into the distance, the slow curve of the horizon, the way in which the clouds cascade across the painting as they might in Fragonard, and the fitful quality of the light indicate plainly enough that, even at this early stage, Gains-borough was no imitator of Ruisdael or Van Goyen and that he was already capable of fusing Dutch and French elements into a style that was recognisably personal, and most obviously characterised at this time by a delicate, pale tonality.

78

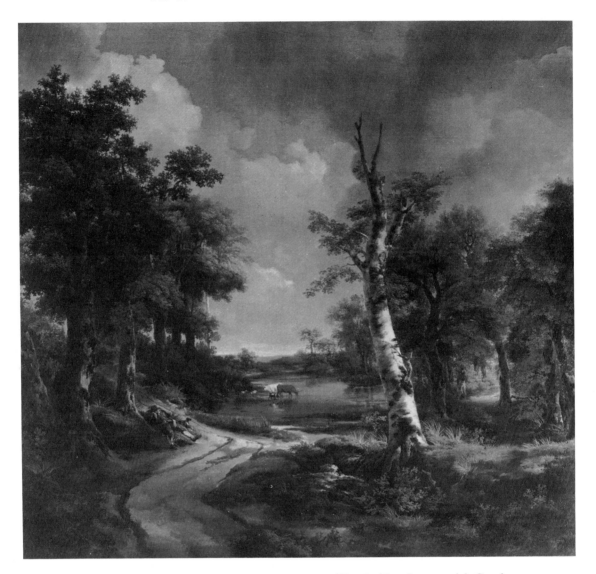

78   Landscape with Mother Carrying a Baby
     and Reclining Peasant
     Canvas, 35.6 × 30.6 (14 × 12 1/16)
     About 1746–7
     Lit: Hayes *Landscape Paintings*, No.14
     *Private collection*

The composition of this freshly painted scene,
though still constructed in carefully demarcated
planes, is dominated by an undulating rococo rhythm.
The mother and baby are somewhat out of scale with
the burdock leaves and the peasant resting in the
shade of the tree, a motif to become characteristic
(Cat.no.81).

79   Wooded landscape with Cattle at a
     Watering Place
     Canvas, 145 × 155 (57 1/2 × 61)
     About 1747
     Lit: Waterhouse, No.826; Hayes *Landscape
     Paintings*, No.20
     *Museu de Arte de São Paulo Assis
     Chateaubriand*

This is the largest landscape Gainsborough is known
to have painted until after his move to Bath in 1759.
The composition, dominated by the prominent
silver birch, is based, broadly speaking, as Dr Mary
Woodall was the first to point out, on a reversal of

*Opposite page*
**Heneage Lloyd and his Sister**  detail
Cat.no.58 (p.80)

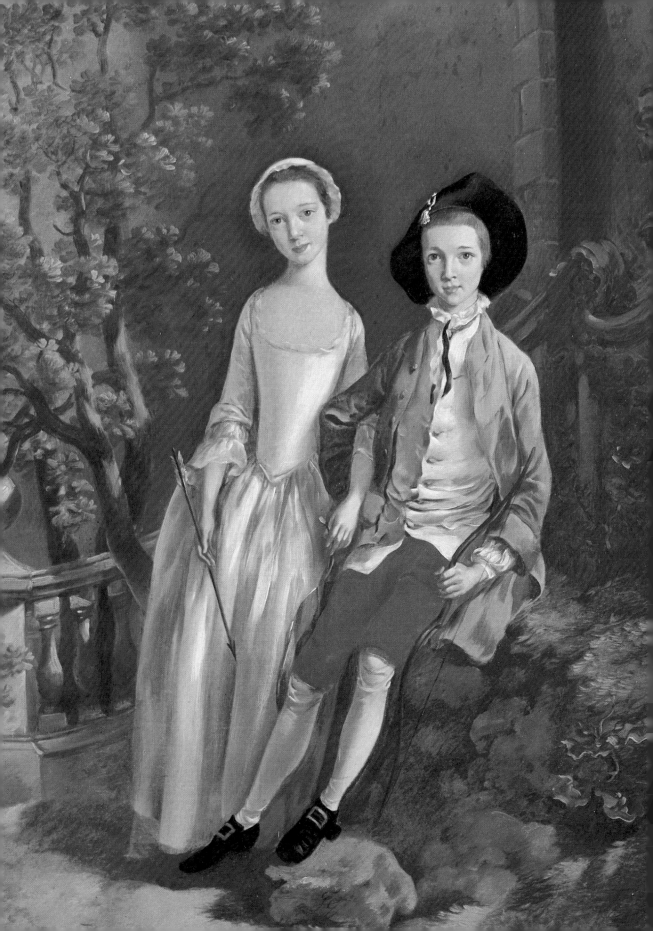

Ruisdael's well-known 'La Forêt' (Louvre, on deposit at Douai), of which Gainsborough had made a large chalk drawing, now in the Whitworth Art Gallery: the principal differences are in the staffage and the introduction of the winding track. The handling is much freer and more mature than in any previous work and, although there are three diverging foci of attention, including the sunlit glade on the right, the herdsman and cattle in the centre are carefully grouped, contrasting with the visually unrelated staffage characteristic of such earlier pictures as the 'Landscape with Sand Pit' in Dublin (Cat.no.77). The backdrop clouds with their fretted outlines echo the silhouette of the trees. The picture originally hung at Drinkstone Park, Suffolk, and may have been commissioned by the builder of the house, Joshua Grigby, whose portrait Gainsborough was later to paint.

## 80   Landscape with Peasant Resting Beside a Winding Track

Canvas, 101.9 × 147.3 (40⅛ × 58)
Signed and dated 1747

Lit: Waterhouse, No.831; Hayes *Landscape Paintings*, No.22
*Philadelphia Museum of Art*
(*W. P. Wilstach Collection*)

The mood of afternoon pastoral contentment which pervades this work is established by the figure resting by the wayside, placed prominently in the foreground. The composition includes motifs, such as the prominent birch tree and the view into a sunlit glade, derived from Ruisdael's 'La Forêt', and, in these and other respects – such as the track leading the spectator into the picture – it represents a development of the ideas used in the São Paulo landscape, though looser and less schematic. The lack of any transition between the foreground and the middleground is masked by the cow and sheep, a device employed by Berchem. The deep tone is close in quality to Ruisdael and the modelling of the reclining peasant in rich, buttery paint is also influenced by Berchem. The picture was etched in the second half of the nineteenth century, when it was in the Perkins collection, by Charles Courtry, Paris.

*Opposite page*
**View of St Mary's Church, Hadleigh** detail
Cat.no.82 (p.94)

### 81 Wooded Landscape with Shepherd and Sheep and Distant Village

Canvas, 43.2 × 54.3 (17 × 21⅜)
About 1748–50
Lit: Hayes *Landscape Paintings*, No.25
*Yale Center for British Art, New Haven*
(*Paul Mellon Collection*)

An exceptionally brilliant and effective early composition, dominated by a diamond-shaped patch of bright sunlight in the foreground, which acts as a fulcrum for the whole scene. This way of treating light, and the broad massing of the shadows, Gainsborough must have learnt from Ruisdael, but to point this out does nothing to lessen the imaginative quality of Gainsborough's transcription. The scene on the right is also Dutch in character and might be a vignette from Jan Both: a shepherd is reclining against a tree which, as in 'Bumper', frames the composition, with a sandy bank behind, and nearby are groups of burdocks, plants of which we know that Gainsborough made careful studies. In freshness and fluency of handling, however, the comparison is still with Watteau. The recession of the middle-ground is a trifle awkward, if we compare the scale of the three sheep in the centre with that of the animals on the far side of the field, but the panorama beyond, where sunlight is passing fitfully over the distant landscape, is beautifully observed and anticipates similar passages in Constable. The picture was probably originally acquired by James West, of Alscot Park, the politician, antiquary and bibliophile, in whose family it descended.

### 82 View of St Mary's Church, Hadleigh

Canvas, 91.4 × 190.5 (36 × 75)
Painted about 1748–50
Lit: Hayes *Landscape Paintings*, No.28
*Private collection* (*on loan to Gainsborough's House, Sudbury*) [colour repr. p.92]

This recently discovered picture, unique in Gainsborough's oeuvre as we know it, was commissioned by the Revd Dr Thomas Tanner, son-in-law of John Potter, Archbishop of Canterbury, who became Rector of Hadleigh in 1743, and was responsible for improving and beautifying the church and for modernising the old Rectory. It is not known to what extent Gainsborough may have acquired a reputation in Suffolk as a topographical painter – although he had recently painted the small roundel of 'The Charterhouse' as one of a series for the decoration of the Court Room at the Foundling Hospital, there is no evidence to indicate that he was active in this popular and relatively lucrative genre, and he was later to inform an aristocratic patron of his disinclination to paint views; but he lived in the neighbouring town of Sudbury and his name may well have been suggested to Dr Tanner by his friend Joshua Kirby, whose firm was employed on the improvements to the church and who had painted an altarpiece for it in 1744. According to an early-nineteenth-century label formerly on the back of the canvas Kirby participated in the execution of the picture, but the visual evidence does not support the supposition that more than one hand was involved, and that Gainsborough's. The view is taken from the south-east. Much has disappeared since Gainsborough's time. The house on the left, the Rectory itself, with its ice house, and the houses on the right have been pulled down; and the fretted Chinese Chippendale gateway in the Rectory wall, the wicket-gate in the arch of the fine Tudor Deanery Tower, and the small south porch, the skylight in the aisle roof and the top of the gallery round the tower, in the church, have been removed. The exterior of St Mary's was restored in the mid-nineteenth century and the coating of plaster (seen in Gainsborough's picture) stripped off to lay bare the original flints; the fields on the left and the area to the east of the church have now been built up, but the rising ground in the distance, beyond the Stour (not visible in the painting), still remains open country, exactly as the artist depicted it. The topographical detail is freely but

carefully and lovingly rendered: for example, Gainsborough has not glossed over the state of disrepair in the string-courses of the church. The motif of the boys playing on the slab of the tombstone seems to be derived from Plate 3 of Hogarth's *Industry and Idleness*, published in 1747. Gainsborough evidently kept up his connection with the family, for he painted Dr Tanner's granddaughter in 1786.

The shape of this canvas suggests that it was intended for a particular position in a room, probably an overdoor rather than an overmantel. Such a purpose would account for the breadth of massing and the slow, undulating rhythms. Depth is suggested more by a naturalistic fall of light and shadow than through the linear means employed in earlier works. The clouds play a dominant compositional rôle similar to those in 'Hadleigh Church' (Cat. no.82). The foreground is warm, even reddish, in tonality, sounding a note of artificiality in the rural scene. And this note is strengthened by the inclusion of various of Gainsborough's favourite incidental motifs of this period: donkeys, a windmill on a hill and, most particularly, a pollarded tree with the stripped bark strongly, and somewhat theatrically, highlit.

83   **Panoramic Landscape with Figures, Donkeys and Distant Windmill**
Canvas, 61 × 106.7 (24 × 42)
About 1754–6
Lit: Waterhouse, No.858; Hayes *Landscape Paintings*, No.49
*The Duke of Norfolk*

84   **River Landscape with Horse Drinking and Rustic Lovers**
Canvas, 94 × 125.7 (37 × 49½)
About 1754–6
Lit: Waterhouse, No.834; Hayes *Landscape Paintings*, No.52
*St Louis Art Museum*
(*Bequest of Cora Liggett Fowler*)

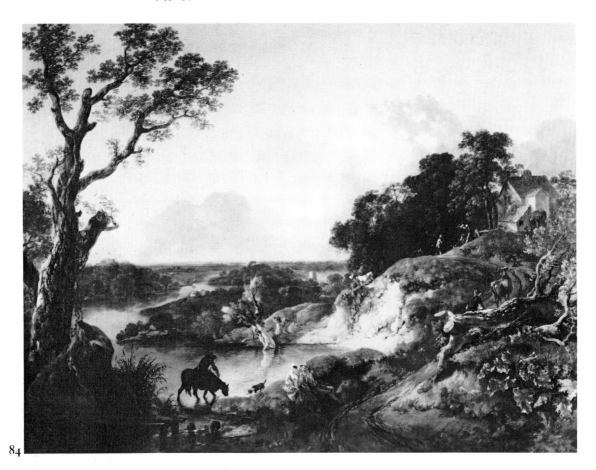

84

The design is the most consistently serpentine of all
Gainsborough's rococo landscapes of the mid 1750s.
The eye is led from the main 'subject' of the picture,
the rustic lovers chatting by the roadside, past the
exceptionally artificial branches on the right, and the
cottage, figures and cow bellowing on the bank, until
it is lost in the softly painted and wonderfully
atmospheric distance. The theme of rustic love (note
the bashful downward glance of the girl and the
symbolism of the basket of eggs) is underlined by the
warm reddish tonality, carried to extremes in the
bright orange tones used in the sandy bank. Even in
so sophisticated a composition Gainsborough has
still used the familiar stock device of a framing tree.
In the early part of the nineteenth century the picture
was in the collection of Mathew Michell, the banker,
patron and close friend of Rowlandson.

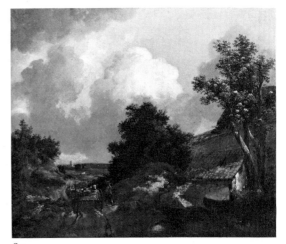

85

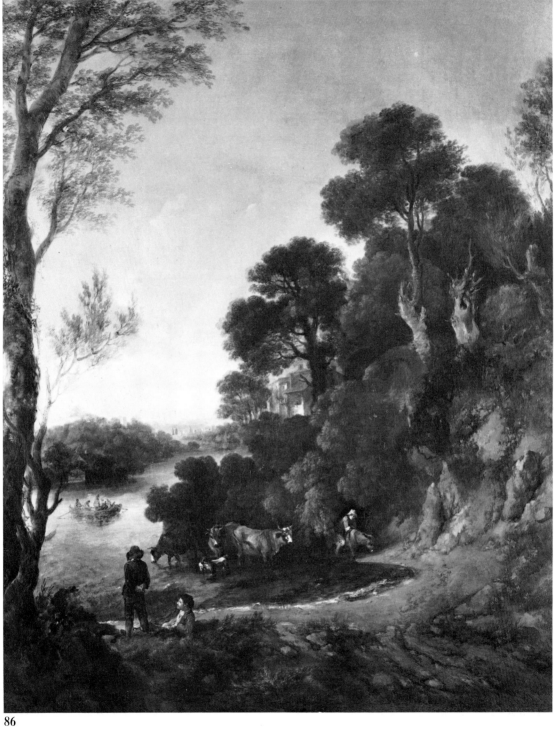

86

**85 Landscape with Farm Buildings and Country Cart**
Canvas, 50.8 × 63.5 (20 × 25)
About 1754-6
Lit: Waterhouse, No.862; Hayes *Landscape Paintings*, No.54
*Private collection (on loan to the Henry E. Huntington Art Gallery, San Marino, California)*

An unusually enclosed composition, dominated by the farm buildings on the right, but opening out into a sensitively painted atmospheric distance characteristic of Gainsborough's landscapes of this period.

**86 River Scene with Cattle Watering and Ferry Boat**
Canvas, 124.5 × 99.1 (49 × 39)
About 1754-6
Lit: Waterhouse, No.827; Hayes *Landscape Paintings*, No.56
*Private collection*

Painted for Thomas Spencer of Hart Hall, the upright format is unusual in Gainsborough's Suffolk landscapes, and was presumably dictated by a requirement to fill a particular space, probably an overmantel. The unnaturally tall framing tree on the left and the build-up of forms on the right show Gainsborough grappling with the pictorial problems posed by the shape. Warm in tonality, and rococo in its rhythmic composition, the handling of the pinks and yellows at the horizon and the glow which permeates the whole canvas seem to have been inspired by Cuyp, whose work was then beginning to become popular among British collectors. The boy lazing on the back of the donkey is an appealing image characteristically sharp in observation.

**87 Peasant and Donkeys Outside a Barn**
Canvas, 49.5 × 59.7 (19½ × 23½)
About 1755-7
Lit: Waterhouse, No.871; Hayes *Landscape Paintings*, No.58
*Private collection*

The introduction of an aged peasant as a principal figure is unique in Gainsborough's early landscapes,

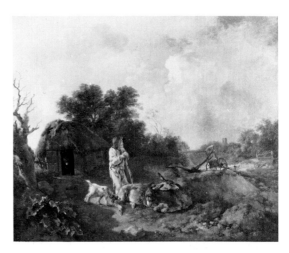

and the sentimental intention of this image, a premonition of his celebrated 'The Woodman' of 1787, is emphasised by the warm, evening glow suggested by the pinkish tones in the clouds, the reddish highlights in the tree and fence on the left, and the reddish tones prevalent in the foreground. This is a rustic reverie, but wholly different in conception to the contemporary French treatment of similar themes, where all is elegance and refinement. The carefully delineated ploughshare is a sharp accent which serves as a foil to the rest of the imagery. The picture has descended in the family from its original purchaser, Jervoise Clarke.

**88 Rustic Courtship**
Canvas, 74.9 × 120.2 (29½ × 47⁵⁄₁₆)
About 1755-7
Lit: Whitley, p.27; Waterhouse, No.844; Hayes *Landscape Paintings*, No.59
*Montreal Museum of Fine Arts (Gift of the family of David Morrice in memory of their parents)*

The theme of rustic courtship, a down-to-earth Anglicised equivalent of the sophisticated pastoral gallantry of Boucher or Fragonard, is a recurrent one in Gainsborough's work of the mid-1750s (compare Cat. no.84). Here the couple are depicted, as so often, beneath a dominating dead tree, the milkmaid somewhat spotlit, the scene glowing from the pinkish light in the clouds, painted in a richly worked impasto. The main subject is complemented by many of

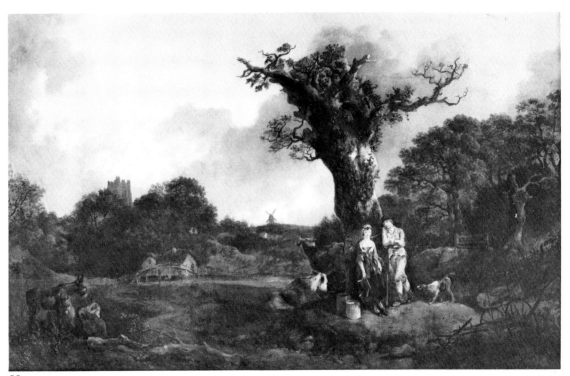

88

Gainsborough's familiar incidental motifs: donkeys, a ploughshare, a church half-hidden by trees, a distant windmill. This picture was among a number Gainsborough sent up for sale to the London dealer, Panton Betew. It was he who had it engraved by François Vivares in 1760.

**89    Landscape with Farmyard Scene**
Canvas, 98.2 × 123.2 (36½ × 48½)
About 1757–9
Lit: Waterhouse, No.835; Hayes *Landscape*
*Paintings*, No.72
*Private collection*
*(on loan to Norwich Castle Museum)*

Loose in handling and exceptionally pale in tone, contrasting with the russet tonality so characteristic of the Suffolk style, this exquisitely painted landscape has something of the shimmer and delicacy of

watercolour and seems to be influenced by the fashionable Italian pastoral landscapist, Francesco Zuccarelli. The implements depicted in the left foreground, a crab harrow and a swing plough, are carefully particularised, but the Suffolk type wheel plough in use in the middle distance, normally about nine feet long, has been considerably condensed (information kindly supplied by Miss Bridget Yates). The familiar dead tree, the ubiquitous donkeys and a church amongst trees complete the scene. Perhaps painted for the Lee-Acton family of Livermere Park (see Cat.no.66), the picture is recorded as hanging on the staircase there in 1821.

**90    Coastal Scene with Shipping**
Canvas, 73.7 × 141 (29 × 55½)
About 1758–9
Lit: Waterhouse, No.843; Hayes *Landscape*
*Paintings*, No.73
*Private collection*

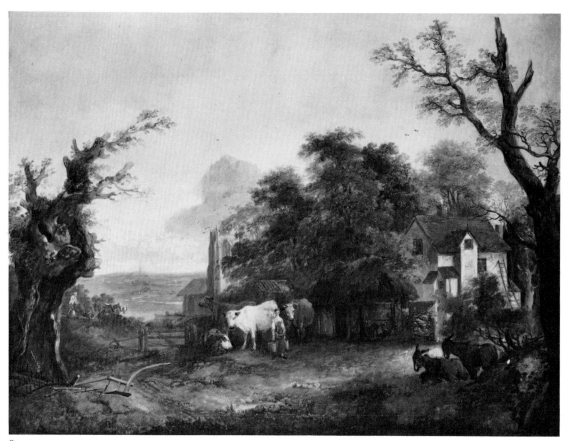

89

90

The subject-matter of this picture is rare in Gainsborough's work of the Suffolk period, and the composition daring. The diagonal stress of the leaning tree which dominates the canvas is repeated in the dark, backdrop clouds on the right, and this flowing rhythm, creating a sense of imbalance, emphasises the motion of the waves; but the same cloud formation also serves to stabilise the compositional movement, as does the central feature of the thatched cottage. The looseness of handling characteristic of the foreground of the previous landscape (Cat.no.89) is more pervasive in this work: there is no attempt, for example, to model the bank on the left, which is brushed in very broadly, leaving the reddish-brown priming to show through, and the face and hand of the little figure are indicated in single blobs of paint. The treatment of the foliage may be compared with that in the landscape depicted on the wall in the background of the 'Richard Savage Nassau' (Cat. no.64). This coastal scene was originally purchased from the artist, subsequent to an unsuccessful raffle, by Mr Berners of Woolverstone.

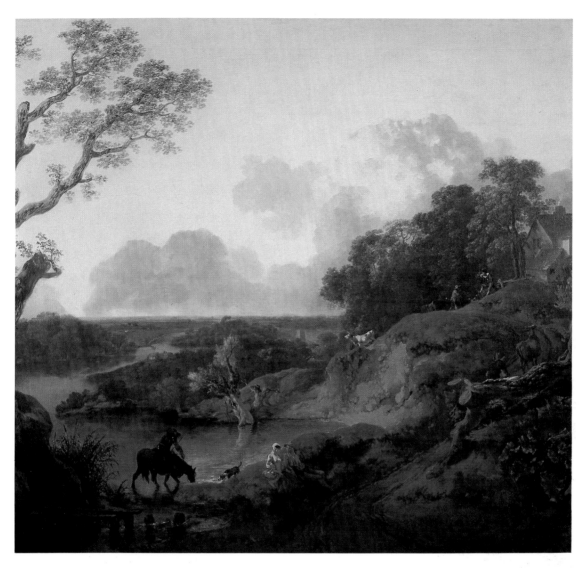

**River Landscape with Horse Drinking
and Rustic Lovers**
Cat.no.84 (p.96)

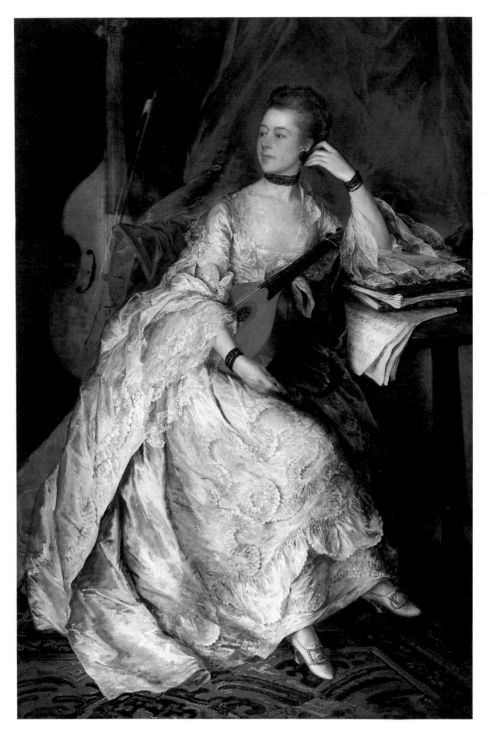

**Ann Ford, later Mrs Philip Thicknesse**
Cat.no.91 (p.107)

**Mr and Mrs George Byam and their Eldest Daughter Selina**
Cat.no.97 (p.110)

**Mary, Duchess of Montagu**
Cat.no.100 (p.112)

# The years of maturity: Bath 1759–74

Gainsborough's move to Bath resulted in a dramatic transformation of his style. His first portrait done there, the full-length of Ann Ford (Cat.no.91), in which the serpentine design of the rococo attained a wholly new breadth and grandeur, was based on a pose by Van Dyck (Fig.27); similarly, the magnificent landscape he painted for his friend Samuel Kilderbee in 1760 (Private collection) combined rustic motifs and swinging rococo line with a composition and sunset glow in emulation of Claude. A metropolitan clientèle and the opportunity of studying fine collections of old master paintings changed both his responses and his outlook. Influenced chiefly by Claude, Rubens and Van Dyck, but also by Ruisdael, Cuyp and Teniers, Gainsborough was no longer to be classified as a charming *petit maître*, which he would certainly have been had he remained in Suffolk, and soon achieved recognition as a painter of the front rank. Public exhibition in London hastened his acclaim.

Many of Gainsborough's best portraits continued to be of personal friends, Garrick

Fig.28 Detail from the full-length of *David Garrick*. Exhibited Society of Artists 1766. Formerly Town Hall, Stratford-upon-Avon (destroyed)

(National Portrait Gallery), de Loutherbourg (Cat.no.122), the Linleys (several portraits at Dulwich College Art Gallery). Likeness remained his ideal, as he explained so trenchantly in his well-known letters to Lord Dartmouth, and in full-lengths such as those of the younger Abel Moysey (Private collection) or of John Scrimgeour (Museum of Art, Raleigh, North Carolina: Fig.29), the pose seems to de derived, not from calculated adaptations of the old masters, as so often with Reynolds, but from Gainsborough's impressions as he saw his sitters going about their business, or pleasure, in the streets of Bath. In the four-square portrait of that great entrepreneur, Sir Benjamin Truman (Tate Gallery), the figure planted firmly in the forefront of the canvas, the features of the bluff old brewer have not been idealised in the slightest, and where in Reynolds would one find the maker's name recorded in the lining of a hat? Gainsborough painted a number of portraits in Van Dyck dress, a fashionable conceit at that

Fig.27 Study for the portrait of Ann Ford, 1760. British Museum, London

Fig.29 *John Scrimgeour*, 1778.
North Carolina Museum of Art, Raleigh, NC

breadth and chiaroscuro, which owed much to the sombre and dramatic side of Ruisdael's painting, is first apparent in the Houston and Worcester landscapes (Cat.nos.108 and 110). In contrast to the wealth of scattered incident in his earlier work, Gainsborough introduced fewer motifs into his landscapes of the Bath period, his figures became correspondingly larger and more prominent, and his subjects were as often as not spotlit. His nostalgia for the countryside was expressed in particular content. Workaday subjects, such as ploughing scenes, disappear. He developed the theme of peasants travelling to or from market, his bucolic rustic lovers were

time, notably 'The Blue Boy' (Huntington Art Gallery), exhibited at the Academy in 1770; and the masterpiece he sent to the first Academy exhibition in 1769, 'Lady Molyneux' (Walker Art Gallery, Liverpool: Fig.9), was consciously in the Van Dyck tradition, the placing of the left arm over the breast being a characteristic Van Dyck motif. In other masterpieces of this period, such as 'Countess Howe' (Iveagh Bequest, Kenwood), the simple distinction of the pose, the noble bearing of the sitter, the delicacy of the colour, and the emphasis on the manifold beauties of the costume, represent a personal transmutation of the qualities of Van Dyck (Fig.30). The bravura of handling in the dress of 'Lady Molyneux' owes more, however, to Van Dyck's master, Rubens, who, from the mid 1760s, exerted the deepest influence on Gainsborough's landscapes.

Fig.30
Sir Anthony Van Dyck
(1599–1641),
*Elizabeth Howard,
Countess of Peterborough.*
Lionel Stopford Sackville,
Drayton

In the early 1760s Gainsborough began to work by candlelight, and, as Reynolds pronounced: 'by candle-light, not only objects appear more beautiful, but from their being in a greater breadth of light and shadow, as well as having a greater breadth and uniformity of colour, nature appears in a higher style'. This

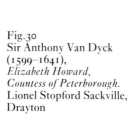

Fig.31 Sir Peter Paul Rubens (1755–1840),
*The Watering Place*. National Gallery, London

transformed into more sophisticated romantic idylls, and the sentimental theme of the 'cottage door', a peasant family grouped on the steps of their simple homestead awaiting the wood-cutter's return at eventide, became obsessional. The lightening of his palette in about 1767, and the increasing vigour, looseness of touch, rich-ness of tint and boldness of effect in his painting were the result of his intense excitement by Rubens, whose landscapes were far better known in England than they were abroad, and many of which Gainsborough could well have seen (Fig.31). His baroque figure groupings and un-naturalistic double lighting in the interests of dramatic effect derived from the same source. At the end of the Bath period Gainsborough

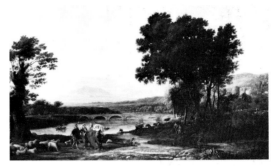

Fig.32 Claude Lorraine (1600–82), *Jacob and Laban.* H.M. Treasury and The National Trust, Petworth House.

painted a number of landscapes with mountain-ous distances and a pervasive sunset glow that were directly inspired by Claude (Fig.32).

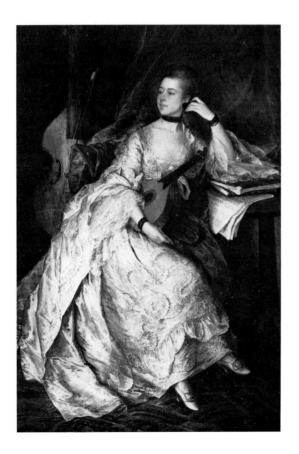

91 **Ann Ford, later Mrs Philip Thicknesse**
(1732–1824)
Canvas, 196.9 × 134.6 (77½ × 53)
Painted in 1760
Lit: Whitley, p.36; Waterhouse, No.660;
Lindsay Stainton, *Gainsborough and his Musical Friends*, catalogue of an exhibition at Kenwood, 1977, No.16
*Cincinnati Art Museum (Bequest of Mary M. Emery)*
[colour repr. p.102]

Ann Ford, who married Gainsborough's early pat-ron and friend, the brilliant but spiteful, vain and quarrelsome Philip Thicknesse, in 1762, a couple of years after this picture was painted, was a lively personality in her own right and a talented amateur musician. She gave a series of public recitals in London in 1760, and both the viola da gamba and the guitar (or cittern), which she played in the course of this season, are featured here. The viola da gamba may be the instrument 'of exquisite workmanship and mellifluous tone' which Gainsborough is known to have coveted, and in return for the gift of which he promised, but failed, to paint a portrait of her husband. This portrait was the first large-scale canvas Gainsborough executed in his new studio at Bath, and for a work which therefore had a particular

importance he seems to have turned for inspiration to Van Dyck. The pose as he sketched it out in his preliminary drawing, now in the British Museum (Fig.27), is broadly that of Van Dyck's 'Lady Digby'. In the finished painting Gainsborough broadened the folds of the lovely white dress, a marvel of bravura handling of paint, so that they cascade downwards in such a way as to emphasise the remarkable serpentine twist of the pose – a pose with which all the forms in the picture are successfully integrated, either following or counterbalancing the movement. This highly original work, rococo in concept but going far beyond the limits of what we understand as rococo art, and at the furthest remove from the classical dignity of Reynolds, evidently caused some stir at the time. Mrs Delany was forthright in her opinion: 'a most extraordinary figure, handsome and bold; but I should be very sorry to have any one I loved set forth in such a manner.'

**92    Uvedale Tomkyns Price (1685–1764)**
      Canvas, 124.5 × 99.1 (49 × 39)
      About 1760
      Lit: Waterhouse, No.556
      *Neue Pinakothek, Munich*

Gainsborough became acquainted with the Prices of Foxley, in Herefordshire, soon after his arrival in Bath. Robert Price (1717–61), the owner of Foxley, the father of Uvedale Price, the writer on 'the Picturesque' (then a young man but who came to know Gainsborough well in the 1760s), was a collector, an amateur landscape draughtsman and a skilled musician. Though Gainsborough is known to have painted Robert, this portrait does not accord with Zoffany's likeness of him and the sitter is, in any case, an older man. The other Gainsborough portrait which descended in the Price family was that of Robert's father, Uvedale Tomkyns, about whom little is known. It is presumably he, at the age of seventy-five, who is the subject of this painting. The dramatic lighting in this searching characterisation, which gives a special emphasis to the head and hands comparable to Reynolds's manner at the same date, was the result of Gainsborough's practice at this time of working by candlelight rather than in the evenness of a north light. The drawing on the wall, executed in black chalk and not with the brush, is a Gainsborough

(perhaps one actually owned by Price) similar in finish to that owned by Sir John Witt (Cat.no.14), and shows that large drawings of this type were sometimes framed and hung rather than being kept in portfolio. The chair in which Price is sitting seems to have been an afterthought, as it is painted in over the drawing and is a different height on this side of the sitter.

**93    Unknown Girl stroking a Greyhound**
      Canvas, 127 × 101.6 (50 × 40)
      Early 1760s
      Lit: Waterhouse, No.282 (as one of
      Gainsborough's daughters)
      *Denise Gratwohl-Imfeld*

An appealing portrait of a young girl in a fashionable white silk figured dress. Though firmly drawn, the head is softly modelled, in contrast to the portraits of the late Ipswich period, and the slight stiffness of pose, characteristic of Gainsborough's earlier work, is countered by the diagonal of the greyhound, taken up in the green curtain on the left. The girl is wearing an unidentified miniature on her bracelet.

93

**94 A Pug Dog**
Canvas, 48.3 × 58.4 (19 × 23)
Early 1760s
Lit:Waterhouse, No.818
*Private collection*

A rapidly painted sketch which it is instructive to compare with the neat touch and more laborious modelling in Gainsborough's early portrait of 'Bumper' (Cat.no.54). Both are lively characterisations of alert and intelligent animals. For the breed, compare Hogarth's well-known self-portrait with his dog, 'Trump' (Tate Gallery).

**95 Thomas John Medlicott**
Canvas, 221 × 144.8 (87 × 57)
Exhibited Society of Artists 1763 (42)
Lit: Waterhouse, No.477
*Hereward T. Watlington*

Gainsborough firmly established the informal character of his portrait style with the public when he sent his full-length of William Poyntz, depicted leaning nonchalantly against a gnarled tree stump, to the Society of Artists in 1762. Next year he followed this up with another informal full-length. Thomas Medlicott, a young man about Bath with a strong attraction for the ladies and described by Fulcher, the early biographer of Gainsborough, as 'the gay and gallant cousin of Richard Lovell Edgeworth', father of the authoress and a friend of Humphry Gainsborough, is shown reclining on a stile in a daring spiralling pose carried on at his feet by the little dog looking up at him. Reynolds, in his portrait of Philip Gell, riposted at the same summer exhibition with an idealised transcription of Gainsborough's theme of the sportsman at ease in a landscape.

96   General James Johnston (1721–97)
Canvas, 206 × 141 (81¼ × 55½)
About 1763–4
Lit: Waterhouse, No.403
*National Gallery of Ireland*

Where Reynolds would have painted a general with some indication, in the background, of his profession and valour, Gainsborough has chosen to set General Johnston against the type of dark, wooded landscape enlivened by flashes of light at the horizon which he was using continually in his full-lengths at this period. The nonchalance of the pose, legs planted firmly apart, and the debonair expression, though clearly indicative of the character of a man who was reputed to be the finest swordsman in the army, are also at some remove from Reynolds's canon of portraiture. In this original and lively composition the silver birch, though as contrived in placing as the tree beside the portrait of Lady Howe at Kenwood, is an integral and brilliantly successful part of the design, spiralling upwards in a serpentine rhythm which echoes and continues the line of the general's scarlet coat.

97   Mr and Mrs George Byam and their Eldest Daughter Selina (born 1760)
Canvas, 249 × 238.8 (98 × 94)
About 1764
Lit: Waterhouse, No.108
*Marlborough College, Wiltshire*
[colour repr. p.103]

This is the most elaborate portrait Gainsborough had painted thus far in his career. George Byam, of Apps Court, near Weybridge, is dressed in his smartest waistcoat, into which his hand is tucked in the approved manner, apparently pointing out some feature in the view to his wife Louisa (niece of Earl Bathurst), who is also dressed at the height of fashion, and whom he is leading by the arm; their small daughter, Selina, is preoccupied with something nearer at hand, and looks out at the spectator in an engaging manner. The motif of the promenade with the figure linked by joint concentration on the distant prospect, which goes back to Dürer, was later taken up with great success by both Reynolds and Raeburn. The background, dark and stormy, painted with a breadth and roughness of touch only to be found in Gainsborough's landscapes proper a decade and more later, seems rather out of key with the refined and elegant figure group.

98

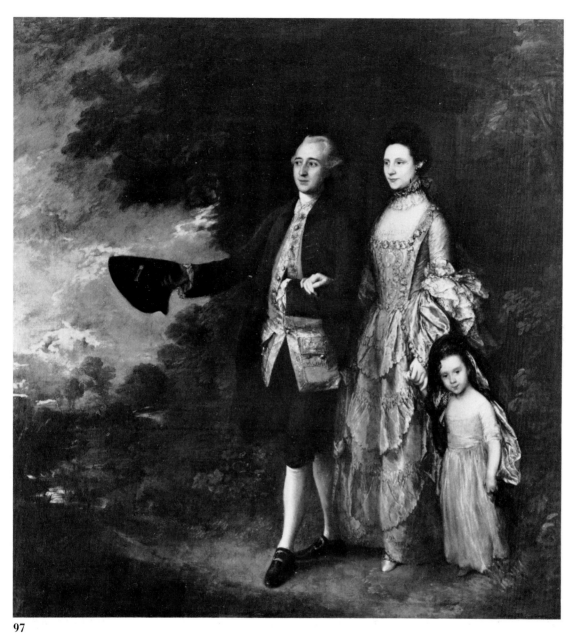

97

98 **Mrs Christopher Horton, later Duchess of
Cumberland** (1743–1808)
Canvas, 76.2 × 63.5 (30 × 25)
Inscribed 1766
Lit: Waterhouse, No.179
*National Gallery of Ireland*

Anne Horton was described by Horace Walpole five
years after this portrait was painted, when she
married the Duke of Cumberland, as 'a young widow
of twenty-four [actually she was twenty-eight],
extremely pretty, not handsome, very well made,
with the most amorous eyes in the world, and

[ 111 ]

eyelashes a yard long. Coquette beyond measure, artful as Cleopatra, and completely mistress of all her passions and projects'. Both Reynolds and Wright of Derby had trouble in pleasing this capricious sitter, but Gainsborough painted her successfully on several occasions, and this head-and-shoulders, a masterpiece of the portraitist's art, not only captures her beauty in a way of which only Gainsborough was capable but suggests both her seductiveness and her early mastery of the ways of the world: there is, indeed, a strong element of hardness and control in the languish of her expression.

characterisation displayed in 'Anne Horton' (Cat. no.98). From now on Gainsborough was capable, when he needed, of adding a new dimension to his Van Dyck manner, perhaps influenced, as in his landscape style of this period, by Rubens.

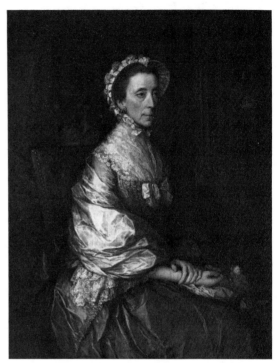

**100  Mary, Duchess of Montagu** (1711–75)
Canvas, 125.7 × 100.3 (49½ × 39½)
About 1768
Lit: Waterhouse, No.491
*The Duke of Buccleuch and Queensberry, Bowhill* [colour repr. p.104]

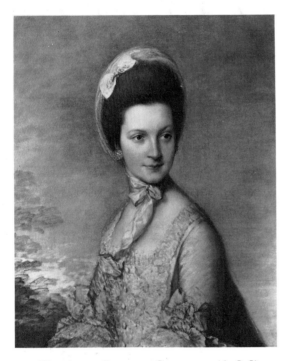

**99  Henrietta, Countess Grosvenor** (d.1828)
Canvas, 100.3 × 87.6 (39½ × 34½)
Exhibited Society of Artists 1767 (58)
Lit: Waterhouse, No.332
*The Duke of Westminster*

'Lady Grosvenor' has unfortunately been cut down from the original full-length, and the head and shoulders are all that survive, but the treatment of the head is instructive. For the intensity of the expression, the dilation of the nostrils and the sharp turn of the head all demonstrate a new force and power in Gainsborough's portraiture which was at the other end of the spectrum from the nuances of

This serene and haunting portrait ranks with the small oval of Mrs Kirby (Cat.no.70) as one of the most compelling and deeply sympathetic of Gainsborough's studies of older women with character. The quiet dignity of the expression is matched by the aristocratic erectness of posture, in turn pictorially supported by the upright of the picture frame; but these elements of severity in the design are softened by the broad highlit curve which forms the basic structure of the composition, by the rough texturing of the crinkled satin cape which lies at the centre of this curve, and by such details as the fingers of the right hand, relaxed and natural in pose. Gains-

*Opposite page*
**Peasants Returning from Market through a Wood** detail
Cat.no.113 (p.120)

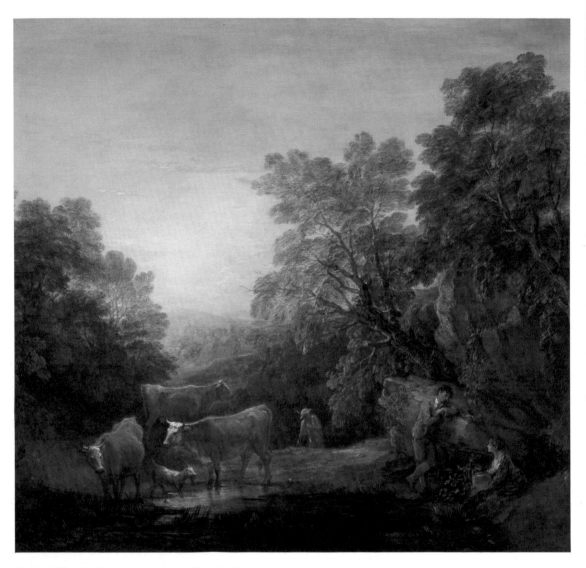

**Rocky Wooded Landscape with Rustic Lovers
and Cattle at a Watering Place**
Cat.no.116 (p.129)

borough referred to this portrait in a letter to Garrick written in the summer of 1768 as 'in my *last* manner'; the picture on the wall evidently represents a landscape also in Gainsborough's latest manner, conceivably an actual landscape bought by the Montagus.

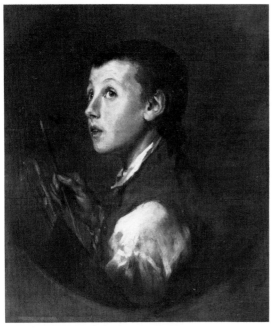

**101  Unknown Youth, Known as 'The Pitminster Boy'**
Canvas, 58.4 × 50.8 (23 × 20)
Later 1760s
Lit: Waterhouse, No.779
*Private collection*

During the summer months, when the Academy was open and the press of business had receded, Gainsborough devoted more of his time to landscape and to travel. He seems to have been a welcome guest at Barton Grange, the Somersetshire home of Goodenough Earle (about whom, unfortunately, nothing is known), and presented a number of drawings to his host on different occasions in the course of the 1760s. This brilliant portrait study is of a local lad who carried his paints for him on sketching trips when he was staying in Somerset. The eager intentness of the boy's expression – conveyed partly through the fixed gaze of the eyes and partly through the lips, parted in concentration – is beautifully caught, and emphasised by the exaggerated lighting.

**102  William Jackson** (1730–1803)
Canvas, 76.2 × 63.5 (30 × 25)
Exhibited R.A. 1770 (86) or (87)
Lit: Lindsay Stainton, *Gainsborough and his Musical Friends*, catalogue of an exhibition at Kenwood, 1977 (under No.5)
*R. G. McIntyre, Sorn Castle*

William Jackson was one of Gainsborough's closest friends. A professional musician who was appointed organist at Exeter Cathedral in 1777, he was also an amateur artist, and he received instructions on drawing from Gainsborough in return for advice on musical matters. 'I think I now begin to see a little into the nature of Modulation and the introduction of flats and sharps; and when we meet you shall hear me play extempore', wrote Gainsborough in 1772. This portrait, which has only recently come to light, has descended from Jackson's natural son, William Elmsley. Previous to the emergence of this picture, the portrait which had passed from Jackson's son to his patron, Sir William Young, and thence by descent (Waterhouse, No.398), had been supposed to be the original, and the present author is at fault in having recommended its inclusion as such in the exhibition at Kenwood in 1977. When it was shown, it was apparent that the handling was not Gainsborough's, and it seems possible that it is a copy by Jackson himself. The original appeared at the Royal Academy of 1770 to no great advantage, Gainsborough expostulating that it was 'as I expected hung a mile high'.

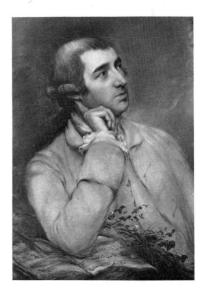

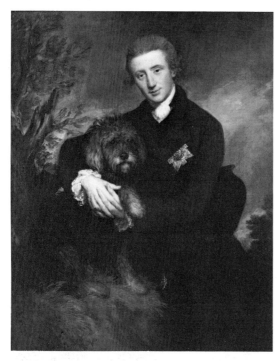

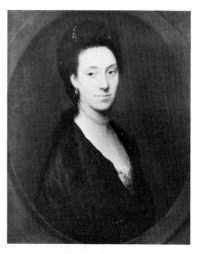

Gainsborough may have been at his best with youthful beauty and high spirits, and with elderly women of character, but this study of a middle-aged sitter is exceptionally tender and revealing. Frances, the eldest daughter of Christopher Horton of Catton Hall, Derby, married Sir Edward Littleton, of Pillaton, in Staffordshire.

**103 Henry, 3rd Duke of Buccleuch** (1746–1812)
Canvas, 123.2 × 96.5 (48½ × 38)
About 1770 (the receipt for the picture is dated 21 November 1770).
Lit: Waterhouse, No.88
*The Duke of Buccleuch and Queensberry, Bowhill*

This is one of Gainsborough's most engaging portraits of a young nobleman. The sweetness of the expression, the tilt of the head and the appeal of the pet dog are contributory elements in this exceptionally gentle conception, unusual in male portraiture of the period (the formal parallels are with such portraits of motherly affection as Reynolds's enchanting 'Lady Spencer and her Daughter' of 1760–1). A man of literary tastes, Henry, who had succeeded to the title at the age of four, was a popular landlord: his friend Sir Walter Scott declared that 'his name was never mentioned without praises by the rich and benedictions by the poor'. He is depicted wearing the star of the Order of the Thistle.

**104 Frances, Lady Littleton** (d.1781)
Canvas, 76.2 × 63.5 (30 × 25)
Early 1770s
Lit: Waterhouse, No.451
*Private collection*

**105 The Hon. William Henry Bouverie**
(1752–1806)
Canvas, 74.9 × 62.2 (29½ × 24½)
Inscribed 1773
Lit: Waterhouse, No.77
*Private collection*

One of a series of half-lengths in feigned oval surrounds which Gainsborough painted of the 1st Earl of Radnor and his three sons, William, Bartholomew and Edward, in 1773–4. Less well-known than the portrait of his brother, Edward, in Van Dyck dress, the head is sensitively modelled and the colouring delicate. Gainsborough seems to have been a welcome guest at Longford Castle, which contained a superb collection of pictures collected by the 1st Earl, and painted, in the late 1760s, two full-scale copies of one which especially excited him, the magnificent Teniers' 'The return from Shooting'.

**106 Elizabeth Tyler** (1739–1821)
Canvas, 61 × 76.2 (24 × 30)
About 1773
Lit: Waterhouse, No.685
*Private collection*

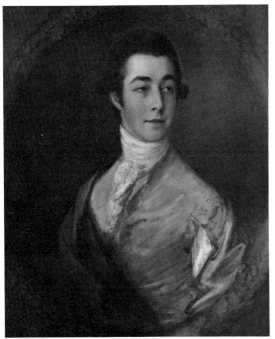

105

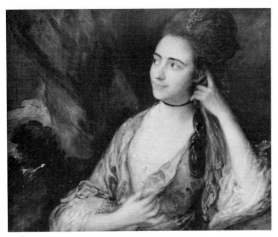

106

the very pale flesh tones stand out against the warm colours in the dress and curtain and the sitter's expression, lively and amused, is caught to perfection. Miss Tyler, a friend of Thomas Raikes, who introduced Sunday school education, and an addict of the theatre, later resided on the outskirts of Bath, where her nephew, the poet Robert Southey, lived with her as a youngster. She had a passion for spotlessness as well as a violent temper, and Southey describes in his autobiography how the Gainsborough hung in her drawing-room, 'with a curtain to preserve the frame from flies and the colours from the sun'. It is not known when the canvas was cut down to its present size.

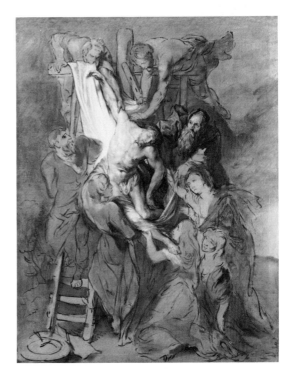

Elizabeth Tyler, the daughter of the Rector of Shobdon, was a favourite of Lady Bateman, of Shobdon Court, and the portrait is said to have been painted for Gainsborough's patron, Lord Bateman, in 1775 (or perhaps finished earlier, as Thicknesse noted in a letter of 1773 or possibly earlier: 'Miss Tyler is sitting to Gainsbro'). The portrait is unusually sketchy and impressionistic in handling, but

**107 The Descent from the Cross** (after Rubens)
Canvas, 121.9 × 97.8 (48 × 38½)
Early to mid 1760s
Lit: Waterhouse, No.1027
*Private collection*

A large-scale, but only partially finished, copy of the central panel of Rubens's great altarpiece for Antwerp Cathedral, executed in reverse, from Vorsterman's engraving, but probably inspired by the *modello* now

[117]

in the Courtauld Institute Galleries, which in the eighteenth century was at Corsham Court, where Gainsborough would have seen it. What seems to have fascinated Gainsborough in the Rubens was the composition, the movement and interlocking of the figures which sustained the powerful diagonal; and there can be very little doubt that it was this picture which inspired the extraordinary pyramid of figures in 'The Harvest Waggon' in the Barber Institute, Birmingham, a group so contrived in disposition, and so much at variance with his declared belief of precisely this date that the figures in a landscape should be strictly subordinate (see under Cat.no.112). Although painted on canvas, Gainsborough's copy retains the highly luminous quality characteristic of a Rubens panel. The picture always remained in the artist's possession and was sold at Christie's, for a trifling sum, when the studio was cleared after Gainsborough Dupont's death in 1797.

### 108 Landscape with Woodcutter

Canvas, 100.3 × 127 (39½ × 50)
About 1762–3
Lit: Whitley, p.81; Waterhouse, No.899; J. T. Hayes, 'A Turning Point in Style: *Landscape with Woodcutter*', *Bulletin of the Houston Museum of Fine Arts*, Summer 1973, pp.25–9; Hayes *Landscape Paintings*, No.77
*Museum of Fine Arts, Houston (Gift of Mrs Elizabeth Wymond Clark in memory of Harry C. Wiess)*

The woodcutter, strongly spotlit by the evening light, is the principal subject, but it is characteristic

of Gainsborough at this period that, far from representing him as a noble image in so grand a landscape, he has shown him as a country yokel, in the act of scratching his head. The distance is also lowered in emotional key by the presence of the two donkeys. The generally subdued tonality and the dramatic chiaroscuro were the product of Gainsborough's habit, at this time, described by the young Ozias Humphry, of painting by candlelight. In the latter part of 1763 Gainsborough was critically ill: 'My life was dispair'd of by Doctor Charleton after he had tried all his skill.' This important landscape was presented by the artist to his physician, of whom he also painted a portrait at full length early in 1764.

### 109 Landscape with Rustic Lovers on a Bank

Canvas, 61 × 73.7 (24 × 29)
About 1762–3
Lit: Waterhouse, No.856; Hayes *Landscape Paintings*, No.79
*Philadelphia Museum of Art (Gift of Mr and Mrs Wharton Sinkler)*

A lyrical masterpiece dominated by the glowing sunset which breaks through the trees above the two lovers. The composition is broadly Claudean, but the delicate, lacy, pink clouds and the ruin on the left are reminiscent of Zuccarelli. Though parts of the picture are loosely handled – the distant river is suggested in a single, sweeping brushstroke – the treatment generally has a jewel-like quality similar to that of the landscape which is its companion. Both works are said to have been painted for Gainsborough's early teacher, Francis Hayman.

## 110 Mountainous Wooded Landscape with Horse drinking and flock of Sheep

Canvas, 146.1 × 157.5 (57½ × 62)
Probably exhibited Society of Artists 1763 (43)
Lit: Waterhouse, No.898; Hayes *Landscape Paintings*, No.80
*Worcester Art Museum*

This is by far the most freely and vigorously handled landscape Gainsborough had painted so far, and the powerful chiaroscuro leaves the spectator with a sense of some high drama unfolding. The composition is broadly Claudean but the heavy, dominating trees and dramatically contrasted areas of light and shadow, effects stimulated by his practice of painting by candlelight, look back to Ruisdael, whom he never ceased to admire. The exceptional vigour and looseness of touch in the handling, notably such lively passages as the pink, yellow and reddish tints suggesting reflected light in the tree stumps in the middle distance, are a first hint of Gainsborough's love for Rubens. Indeed the arrangement of the masses, the use of brilliant clouds to act as a foil to the dark green foliage, the highlighting of the leaves and the pose of the horse drinking all suggest that Rubens's 'The Watering Place', then in the possession of the Duke of Montagu, may already have been known to Gainsborough. This masterpiece was never sold, and appeared in the family sale at Christie's in 1797. It soon passed into the collection of William Beckford. A later owner was the Birmingham manufacturer, Joseph Gillott, the patron of Turner.

## 111 Hilly Wooded Landscape with Peasant Crossing a Footbridge

Canvas, 63.5 × 76.2 (25 × 30)
About 1763-4
Lit: Waterhouse, No.896; Hayes *Landscape Paintings*, No.82
*Private collection*

A small landscape in the Claudean manner, brilliantly, but sketchily handled, dominated by the stormy sky and correspondingly rich in chiaroscuro. The feeling for light is exceptionally sensitive, and the tree trunk on the left is modelled in a variety of colours indicative of reflected light from the setting sun. The picture was originally acquired by John Jacob of 'The Rocks', near Bath.

## 112 Wooded Landscape with Country Waggon, Milkmaid and Drover

Canvas, 144.8 × 119.4 (57 × 47)
Exhibited Society of Artists 1766 (53)
Lit: Waterhouse, No.900; Hayes *Landscape Paintings*, No.87
*Private collection*

A shaft of bright sunlight is breaking through the foliage and dramatically spotlights the incident which constitutes the subject-matter of this picture, a drover who has deserted his waggon to pay court to a pretty milkmaid, who is seen looking downwards with bashful expression. The picture admirably illustrates Gainsborough's belief at this time, which was expressed in a letter written the following year, that a landscape should never 'be filled with History, or any figures but such as fill a place (I won't say stop a Gap) or to create a little business for the Eye to be drawn from the Trees in order to return to them with more glee.' The theme harks back to the Ipswich

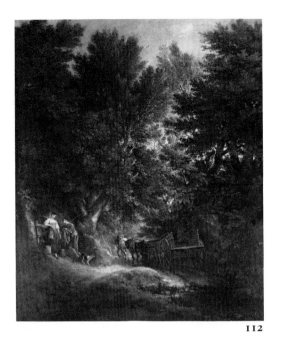

112

pastorals, while the heavy, dark, dominating trees are inspired by Ruisdael. The mood, tonality and touch still have much in common with the Worcester picture, but this was the last great landscape Gainsborough executed in this sombre style. It was purchased by Sir William St Quintin, whose portrait, and those of several members of his family, Gainsborough had painted not many years before (for example, Cat.no.67). The canvas was priced at forty guineas. In Sir William's account book, under the year 1766, there appears the entry: 'Gainsborough. 1 picture £43.11.6.'

### 113 Peasants Returning from Market Through a Wood

Canvas, 121.3 × 170.2 (47¾ × 67)
About 1767–8
Lit: Waterhouse, No.906; Hayes *Landscape Paintings*, No.89
*Toledo Museum of Art* (*Gift of Edward Drummond Libbey*) [colour repr. p.113]

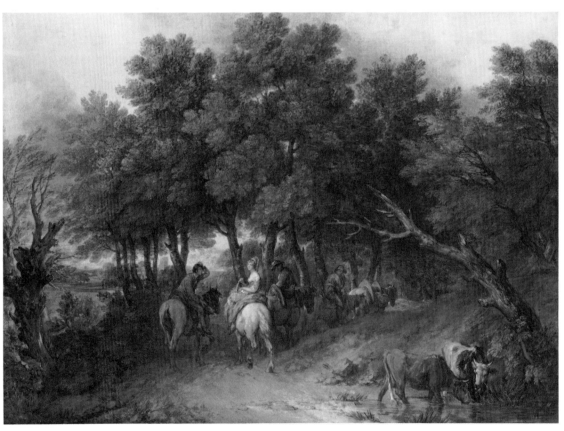

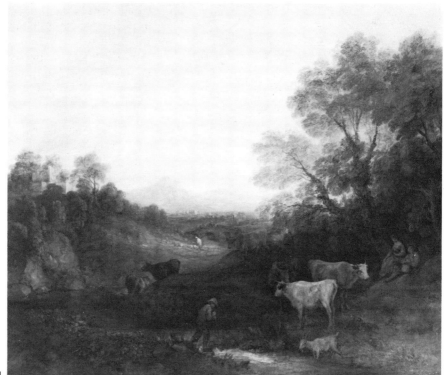

114

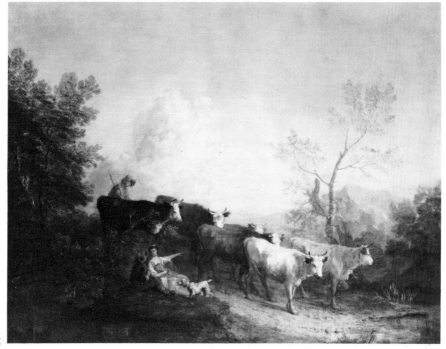

115

This superb landscape is the key picture of Gainsborough's new and lighter style. It was almost certainly a commissioned work, painted for Lord Shelburne, and together with a Barret and Wilson's 'Apollo and the Seasons', one of the three pictures for the decoration of Shelburne's Wiltshire home, Bowood, 'intended to lay the *foundation of a school of British landscapes*'. The motif of rustic dalliance has now been incorporated into the broader theme of peasants going to market, and the composition forms a majestic arc over the group of horses and figures winding into the distance, while the handling, fresh and brilliant and wholly different from the comparatively laboured technique of the St Quintin picture, is even bolder and more adventurous than in the slightly earlier 'The Harvest Waggon' in the Barber Institute, Birmingham. The figures and horses are hardly more than sketched; the panorama on the left is suggested in a few rapid brush strokes; and the tree trunks are roughly modelled, partially in reflected lights, with rich hues of red, yellow, orange, blue and violet predominating. Above all, a brilliant morning sky is painted in tones of pink and yellow, put on with a thickly loaded brush, so that the light glints through the foliage and between the trees, giving the entire composition a tremendous vitality and sparkle. In the whole conception and handling of this picture, Gainsborough's intense excitement by Rubens, the Rubens of the broad, vigorous, high-keyed landscapes of the 1630s rather than the Rubens of 'The Watering Place', is abundantly apparent. The picture was engraved by Francesco Bartolozzi in 1802.

**114 Pastoral Landscape with Distant Bridge**
Canvas, 120 × 145 (47¼ × 57¼)
About 1772-4
Lit: Hayes *Landscape Paintings*, No.108
*Yale Center for British Art, New Haven*
*(Paul Mellon Collection)*

Though Gainsborough has included his usual rustic lovers, a prominent group of cows and other typical subject-matter in this landscape, the composition is one of the most consciously Claudean Gainsborough ever painted. The mass of trees framing the scene on the right, the bridge in the middleground, the carefully mapped out distance (rare in a mature Gainsborough landscape), the mountains and the glowing horizon are all elements comparable with Claude. It is tempting to think that the picture may have been specially commissioned to hang with a Claude, but unfortunately nothing is known about the circumstances of its painting. A study for the picture was originally in the possession of Sir Thomas Lawrence, and may actually have been given to him by Gainsborough.

**115 Landscape with Cattle Returning Home**
Canvas, 97.8 × 125.7 (38½ × 49½)
About 1772-4
Lit: Whitley, pp.361-2; Waterhouse,
No.953; Hayes *Landscape Paintings*, No.110
*Trustees of the Bowood Settlement*

A scene of pastoral contentment in which the drover's head is tilted gently forward as if in reverie and the girl in the foreground is pointing out to her companion the beauties of the distant landscape, a motif derived from Claude. The pale blues of the sky melt imperceptibly into the horizon, and the mountains, bathed in the aftermath of sunset, are softly painted in beautifully modulated tones of grey and blue. This landscape was one of two owned by Gainsborough's intimate friend, Carl Friedrich Abel, and presumably, therefore, one of the 'two valuable landscapes' which, with 'several beautiful drawings', the artist is reported to have exchanged for a viola da gamba he particularly admired. It seems to have been acquired by the 3rd Marquess of Lansdowne by 1814.

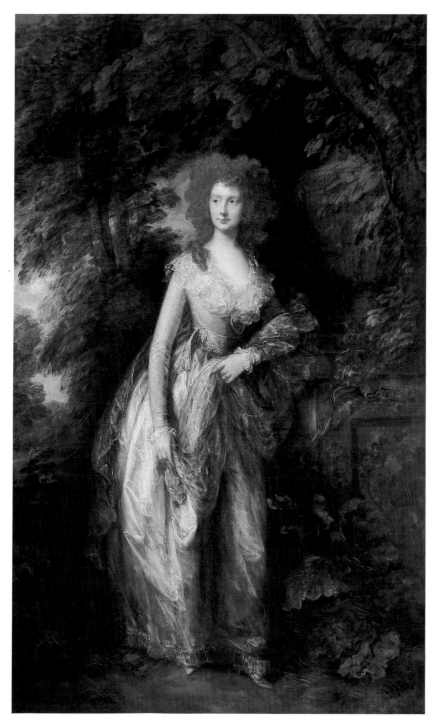

**Mary, Duchess of Richmond**
Cat.no.134 (p.144)

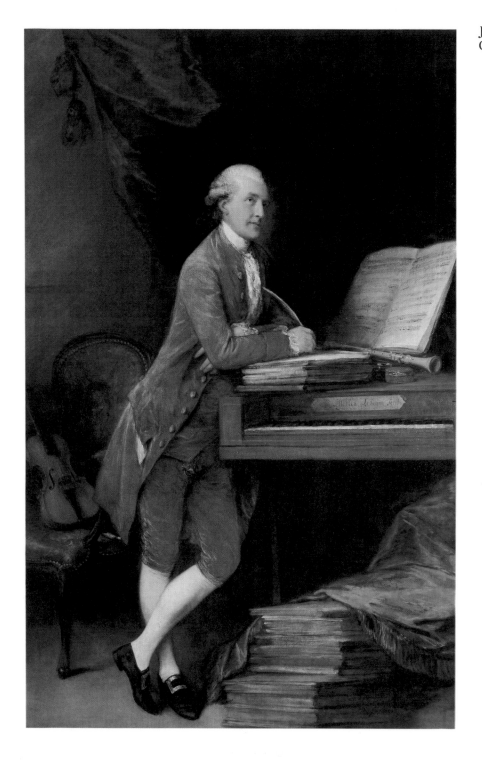

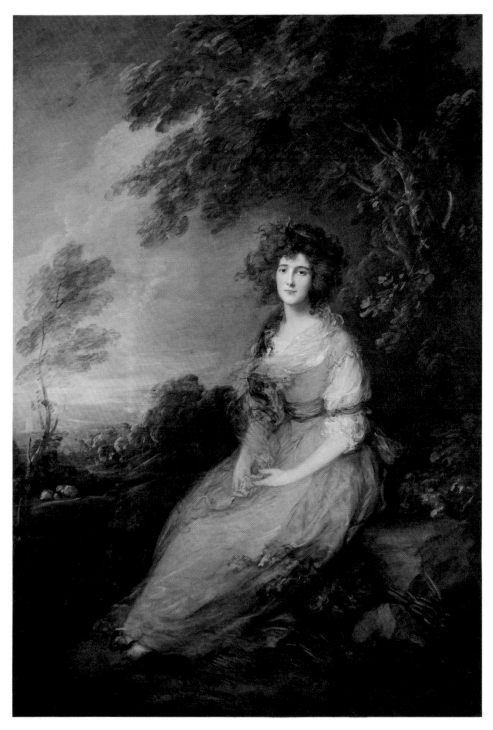

**Mrs Richard Brinsley Sheridan, née Elizabeth Linley**
Cat.no.129 (p.140)

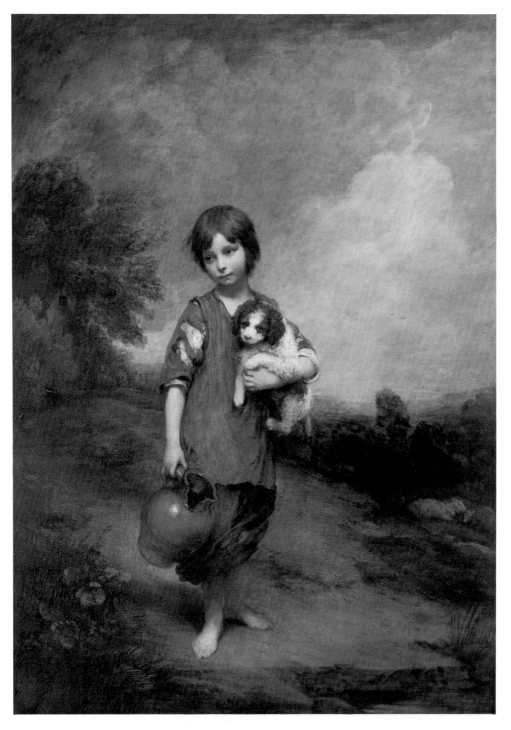

**Cottage Girl with Dog and Pitcher**
Cat.no.139 (p.147)

# The London period: 1774–88

When Gainsborough moved to London in 1774 he was one of the two or three most admired painters in England. Visitors to the 1777 Academy exhibition could have been in no doubt of his powers. The incomparable 'Mrs Graham' (National Gallery of Scotland, Edinburgh: Fig. 12) is Gainsborough's most complete and most richly executed statement of Van Dyck nobility, the composition of his 'Carl Friedrich Abel' (Huntington Art Gallery: Fig.33) the nearest he approached to the full Italian baroque, and

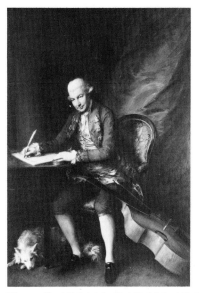

Fig.33 *Carl Friedrich Abel*. Exhibited R.A. 1777. Henry E. Huntington Art Gallery, San Marino

'The Watering Place' (National Gallery: Fig.34) monumental in its grandeur, influenced in subject matter by Rubens and in design by Claude, but closer in its heroic style to the master most revered throughout the eighteenth century as the fount of the grand manner in landscape painting, Titian.

Gainsborough was now seeking both to heighten his effects and to diversify his style. He planned also to disseminate his work by means of print-making, though no editions of his prints seem to have been published in his lifetime. The nine landscapes he sent to the Academy in 1780 and 1781 are the epitome of his new directions. In his mountain landscapes Claudean compositions took on the qualities of the sublime, and much of his imagery anticipated what Uvedale Price, his young friend of the 1760s, was later to categorise as 'Picturesque'. Hoppner spoke of 'the studies he made at this period of his life, in chalks, from the works of the more learned painters of landscape, but particularly from Gasper [sic] Poussin'. 'The Country Church-yard', of which only fragments now survive, indicates the kind of subject painting he wished to pursue, elegies redolent of melancholy feeling;

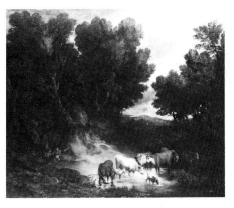

Fig.34 *The Watering Place*. Exhibited R.A. 1777. National Gallery, London

though he hinted in 1783 that he was thinking of turning 'a serious fellow', history painting proper, those noble subjects from mythology or battle beloved of Benjamin West, he considered as 'out of his way'. His 'cottage door' compo-

sitions, of which the finest was exhibited in 1780 (now Huntington Art Gallery: Fig.20), were the starting point for his fancy pictures, those affecting studies of beggar children which were his own personal answer to Reynolds's preaching about the virtues of the grand manner and were his most popular works of the 1780s. 'The Woodman' (Fig.17) (destroyed by fire in 1810), which he regarded as his greatest work, was symbolic of his feelings for country life, the embodiment of honest labour, and anticipated Wordsworth in its appeal.

Fig.35 *Sophia Charlotte, Lady Sheffield*, 1785. The National Trust, Waddesdon Manor

Mood and atmosphere, as well as sentiment, were of the essence of Gainsborough's late style. His finest portraits are marked by an exquisite silvery tonality, or by a liveliness of design and unprecedented vigour and rapidity of handling (Giovanna Baccelli: Tate Gallery); but, above all, following his Watteauesque painting of 'The Mall' (Frick Collection: Fig.15), he began to envelop his sitters in their landscape setting so that they seemed to live and breathe in a romantic world of the artist's creation (Fig.35). These works are one of the highpoints in British

art, Gainsborough's most original contribution to the art of portraiture.

His pigments running with turpentine, Gainsborough's handling became increasingly rhythmic and flowing; there was a period in about 1784–5 when this technique took over, as in his breathtaking 'Hounds coursing a Fox' (Iveagh Bequest, Kenwood: Fig.36). He also experimented with transparencies to achieve ever bolder effects. Even Reynolds, controlled painter

Fig.36 *Hounds Coursing a Fox*, c.1785. Iveagh Bequest, Kenwood

Fig.37 Detail from the full-length portrait of *Juliana, Lady Petre*, 1788. Henry E. Huntington Art Gallery, San Marino

that he was, spoke admiringly of Gainsborough's impressionistic technique of these years, 'all those odd scratches and marks . . . which even to experienced painters appear rather the effect of

accident than design . . . this shapeless appearance, by a kind of magick, at a certain distance assumes form, and all the parts seem to drop into their proper places' (Fig.37).

At the end of his life Gainsborough seemed to be attaining new heights. In 'The Market Cart' (Tate Gallery) the nobility of the trees, the bright clouds above, the tranquillity of mood and the easy naturalism of the scene anticipate the mature Constable.

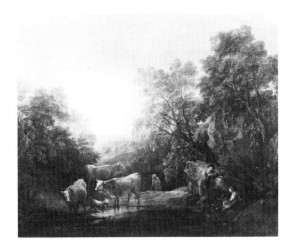

**116 Rocky Wooded Landscape with Rustic Lovers and Cattle at a Watering Place**
Canvas, 119.4 × 147.3 (47 × 58)
About 1773–4
Lit: Waterhouse, No.922; Hayes *Landscape Paintings*, No.113
*Viscount Camrose* [colour repr. p.114]

One of Gainsborough's most consciously Claudean compositions, this canvas is also one of his most powerful landscapes of the late Bath period. The yellowish glow at the horizon is as compelling as any to be found in Turner, and the handling is forceful and brilliant throughout: rough slabs of encrusted white, yellow and pink impasto are laid on in the sky with the palette knife, and the rocks on the right are enlivened with tints of yellow, pink and violet reflected from the setting sun. The rustic lovers are more idealised than in earlier works. Like 'The Harvest Waggon' in the Barber Institute, Birmingham, this picture was presented by the artist to his friend Walter Wiltshire, the Bath carrier, and is reputed to have been painted at his country seat, Shockerwick Park.

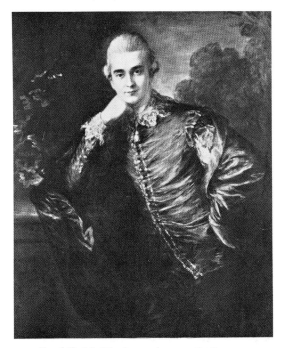

**117 Paul Cobb Methuen** (1752–1816)
Canvas, 127 × 101.6 (50 × 40)
The receipt for the payment is dated 1776
Lit: Waterhouse, No.482
*Methuen collection*

Gainsborough exhibited his celebrated portrait of Jonathan Buttall, known as 'The Blue Boy', at the Academy of 1770. Paul Cobb Methuen is depicted in an identical 'Van Dyck' suit, and it is likely, therefore, that this was a studio property which Gainsborough kept for the benefit of those clients who wanted to be painted in 'fancy dress', a fashion which can be traced back to the 1730s. The directness of the portrayal, and the alertness of the expression, distinguish Gainsborough's interpretation of Van Dyck from the reticence and languor of his great seventeenth-century predecessor.

[ 129 ]

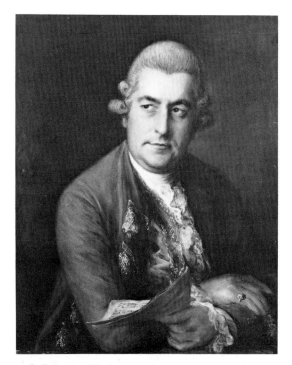

of close personal friends such as Garrick and de Loutherbourg. The strength of the sitter's personality is conveyed partly through the kindly but assured and firm expression, and partly through the weight of the arms resting on the table. The uneasy transitions of the right forearm (Gainsborough often scamped anatomical precision) are hidden by the music-paper. Gainsborough painted a fine replica for Bach himself, an unusual example, after Dupont became his assistant in the studio, of his executing two versions of the same portrait with his own hand.

**118 Johann Christian Bach** (1735–82)
Canvas, 74.3 × 61.6 ($29\frac{1}{4}$ × $24\frac{1}{4}$)
Painted in 1776
Lit: Waterhouse, No.31; Frederick
Cummings, *Romantic Art in Britain*, catalogue
of an exhibition at Detroit and Philadelphia,
1968 (No.19); Lindsay Stainton, *Gainsborough
and his Musical Friends*, catalogue of an
exhibition at Kenwood, 1977 (under No.9)
*Bologna Civico Museo, Bibliografico Musicale*

J. C. Bach was the eleventh son of Johann Sebastian Bach. Organist at Milan Cathedral 1760–2, he was invited to London in May 1762 and remained in England for the rest of his life. With C. F. Abel, another close friend of Gainsborough, with whom he shared a house, he organised many successful series of subscription concerts, culminating in those given at the celebrated Hanover Square Rooms, opened in 1775, which they part owned. Bach's teacher, Giovanni Battista Martini, did his pupil the signal honour of asking for a portrait of him for display in the Liceo Musicale in Bologna; completed by May 1776, it was not actually dispatched until 1778, 'an excellent portrait of myself by one of our best painters'. It forms one of a group of simple but deeply sympathetic portraits Gainsborough did

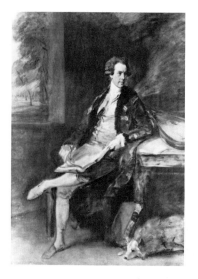

**119 Willoughby, 4th Earl of Abingdon**
(1740–99)
Canvas, 208.3 × 144.8 (82 × 57)
Unfinished
Mid 1770s
Lit: Waterhouse, No.5; Lindsay Stainton,
*Gainsborough and his Musical Friends*,
catalogue of an exhibition at Kenwood, 1977,
No.8
*Private collection*

Lord Abingdon, an outspoken radical peer, supporter of Wilkes, the American colonists and the French Revolution, was a keen race-horse owner and a musical amateur, friend of both Abel and J. C. Bach (his sister married the Italian dancer and impresario, Giovanni Gallini, who acquired the Hanover Square concert rooms where Bach and Abel performed). This unfinished, informal full-length, painted at just about the time Capability Brown was altering his

gardens and park at Rycote, in Oxfordshire, amply demonstrates Gainsborough's normal procedure in his approach to a portrait. The composition, pose and arrangement of the accessories would all be blocked out before serious work was started on the head itself, which was then carried to a high degree of finish. No more sittings would be needed after this, and in the press of business many canvases would fail to reach completion. The half-length of Lord Cathcart, the handsome brother of the beautiful Mrs Graham, another surviving unfinished canvas, was, rather surprisingly, actually exhibited in its unfinished state at Gainsborough's first exhibition of his pictures at Schomberg House in July 1784. It is not known why Gainsborough left Abingdon's portrait unfinished, but the sitter was evidently sufficiently pleased with it to buy it after the artist's death.

Though neatly framed by the dense foliage and the overhanging branch, the sitter is depicted informally, as though he was resting on a bank for a moment in the course of taking a walk. Wilkinson was in fact a wealthy iron-master, whose foundries were later to provide most of the cannon used in the Peninsular War. Something of the toughness, and indeed unscrupulousness, of his character is revealed in Gainsborough's portrayal. The panoramic landscape, closed by mountains, on the left, which acts as a foil to the mass of foliage, is a paraphrase of Claude.

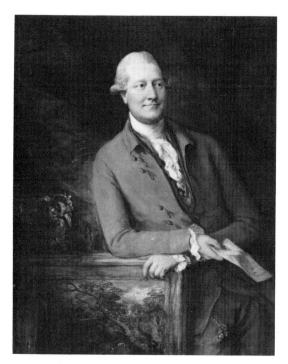

121 **James Christie** (1730–1803)
Canvas, 125.7 × 100.3 (49½ × 39½)
Exhibited R.A. 1778 (117)
Lit: Waterhouse, No.147
*J. Paul Getty Museum, Malibu, California*

Very little is known about the first James Christie, who resigned his commission in the Navy to start a business as an auctioneer in Pall Mall in 1762. Auction sales were a place of fashionable social gathering in the eighteenth century. Christie was reputed to have been tall, dignified and eloquent, and some impression of his confidence and distinction is

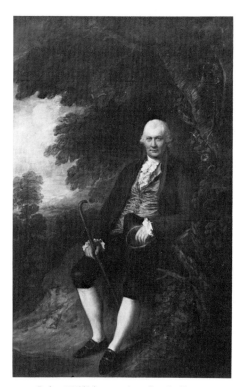

120 **John Wilkinson** (1728–1808)
Canvas, 232.4 × 145.4 (91½ × 57¼)
Mid 1770s
Lit: Waterhouse, No.722
*Gemäldegalerie der Staatlichen Museen zu Berlin, D.D.R.*

conveyed by Gainsborough's portrait. By this date Christie had moved to premises adjacent to Gainsborough, and the latter's jovial presence at his auctions was held to be an element in his success. Christie is seen here leaning over a Gainsborough landscape.

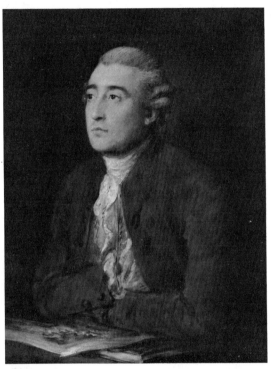

**122 Philip James de Loutherbourg**
(1740–1812)
Canvas, 76.5 × 62.9 (30⅛ × 24¾)
Exhibited R.A. 1778 (408)
Lit: Waterhouse, No.456; Peter Murray,
*Dulwich Picture Gallery*, London, 1980, No.66
*Governors of Dulwich Picture Gallery, London*

De Loutherbourg was a French landscape, topographical and historical painter with an ability to work in a number of fashionable styles. Settling in London in 1771, with an introduction to Garrick, he became the most accomplished scene painter of his day. He devised the *Eidophusikon* (see Cat.no.145), and later developed a taste for alchemy. This canvas is a more intense and rather more rapidly handled variation on the direct type of portrait, represented by the 'J. C. Bach' (Cat.no.118), that Gainsborough

painted of his friends. De Loutherbourg was mercurial and highly-strung, and he is seen leaning eagerly forward, tense, nostrils dilated and expression set; the head is strongly lit, and the waistcoat is indicated summarily in rough touches of yellow over the pink priming.

**123 The Hon. Anne Duncombe, later Countess of Radnor** (1759–1829)
Canvas, 124.5 × 99.1 (49 × 39)
The receipt for the payment is dated
4 June 1778
Lit: Waterhouse, No.571
*Private collection*

In some ways suggestive of the formality of Reynolds, or of the poise and elegance of French contemporaries such as Nattier, the golden yellow harmonies, the pose, the sweet expression and the general air of sentiment in this exquisite portrait of an eighteen-year-old girl looking up from her book are wholly Gainsboroughesque. Gainsborough painted an equally ravishing portrait of Anne's high-spirited sister, Frances, at full-length in Van Dyck dress, walking gaily through an arcadian landscape (Frick Collection, New York), at roughly the same date.

**124 Mrs Thomas Gainsborough, née Margaret Burr** (1728–98)
Canvas, 76.8 × 64.1 (30¼ × 25¼)
About 1778
Lit: Waterhouse, No.299
*Courtauld Institute Galleries, London*

Gainsborough married in 1746, and there was a tradition in his wife's family that for many years he painted Margaret on the anniversary of their wedding day. Certainly he must have painted his wife many times, as he did his daughters, but few portraits survive. The portrait now in East Berlin shows her at the age of thirty; this canvas represents her about twenty years later, at fifty, and it is tempting to think that it was her fiftieth-birthday portrait. The composition is lively and unusual. A strong sense of movement is created by the play of the satin and lace of the black mantle, and this is reinforced by the positioning of the hands. The whole effect is of a

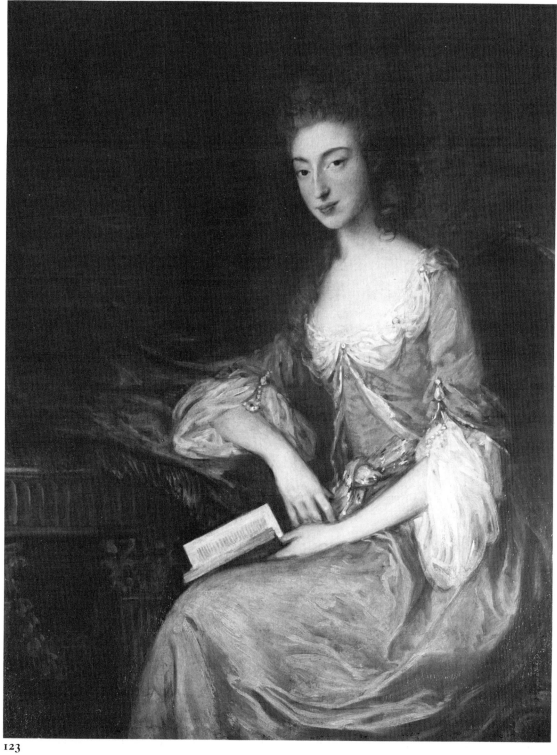

123

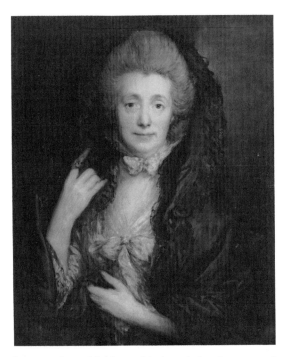

loose oval – a highly sophisticated development of the device of the feigned oval – within which the head is frontally set, immediately engaging the spectator's attention. The portrait is immensely sympathetic, and affords the surest possible evidence of Gainsborough's deep affection for his wife, with whom we know he found it difficult to get on; not long before this picture was painted he wrote to his sister, Mrs Gibbon: 'If I tell you my wife is weak but good, and never much formed to humour my Happiness, what can you do to alter her?'

### 125 The Revd Sir Henry Bate-Dudley
  (1745–1824)
  Canvas, 223.5 × 149.9 (88 × 59)
  Exhibited R.A. 1780 (189)
  Lit: Waterhouse, No.45
  *Trustees of the Burton Property Trust* (on loan to the Department of the Environment, Marlborough House)

The Revd Henry Bate, later Sir Henry Bate-Dudley, proprietor and editor first of the *Morning Post*, then, after 1780, of the *Morning Herald*, was the most consistent supporter of Gainsborough in the daily press. He devoted much of his time to agricultural improvement and to country pursuits on his estate at Bradwell in the remote north-east of Essex, where he entertained lavishly, and it seems to have been here that Gainsborough had his country cottage (Rowlandson drew it in 1783). Although, in this full-length, Bate-Dudley is dressed simply and soberly, with neither fancy waistcoat nor flashy accoutrements, the firm stance, the slightly aggressive arc of the right arm and cane, and the equally determined expression, all combine to produce something of a military air entirely in keeping with his reputation as 'the fighting parson'.

### 126 Johann Christian Fischer (1733–1800)
  Canvas, 228.6 × 150.5 (90 × 59¼)
  Exhibited R.A. 1780 (222)
  Lit: Waterhouse, No.252; Oliver Millar, *The Later Georgian Pictures in the Collection of Her Majesty The Queen*, London, 1969, Vol.1, No.800; Oliver Millar, *Gainsborough*, catalogue of an exhibition at The Queen's Gallery, 1970, No.1; Lindsay Stainton, *Gainsborough and his Musical Friends*, catalogue of an exhibition at Kenwood, 1977, No.10
  *Her Majesty The Queen* [colour repr. p.124]

This portrait of Johann Christian Fischer, the most celebrated oboeist of his day (his two-key oboe is seen here on top of his Merlin harpsichord-cum-pianoforte) and a member of the Queen's Band, who had settled in London in 1768 after being in the service of Frederick the Great, was exhibited a few months after his short-lived marriage to Gainsborough's daughter Mary – a match of which the artist disapproved, though, as he wrote to his sister: 'I can't say I have any reason to doubt the man's honesty or goodness of heart, as I never heard any one speak anything amiss of him.' The gentle, artistic character of the sitter is perfectly conveyed by the happy concentration of the expression, the softly modulated flesh tones, the relaxed pose, and the rippling undulation of the coat; while the composition, much subtler in its use of diagonal stresses than the 'Carl Friedrich Abel' in the Huntington Art Gallery, and the muted harmonies of the colour scheme, crimson against a background of greens and browns, emphasise this interpretation. Recent cleaning has revealed numerous alterations underlying the present design, but these are so extensive that it is

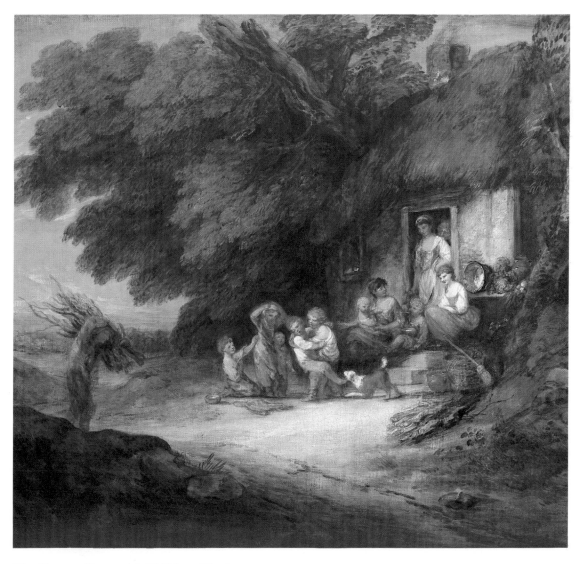

**The Cottage Door with Children Playing**
Cat.no.142 (p.148)

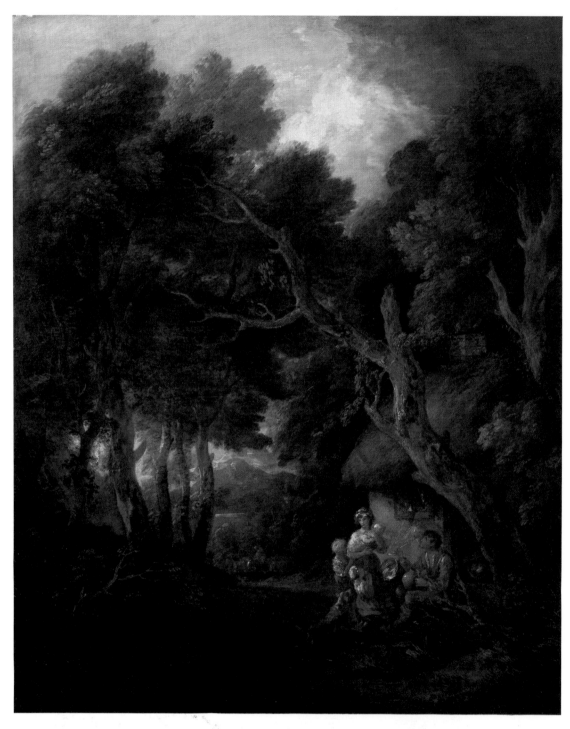

**Peasant Smoking at a Cottage Door**
Cat.no.152 (p.154)

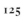

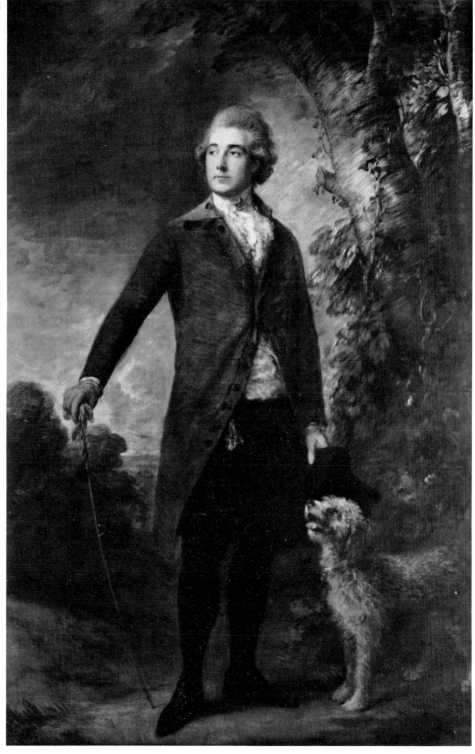

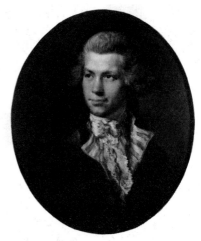

drawings (for example, Cat.no.41) and this portrait, which shows him to have been a lively and good-humoured young man, is supposed to have been painted as a wedding present.

**128 Henry Frederick, Duke of Cumberland (1745–90) with his Wife Anne, formerly Mrs Horton (1743–1808), attended by Lady Elizabeth Luttrell (d.1799).**
Canvas, 163.8 × 124.5 (64½ × 49). Oval
About 1783–5
Lit: Waterhouse, No.178; Oliver Millar, *The Later Georgian Pictures in the Collection of Her Majesty The Queen*, London, 1969, Vol.1, No.797; David Manning, 'Gainsborough's Duke and Duchess of Cumberland with Lady Luttrell', *The Connoisseur*, June 1973, pp.85–93.
*Her Majesty The Queen*

Gainsborough's portrait of the Duke and Duchess of Cumberland strolling in the grounds of Cumberland Lodge, Windsor Great Park, with the Duchess's sister, Lady Elizabeth Luttrell, sketching in the background, is one of his most original and subtly balanced compositions. It is of superlative quality throughout, and survives in a perfect state of preservation. The design began simply enough, as a conversation piece with a flat, decorative background, very similar to Zoffany, as can be seen from Gainsborough's first sketch, now in the royal collection (Fig.19). In the second drawing, in the British Museum (Fig.20), the trees, now more romantic in character, are integrated with the figures rather than

possible the canvas had been used for a previous sitter and then discarded. Conceivably the completed full-length of Fischer described by Thicknesse in a letter of 4 August 1774 as 'painted . . . in Scarlet, laced, like a Colonel of the Guards' is the work beneath. The reference is otherwise puzzling. The portrait was acquired by the amateur flautist Lord Abingdon (Cat.no.119), for whom it may have been painted; sold by his successor, the 5th Earl, it entered the royal collection in 1809 when it was presented to the Prince of Wales by his brother, the Duke of Cumberland.

**127 William Pearce (*c*.1751–1842)**
Canvas, 63.5 × 53.3 (25 × 21). Oval
About 1780
Lit: Whitley, pp.392–3; Waterhouse, No.538
*Private collection*

William Pearce, Chief Clerk of the Admiralty, was also a literary amateur and poet who wrote the libretti for several comic operas produced at Covent Garden. He was a friend of the Prince of Wales as well as of Bate-Dudley. Gainsborough gave him a number of

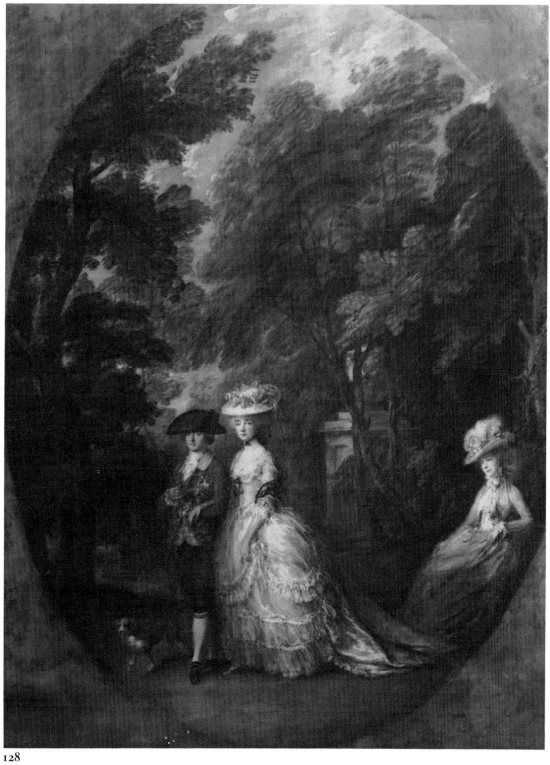

128

being just a setting, and the pattern of light and shade is more complex. The finished picture is neither horizontal nor vertical in format, but oval; the trees, towering over the figures, have now taken on a vigorous life of their own, the Duke's pose has reverted to that adopted in the initial sketch, and the garden urn, also seen in this drawing, has been effectively disposed as a pictorial link between the Cumberlands and Lady Elizabeth. The costumes, notably the elaborate polonese dress and the hats, are those of 1783–5, and similar to those which appear in 'The Mall'; it has recently been pointed out that, like 'The Mall', the picture is Watteauesque in inspiration and has its roots in such pictures of couples strolling in a garden as 'La Cascade' (where even the relationship of Lady Elizabeth is anticipated in the seated musician). Apparently painted 'at the Duke's instance', the picture was never sold, and was bought by, or on behalf of, the Prince of Wales at Mrs Gainsborough's sale at Christie's in 1792.

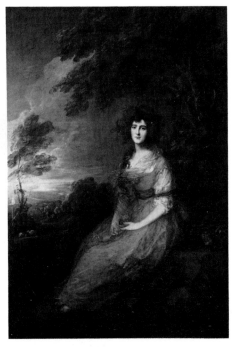

**129 Mrs Richard Brinsley Sheridan, née Elizabeth Linley (1754–92)**
Canvas, 219.7 × 153.7 (86½ × 60½)
Painted in the spring of 1785, and slightly altered in the winter of 1786
Lit: Whitley, pp.238 and 265; Waterhouse, No.613
*National Gallery of Art, Washington*
(*Andrew W. Mellon Collection*)
[colour repr. p.125]

Gainsborough knew Elizabeth Linley from the time she was only six years old. A great beauty who was also a talented musician and the leading soprano at the Three Choirs Festival in 1771 (she is probably the singer represented in Gainsborough's sketch 'The Music Party': Cat.no.26), she eloped to France with Sheridan in 1772. In this full-length, done thirteen years later than the double portrait at Dulwich, where she was portrayed just before her marriage, Gainsborough has produced a masterpiece in a wholly new style, the beginnings in English painting of that romantic approach to portraiture which Lawrence was to take to its furthest lengths. The abandon of the hair, which curls right down to the waist, and of the gauze wrap that is intertwined with it, is matched by the sketchiness of the brushwork throughout the dress. More important, how-

ever, the character of the brushwork in the hair and costume is taken up in the foliage of the trees, so that trees and figure form a natural compositional flow and the sitter really seems to be enveloped by the landscape in which she is seated so much at her ease. It is significant that Bate-Dudley thought it worthwhile mentioning that the lambs in the background, not included in the design when the painting was exhibited, were added by Gainsborough to give the picture 'an air more pastoral that it at present possesses'. Dupont made a mezzotint of this portrait, which was never published.

**130 William Hallett (1764–1842) and his Wife Elizabeth, née Stephen (1763/4–1833), known as 'The Morning Walk'**
Canvas, 236.2 × 179.1 (93 × 70½)
Painted in the autumn of 1785
Lit: Waterhouse, No.335; Martin Davies, *The British School*, National Gallery Catalogue, 2nd edn., 1959, pp.44–5
*Trustees of the National Gallery*

The Halletts were married in July 1785 and this marriage portrait, surely the most perfect of the genre, was painted shortly afterwards. The picture is a remarkable development of the kind of poetic

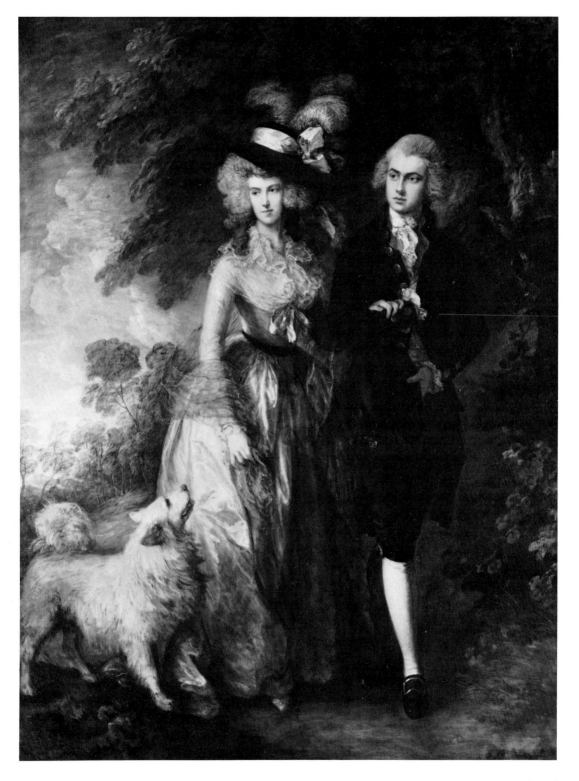

portrait, in which the sitter is seen walking gently forward towards the spectator through a romantic wooded landscape, with which Gainsborough had begun to experiment earlier in the year in his 'Lady Sheffield' (Waddesdon Manor). It is as much a portrait of the romance of young love as it is a likeness of the two individuals; Mrs Hallett's costume, with its apple-green ribbons and bows, diaphanous wrap and sketchiness of handling, links as closely with the sylvan landscape as that of Mrs Sheridan. The French poet Gautier said that, in front of it, he felt 'a strange retrospective sensation, so intense is the illusion it produces of the spirit of the eighteenth century. We really fancy we see the young couple walking arm in arm along the garden avenue.' A more down-to-earth note is struck by the lively and superbly painted Spitz dog, compositionally the starting point of one of the two crossing diagonals that form the framework of the design, and which meet, appropriately, in Mrs Hallett's left hand.

Lit: Whitley, p.234; Waterhouse, No.50
*Mrs Prue M. Guild (née Beaufoy)*

Henry Beaufoy was the son of Mark Beaufoy, a successful Quaker businessman whom Gainsborough had painted several years before (this portrait was recently destroyed by fire). The strong studio lighting emphasises the vigorous expression and stance of this brilliant young politician. An associate of Gainsborough's patron and friend, Lord Shelburne, Beaufoy was an active and independent M.P., Chairman of the Commons committee which examined the state of British fisheries in 1785, who spoke on trade and finance and was concerned with fostering new industries in Scotland, but died with his promise unfulfilled. He is seen here wearing the Windsor uniform, a court dress intended principally for use when the Court was at Windsor, the king's favourite residence, introduced in about 1779 by George III – in its plainness it followed the precedent of Frederick the Great. The picture is not quite finished, the right hand holding the hat and stick being only blocked in.

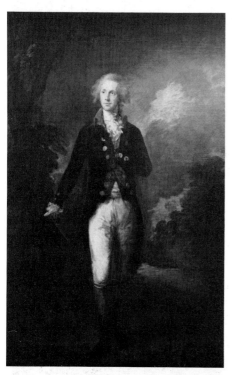

131  **Henry Beaufoy** (1750–95)
Canvas, 228.7 × 149.9 (90 × 59)
About 1785

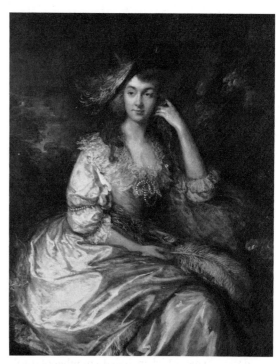

132  **Frances Susanna, Lady de Dunstanville**
(d.1823)
Canvas, 125.7 × 100.3 (49½ × 39½)

Exhibited at Schomberg House in the autumn of 1786
Lit: Waterhouse, No.220
*Corcoran Gallery of Art, Washington*
*(William A. Clark Collection)*

In this bold, spiralling composition, somewhat on the lines of his 'Ann Ford' (Cat.no.91), and set well forward in the canvas, it is the brilliant, broken brushwork in the satin dress which provides the main focus of attention. The portrait itself is suggestive of a somewhat empty-headed lady of fashion. The sitter's husband was an admirer of Gainsborough's 'fancy' pictures, and had bought the celebrated 'Cottage Girl with Dog and Pitcher' (Cat.no.139) the previous year.

**133 Edward, Duke of Kent** (1767–1820)
Canvas, 76.2 × 63.5 (30 × 25)
About 1786–7
Lit: John Hayes, 'An unknown Gainsborough Portrait of Edward, Duke of Kent', *The Burlington Magazine*, July 1966, pp.362–5
*Yale Center for British Art, New Haven*
*(Paul Mellon Collection)*

The Duke of Kent was George III's least favourite son. He pursued a military career and, although pedantic in his insistence on the minutiae of etiquette and discipline, was successively commander-in-chief of the forces in British North America and Governor of Gibraltar, retiring as a Field-Marshal. His daughter was the future Queen Victoria. This portrait was painted during the intervals of his youthful service abroad, in Hanover and Geneva, shortly after, in May and June 1786 respectively, he was gazetted Colonel and elected to the Order of the Garter, the riband of which he is wearing. Though smartly dressed (the green coat with its buff collar and gold frogging appears not to be a military uniform) and elegantly posed, the informal outdoor setting is unusual for a portrait of a royal prince at this time. Nothing is known about the history of the picture. Perhaps it was commissioned by the Duke to take abroad, but never finished. Conceivably – a modello for a larger canvas – it was intended to form part of the scheme, which included a number of royal portraits by Gainsborough, that the Prince of Wales was then devising for the embellishment of Carlton House.

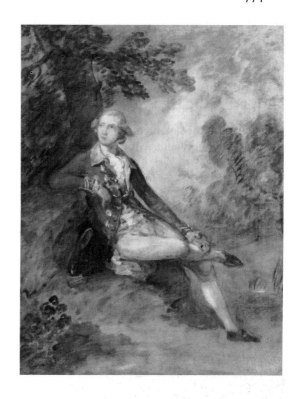

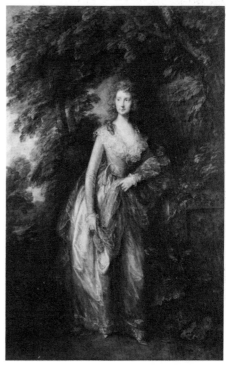

134

[143]

**134 Mary, Duchess of Richmond** (1740–96)
Canvas, 232.4 × 151.1 (91½ × 59½)
About 1786–7
Lit: Waterhouse, No.576
*National Trust (Rothschild Collection, Ascott)*
[colour repr. p.123]

This full-length of Mary, wife of the third Duke of Richmond, a leading protagonist of parliamentary reform, is one of the most ravishing of Gainsborough's late romantic portraits. She is depicted wearing a blue satin dress, with a blue gauze scarf, her beautiful red hair falling over her shoulders, and set against a richly wooded landscape, her left arm resting on a pedestal. The enigmatic smile and slightly distant expression heighten the poetic mood of the canvas. It is a portrait of youthful beauty and hauteur, in the Van Dyck tradition, yet the sitter was more than forty-five when she was painted. Notice the long, thin right arm, an idiosyncrasy, seen in many of Gainsborough's late works, suggestive of the use of a lay-figure.

**135 Robert, Viscount Belgrave (later 1st Marquess of Westminster)** (1767–1845)
Canvas, 76.2 × 63.5 (30 × 25)
Later 1780s

Lit: Waterhouse, No.60
*The Duke of Westminster*

Although this portrait admirably conveys the pride of the high-born young aristocrat, Belgrave was described by his tutor as 'most amiable' and 'accomplished'. He was later responsible for the extensive rebuilding of the family mansion, Eaton Hall, and for the layout of Belgravia. Though the head is firmly modelled, the rest of the picture is executed in the broad, loose style characteristic of Gainsborough's later years which was to be followed, in the decade after his death, by Dupont.

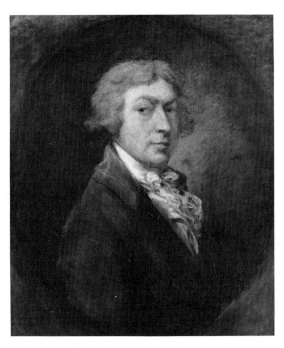

**136 Self Portrait**
Canvas, 74.9 × 61 (29½ × 24)
About 1787
Lit: Waterhouse, No.292
*Royal Academy of Arts, London*

This self portrait, done when Gainsborough was sixty, was probably the picture he was painting for his friend Abel when the latter died in 1787. The searching eye of a man who ceaselessly scrutinised the visible world, 'continually remarking to those who happened to be about him, whatever peculiarity

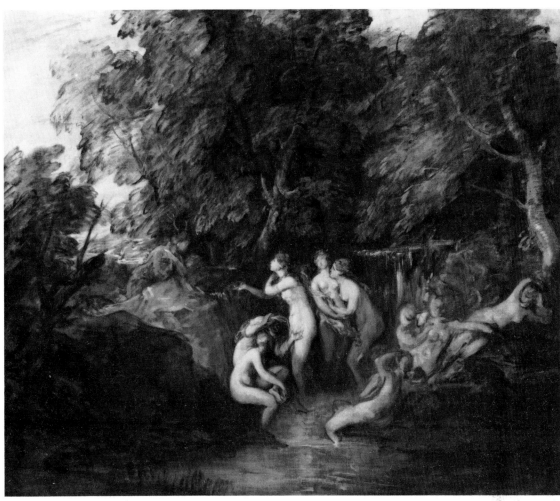

137

of countenance, whatever accidental combination of figures, or happy effects of light and shadow, occurred in prospects, in the sky, in walking the streets, or in company', is fully evident. A year later, in his own last illness, it was this portrait by which he wished posterity to remember him: 'It is my strict charge that after my decease no plaster cast, model, or likeness whatever be permitted to be taken: But that if M$^r$ Sharp, who engraved M$^r$ Hunter's print, should chose [sic] to make a print from the $\frac{3}{4}$ sketch, which I intended for M$^r$ Abel, painted by myself, I give free consent.' Gainsborough's daughter, Margaret, gave the portrait to the Royal Academy in 1808.

137 **Diana and Actaeon**
Canvas, 158.1 × 188 ($62\frac{1}{4}$ × 74)
About 1785
Lit: Chauncey Brewster Tinker, *Painter and Poet*, Cambridge, Mass., 1938, pp.78–80; Waterhouse, No.1012; Oliver Millar, *The Later Georgian Pictures in the Collection of Her Majesty The Queen*, London, 1969, Vol.1, No.806; Oliver Millar, *Gainsborough*, catalogue of an exhibition at The Queen's Gallery, 1970, No.12; Hayes *Landscape Paintings*, No.160
*Her Majesty The Queen*

[145]

The 'Diana and Actaeon' is one of the most beautiful and idyllic of all Gainsborough's works, the only subject drawn from classical mythology he ever attempted, and conceivably inspired by Wheatley's recently executed (1783) 'Bathers by a Waterfall'. It is also one of the few canvases for which he made more than one preliminary drawing, so that the development of his ideas can be followed stage by stage. These drawings are very varied in character and intention, and provide the most valuable means of insight into the workings of Gainsborough's pictorial imagination that has come down to us. The story, taken from Ovid's *Metamorphoses*, tells how Actaeon, hunting in the sacred valley of Gargaphe, stumbled unwittingly on the bathing place of Diana and her attendants; Diana at once threw a handful of water at his face and turned him into a stag, where-upon he was torn to pieces by his own hounds. The first sketch (Cat.no.40), brilliant and dramatic in concept, concentrates on the embarrassment caused by the intruding huntsman; the sense of confusion is heightened by the vigorously sketched tree trunks, spiralling in different directions above the figures. In the second sketch Diana has been moved to the left, there are fewer bathers and the nymphs have been grouped broadly in a semicircle, where they are partially sheltered by the foliage, now a protec-tive mass bearing down on the figure of Actaeon. The third sketch shows Actaeon silhouetted against the sky and a largely different arrangement of the figures; neither the attitudes of the nymphs nor the massing of the trees any longer suggest agitation. This calmer design was substantially that used for the painting itself, though the posture of Actaeon has been changed again and there are alterations in the background, notably the inclusion of a waterfall linking the two groups of figures; these were pos-sibly evolved on the canvas itself, since numerous *pentimenti* can be detected. The picture was never finished in the strict sense of the word; most of the figures and much of the landscape are only sketched in. But, like the Washington landscape, it is complete as a work of art. Sir Oliver Millar has pointed out that 'cleaning and restoration, completed in 1969, seems to confirm that the picture . . . is a large sketch and not an unfinished design.' This view seems to be correct, as the character of the brushwork does not suggest that the picture could have been carried further, and the possibility that the work was, in any case, an

entirely private one is suggested by the fact that, alone of all Gainsborough's important late works, it was never mentioned in the press. The figures, one of them certainly based on a classical model, are beautifully grouped and demonstrate the loss we have sustained by Gainsborough's not having em-ulated his French contemporaries as a painter of the nude; the nymph on the right, reclining on the bank like a Matisse odalisque, emphasises the mood of *poesie* successfully created by the fresh silvery harmonies of the colour. The canvas remained in Gainsborough's studio until his death, and appeared in the family sale at Christie's in 1797, where it was bought on behalf of the Prince of Wales for £2.3.0.

**138 Peasant Girl Gathering Mushrooms**
Canvas, 127 × 101.6 (50 × 40)
Unfinished
1780s
Lit: Waterhouse, No.812
*Private collection*

This unfinished 'fancy' subject remained in Gains-borough's studio until his death, and was sold at Christie's in 1797. There is a companion picture, also unfinished, of a girl holding a penny.

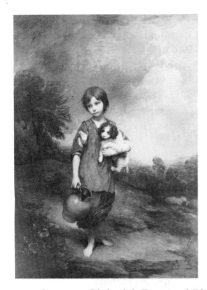

**139 Cottage Girl with Dog and Pitcher**
Canvas, 174 × 124.5 (68½ × 49)
Painted in the spring of 1785
Lit: Whitley, pp.241–3; Waterhouse, No.803
*Sir Alfred Beit, Bt.*
[colour repr. p.126]

'The Cottage Girl with Dog and Pitcher' is the epitome of Gainsborough's sentiment, and perhaps the finest of all his fancy pictures. The expression is wistful, but, though Hazlitt criticised 'a consciousness in the turn of the head, and . . . a regular insipidity . . . to which real nature is a stranger', neither cloying nor unnaturalistic, and the figure is posed with perfect aplomb between the cottage hidden amongst trees on the left and the bright cloud on the right. The picture was universally admired, and was promptly purchased, for two hundred guineas, by Sir Francis Basset, who sat to Gainsborough in the following year. A contemporary praised the pose of the dog as 'extremely natural and pleasing', and called the distance 'a charming landscape, with sheep and pastoral objects'; C. R. Leslie, the biographer of Constable, said it was 'unequalled by anything of the kind in the world. I recollect it at the British Gallery, forming part of a very noble assemblage of pictures, and I could scarcely look at or think of anything else in the rooms.' It has been suggested that the sitter was Jack Hill, a Richmond child whom Gainsborough introduced in his 'Woodgatherers' and 'Interior of a Cottage', both painted in 1787, but Jack Hill was a younger child and con-

temporary accounts all agree that the sitter was a girl. The model seems to have been the same as Gainsborough had used for the 'Girl with Pigs'; he had met her near Richmond Hill, carrying under her arm the puppy he has painted her with here.

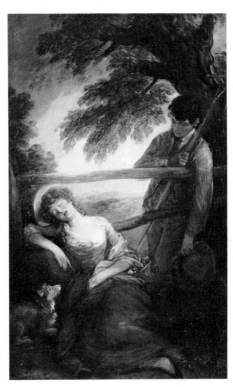

**140 Haymaker and Sleeping Girl**
Canvas, 226 × 148.6 (89 × 58½)
About 1785
Lit: Waterhouse, No.815
*Boston Museum of Fine Arts (Maria T. B. Hopkins and Seth K. Sweetser Residuary Funds)*

The 'Haymaker and Sleeping Girl' is in a different vein from the rest of Gainsborough's fancy pictures; the sentiment is no longer of an abstract nature, and the theme derives from those rustic lovers who had played a prominent role in so many of his landscapes from the 1750s onwards. The haymaker, prototype of the Victorian love-sick rustic, is gazing adoringly at the beautiful features and half-revealed breast of the sleeping girl, posed, deliberately, like a Correggio goddess, and the relationship between the two figures, with which the spectator feels an instant

[147]

rapport, is beautifully sustained by the interplay of interlocking diagonals. The high key and fluent handling are emphasised by the delicious patch of sunlit landscape which opens up between the figures. It was this picture, and not, to Gainsborough's disappointment, 'The Woodman', the canvas he regarded as his masterpiece, that Dupont selected when, one day, pleased with his nephew's work, Gainsborough offered him the choice of anything in his studio. The painting remained in the possession of the Dupont family until 1891.

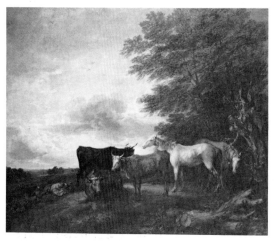

141 **Repose**
  Canvas, 121.9 × 148.6 (48 × 58½)
  About 1777–8
  Lit: Waterhouse, No.908; John Hayes,
  *Gainsborough as Printmaker*, London, 1971,
  p.107; Hayes *Landscape Paintings*, No.119
  *Nelson Gallery – Atkins Museum, Kansas City*
  (*Nelson Fund*)

This was one of Gainsborough's favourite pictures. He could never be induced to sell it, and he gave it to his daughter Margaret, for whom it was intended as a 'wedding portion' (she never married). Tradition has it that the work 'underwent sundry glazings, and was a long time in hand.' Gainsborough made extensive alterations in the design, which was rare with him. The herdsman was originally intended to be standing, as can be seen from the *pentimento* in the preparatory drawing (also in the Nelson Gallery). A large tree arching over the composition on the left, and a fountain on the right, which were Gainsborough's last ideas, and painted in a soluble medium,

were cleaned off during the restoration carried out in the early part of this century. The animals are monumental in conception, and the compact, frieze-like arrangement has a certain affinity with Stubbs. The deep tonality and the thick, broken impasto at the horizon are typical of Gainsborough's landscapes of this period, of which the best known is 'The Watering Place' (National Gallery), exhibited at the Royal Academy in 1777. Gainsborough made a soft-ground etching of 'Repose', but no impressions are known to have survived. Elhanan Bicknell and Joseph Gillott were among prominent Victorian collectors who once owned the painting.

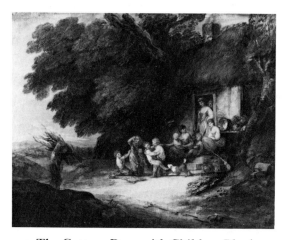

142 **The Cottage Door with Children Playing**
  Canvas, 122.5 × 149.2 (48¼ × 58¾)
  Probably exhibited R.A. 1778 (120)
  Lit: Waterhouse, No.940; John Barrell, *The Dark Side of the Landscape*, Cambridge, 1980, pp.70, 75 and 76; Hayes *Landscape Paintings*, No.121
  *Cincinnati Art Museum* (*Given in honour of Mr and Mrs Charles F. Williams by their children*)
  [colour repr. p.135]

The theme of this picture is very similar to 'The Woodcutter's Return' (Duke of Rutland, Belvoir Castle) of five years earlier, and the figure grouping is contrived with equal care and success, the arrangement being considerably improved between preparatory drawing and finished painting. In contrast to the Rutland picture, however, the figure composition is based on a rhythmically flowing diagonal rather than on a pyramid, the children are lively instead of placid, and the husband returning with

faggots for the evening fire is more satisfactorily placed, as he is physically more detached from the group outside the cottage. The distance is hardly more than sketched, and the thick yellow impasto in the lights at the horizon is applied with an unprecedented looseness of touch. Gainsborough followed up this canvas with what is generally recognised as the most majestic, most vigorous and most effectively composed of his 'cottage door' subjects: this was the work exhibited at the Royal Academy in 1780 and now in the Huntington Art Gallery, having been acquired from the Duke of Westminster through Duveen at the same time as 'The Blue Boy'. The Cincinnati picture was also sold to America by Duveen, and was previously in two famous collections, those of Lord Mulgrave (who may have bought it direct from Margaret Gainsborough) and Lord Normanton.

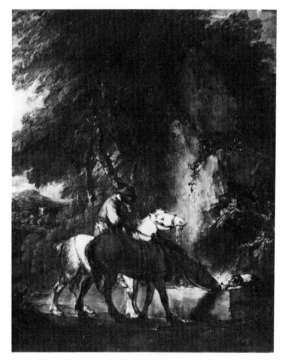

143 **Horses Watering at a Trough**
Canvas, 123.2 × 99.1 (48½ × 39)
Exhibited R.A. 1780 (74)
Lit: Waterhouse, No.944; Hayes *Landscape Paintings*, No.124
*British Rail Pension Fund*

In this moment of rest between the labours of the day and the return home, the drover is seen gently dozing while his horses drink at the trough. Except for the pinks and yellows at the horizon the tonality is deep; large, picturesque rocks are used for the first time in Gainsborough's landscapes, and they form a natural complement to the richly romantic foliage which fills out the canvas and arches protectively over the scene below. When the picture was exhibited at the Academy, it was described as 'inimitably fine'. At the turn of the century it was owned by one of the foremost connoisseurs of the day, Sir John Fleming Leicester, a collector of contemporary British painting and founder of the British Institution. A mezzotint was made by Henry Dawe (1790–1848).

144 **Coast Scene with Fishermen Setting Out**
Canvas, 101.9 × 127.6 (40⅛ × 50¼)
About 1781–2
Lit: Waterhouse, No.954; Hayes *Landscape Paintings*, No.129
*National Gallery of Art, Washington*
(*Alisa Mellon Bruce Collection*)

In 1781 Gainsborough exhibited at the Academy two seascapes, or rather coastal scenes, one a storm, one a calm, pictures deliberately constrasted in mood in the tradition of such fashionable painters as Vernet. In this squally canvas, with its wonderfully atmospheric treatment of the sea as it recedes towards the horizon, the waves and foam are brilliantly rendered and the air seems full of moisture; as Horace Walpole wrote of the 1781 exhibits, 'one steps back for fear of being splashed'. The sweeping diagonals of the composition emphasise the turbulence of the scene, and the rock forms Gainsborough had first used in a pastoral context (Cat.no.143) have now become monumental and forbidding. This was another of Gainsborough's pictures purchased by Sir J. F. Leicester; he acquired it in 1805.

145 **Gainsborough's 'Peep Show' Box**
About 1781–2
Lit: Waterhouse, Nos.970–81; Jonathan Mayne, 'Thomas Gainsborough's Exhibition Box', *Victoria and Albert Museum Bulletin*, Vol.1., No.3, July 1965, pp.17–24; Hayes *Landscape Paintings*, No.132
*Victoria and Albert Museum*

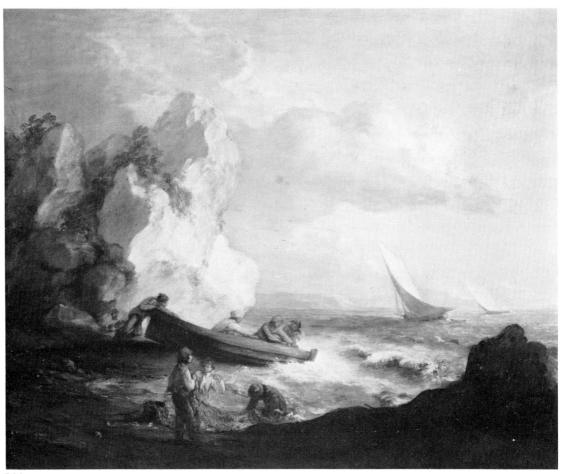

144

Gainsborough was familiar with transparency paint-
ing, and had himself painted transparencies for the
decoration of Bach and Abel's concert rooms in
Hanover Square, opened in February 1775. But it
seems to have been de Loutherbourg's (Cat.no.122)
*Eidophusikon* (magical representation), a novel
theatrical entertainment in which illusionistic effects
of sunrise and sunset, storm, thunder, shipwreck and
fire were created on a miniature stage without actors
with the aid of moving scenery, dramatic lighting and
sound, first shown in London in February 1781, and
which not surprisingly took the town by storm – that
inspired his own 'peep show' for displaying his ideas
for landscapes. Gainsborough's rather amateurish
box contained a proscenium arch with several slats
behind, the foremost of which was occupied by a

translucent silk screen; each transparency was in-
serted behind the screen and illuminated by five
candles inserted in candle-holders at the back of the
box; the spectator viewed the transparency at a dis-
tance of some three feet through a large peep-hole,
fitted with a magnifying lens, in the front of the box.
Gainsborough must have painted numerous trans-
parencies for showing in his box, but only ten survive
(an example is Cat.no.146): all these are completely
tonal in quality, executed in a range of blues, greens
and browns, and Gainsborough's aim was clearly
to heighten and dramatise his effects of light, to
out-Rubens Rubens and to seek a more exact pic-
torial approximation to the effects of which every
painter knows Nature alone is capable. The box, and
the surviving transparencies, were originally pur-

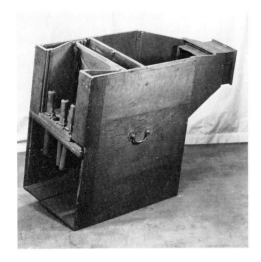

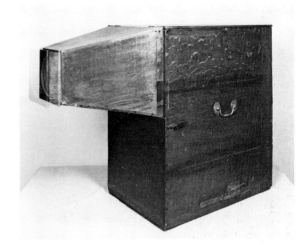

chased privately from Margaret Gainsborough by Dr Thomas Monro, a passionate collector of Gainsborough's drawings and the patron of the youthful Girtin and Turner.

**146 Moonlight Landscape with Figure at the Door of a Cottage**
Transparency on glass, 27.9 × 33.7 (11 × 13¼)
About 1781–2
Lit: Waterhouse, No.971; Hayes *Landscape Paintings*, No.134
*Victoria and Albert Museum*

One of the ten surviving transparencies Gainsborough made for his 'peep show' box (Cat.no.145). This is the first occasion on which he had painted a moonlight scene and the first in which he had tried out an indoor lighting effect: the window, and the doorway against which the figure is silhouetted, are brilliantly illumined by fire-light. Edward Edwards, a minor contemporary painter, described the effects produced by Gainsborough's transparencies as 'truly captivating, especially in the moon-light pieces, which exhibit the most perfect resemblance of nature'.

**147 Mountain Landscape with Shepherd and Sheep**
Canvas, 120 × 148.6 (47¼ × 58½)
Signed with initials
Painted in the autumn of 1783
Lit: Whitley, pp.229 and 259; Waterhouse, No.992; Hayes *Landscape Paintings*, No.146
*Bayerische Landesbank, Munich (on loan to the Neue Pinakothek, Munich)*.

In the late summer of 1783 Gainsborough made the by then fashionable tour of the Lake District in the company of his old friend Samuel Kilderbee (Cat. no.60). He wrote to his friend William Pearce (Cat.no.127): 'I purpose to mount all the Lakes at the next Exhibition, in the great stile'. This upland scene was the first-fruits of his visit. But, though the mountains are evidently based on Langdale Pikes, of which he had made a drawing (Cat.no.33), the contours of the peaks have been even more relaxed, and all the elements in the composition – banks,

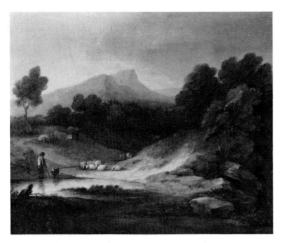

rocks and trees – are caught up in a sweeping lateral rhythm comparable to Rubens. The greyish tonality and misty atmosphere are Lakeland in character, and a contemporary reporter described the picture as 'though not a portrait of any particular spot . . . highly characteristic of that country.' In the event, owing to Gainsborough's quarrel with the Academy, the painting was not shown 'at the next Exhibition'. It was displayed at Gainsborough's first exhibition in his own studio at Schomberg House, in July 1784. Bought by the Prince of Wales, it was never paid for, and remained at Schomberg House until the settlement of his debts to Gainsborough in 1793. The Prince presented this landscape and its companion (Cat.no.150) to Mrs Fitzherbert in 1810.

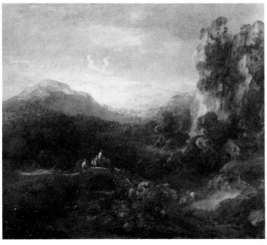

148

### 148 Mountain Landscape with Bridge

Canvas, 113 × 133.4 (44½ × 52½)
Unfinished
About 1783–4
Lit: Waterhouse, No.1008; Hayes *Landscape Paintings*, No.151
*National Gallery of Art, Washington (Andrew W. Mellon Collection)*

As can be seen also from his landscape based on memories of Langdale Pikes (Cat.no.147), and indeed the drawing done on the spot (Cat.no.33), the grand solemnity and ruggedness of mountain scenery did not really stir Gainsborough, any more than it did Constable; his concern was with rhythm and flowing movement. These qualities are the keynote of this picture. The lateral movement of the group crossing the bridge is stressed by the lighting, which picks out the track behind it and the bank in front, and the undulating line formed by this progression is echoed in the dark trees in the middle distance and the mountains beyond. The high cliffs on the right, which were developed in the course of working out the design, are somewhat obtrusive, and may have accounted for Gainsborough's ultimate failure to carry the picture through. But for posterity the advantage of its unfinished state is that it is possible to study Gainsborough's extraordinary sureness, as well as brilliance and spontaneity, of handling, in the initial stages of his work on one of his great canvases: to take just one detail, the rich, creamy brushstrokes roughly blocking out the shapes of the figures crossing the bridge are already vitally suggestive of both form and movement. The picture was bought at the family sale at Christie's in 1797 by Sir John Leicester.

### 149 Landscape with Country Carts

Canvas, 128 × 102.6 (50⅜ × 40⅛)
About 1784–5
Lit: Waterhouse, No.941a; Hayes *Landscape Paintings*, No.156
*Fine Arts Museums of San Francisco (Roscoe and Margaret Oakes Collection)*

The totally enclosed nature of the landscape, especially in a large-scale work, is very unusual for Gainsborough; and the subject-matter, two country carts travelling down a wooded lane, is new. The only comparison is with the Ruisdael-like landscape of

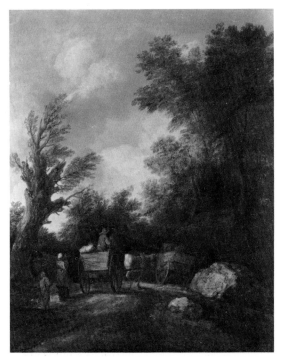

1766 (Cat.no.112). The loose, feathery foliage is close in character to the work of other Dutch landscapists, such as Salomon van Ruysdael or Adriaen van der Velde, and the picture is in fact a close copy of a painting by Pieter Molijn, but with the addition of a framing tree on the left. The flowing, upward movement of the trees, which are modelled in rich glazes, is echoed in the soft, spiralling clouds. The picture was given by Gainsborough to Samuel Kilderbee (Cat.no.60) 'as his CHEF D'OEUVRE . . . in Memory of Friendship.'

**150  The Harvest Waggon**
  Canvas, 121.9 × 149.9 (48 × 59)
  Signed with initials
  Painted in the winter of 1784–5
  Lit: Whitley, pp.258–9; Waterhouse, No.993;
  Frederick Cummings, *Romantic Art in Britain*,
  catalogue of an exhibition at Detroit and
  Philadelphia, 1968 (No.22); John Barrell, *The
  Dark Side of the Landscape*, Cambridge, 1980,
  pp.68–70; Hayes *Landscape Paintings*, No.157
  *Art Gallery of Ontario, Toronto*
  (*Gift of Mr and Mrs frank P. Wood, 1941*)

The subject is related to Gainsborough's earlier Harvest Waggon, in the Barber Institute, Birmingham, painted nearly twenty years before, and includes the motifs of the drover holding the horses still and the girl being helped into the waggon; but the spotlit figure group is no longer pyramidal, the trees and rocks behind enclose rather than heighten the design, and the winding track has become the dominant compositional rhythm. In contrast to the earlier work, it is the landscape that is in vigorous movement, not the figures and horses, and the concept is baroque rather than classical. The Claudean background of the Birmingham picture has been replaced by a *mis-en-scène* inspired by Rubens that envelops the entire composition: the wiry, twisting tree trunk cut off at the top, which frames the canvas, and the semi-circle of intermingled trees and rocks enclosing deep shadows, seem to derive from a famous Rubens, 'Cart overturning by Moonlight', of which Gainsborough could have seen a version in Lord Harcourt's collection at Nuneham. The child at the back of the waggon is astonishingly close to Rembrandt in technique, and the girl in shadow is based on Hogarth's 'Shrimp Girl' (Tate Gallery). The picture was bought direct from Gainsborough's studio by the Prince of Wales, but was not paid for until 1793; the Prince later gave it to Mrs Fitzherbert (see also under Cat.no.147).

**151  Wooded Landscape with Herdsman and
    Cattle**
  Canvas, 76.2 × 63.5 (30 × 25)
  About 1786
  Lit: Hayes *Landscape Paintings*, No.182
  *Private collection*
  (*on loan to York City Art Gallery*)

The broad outlines of the design are identical with 'The Market Cart' (Tate Gallery), painted in the winter of 1786, but a herdsman driving cattle fills the place of the market cart, and neither the figures in the foreground, the faggot-gatherers, or the trees on the left, have been included. Although the canvas is no more than broadly sketched, the effects of light are beautifully differentiated, and it is comparable in technique, brilliance and sureness of touch with such masterly late wash drawings as the sheet in Berlin (Cat.no.51). The picture seems likely to be an oil sketch for a composition with which, for some reason, Gainsborough felt dissatisfied (the scale of

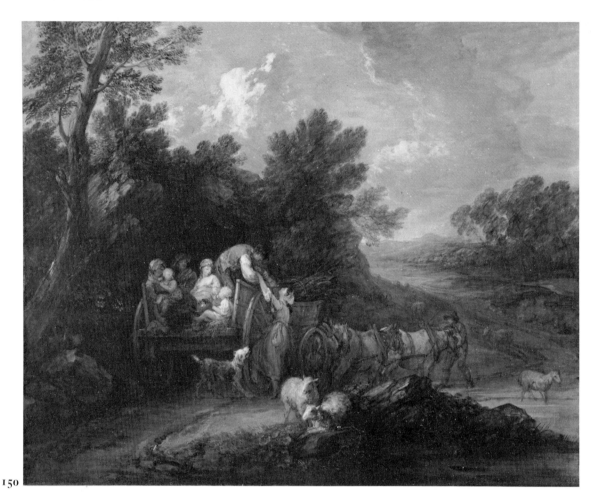

150

the magnificent trees may have seemed out of keeping with the simple, pastoral subject) and which he afterwards turned to good account in developing the composition of 'The Market Cart'.

## 152 Peasant Smoking at a Cottage Door
Canvas, 195.6 × 157.5 (77 × 62)
Painted in the spring of 1788
Lit: Whitley, pp.323–4; Waterhouse, No.1011; Hayes *Landscape Paintings*, No.185
*University of California at Los Angeles* (*Gift of Mrs James Kennedy*) [colour repr. p.136]

This was the last landscape of any size by Gainsborough, and the most majestic of all his pastorals. Unsold because the price, five hundred guineas, was too high, it was acquired after the artist's death by Bate-Dudley, and later passed to Sir George Beau-

mont. Designed as a companion to 'The Market Cart', it is rich and romantic in conception where the former is serene; the foliage is dramatically massed, the spotlight more theatrical, the sunset glow breaking through the trees more vivid than Claude, the paint at the horizon thick and encrusted. The composition is dominated by the near-dead tree trunk, distinctly reminiscent of the similar tree in 'The Cottage Door' of 1780, which links together the two tree masses; beneath this the peasant family are grouped on the steps of their cottage in a pyramid rather looser in arrangement than was the case in the Huntington picture. Bate-Dudley described this painting as exhibiting 'one of those sweet recesses, where the mind never fails to find a source of enjoyment: 'Tis reading *Poetry*, and compressing all its enchantments to the glance of the eye'.

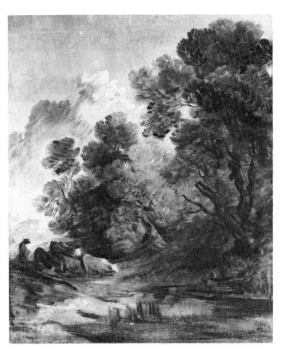

151

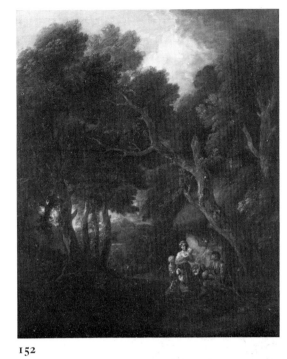

152

# List of Lenders

## Private Collections

Her Majesty The Queen  126, 128, 137

Sir Alfred Beit  73, 139
Trustees of the Bowood Settlement  115
British Railways (wages grades) Pension Fund  143
The Duke of Buccleuch and Queensberry  100, 103
Trustees of the Burton Property Trust  125

Viscount Camrose  116
The Marquess of Cholmondeley  59
Lord Clark  28

Denise Gratwohl-Imfeld  93
Mrs Prue M. Guild  131

The Earl of Haddington  61
Holker Estate Trust  37

The Earl of Inchcape  69
Ingram Family Collection  16

Marlborough College  97
R.G. McIntyre  102
Methuen Collection  117

The Duke of Norfolk  83

Private Collection  1, 3, 6, 8, 25, 30, 35, 38, 40, 44,
   45, 46, 47, 48, 54, 56, 57, 66, 67, 74, 76, 78, 82,
   85, 86, 87, 89, 90, 94, 101, 104, 105, 106, 107,
   111, 112, 119, 123, 127, 138, 151

Mrs Gertrude B. Springell  20

H. Cornish Torbock  9

Dr Charles Warren  33
Hereward T. Watlington  95
The Duke of Westminster  99, 135
Sir John and Lady Witt  14, 32
Trustees of the late H.C. Wollaston  71

## Public Collections

Amsterdam, Rijksprentenkabinet,
   Rijksmuseum  18

Berlin (DDR), Gemäldegalerie der Staatlichen
   Museen zu Berlin  120
Berlin (West), Staatliche Museen Preussischer
   Kulturbesitz, Kupferstichkabinett  11, 12, 13,
   51, 52
Birmingham, City Museum and Art Gallery  23, 24
Bologna, Civico Museo Bibliografico Musicale  118
Boston, Museum of Fine Arts  140

Cambridge, Fitzwilliam Museum  58, 70
Cincinnati, Cincinnati Art Museum  75, 91, 142

Dublin, National Gallery of Ireland  77, 96, 98

Edinburgh, National Gallery of Scotland  4
Edinburgh, National Trust for Scotland, (Brodick
   Castle)  64

Houston, Museum of Fine Arts  108

Ipswich Borough Museums  63

Kansas City, Nelson Gallery – Atkins
   Museum  141

London, British Museum  5, 10, 17, 21, 26, 41, 53
London, Courtauld Institute Galleries  7, 124
London, Dulwich Picture Gallery  122
London, National Gallery  62, 130
London, National Trust, (Bearsted Collection,
   Upton House)  72
London, National Trust, (Rothschild Collection,
   Ascott)  134
London, Royal Academy of Arts  136
London, Victoria and Albert Museum  27, 65, 145,
   146
Los Angeles, University of California  152